THE PHOTOGRAPHIC EYE

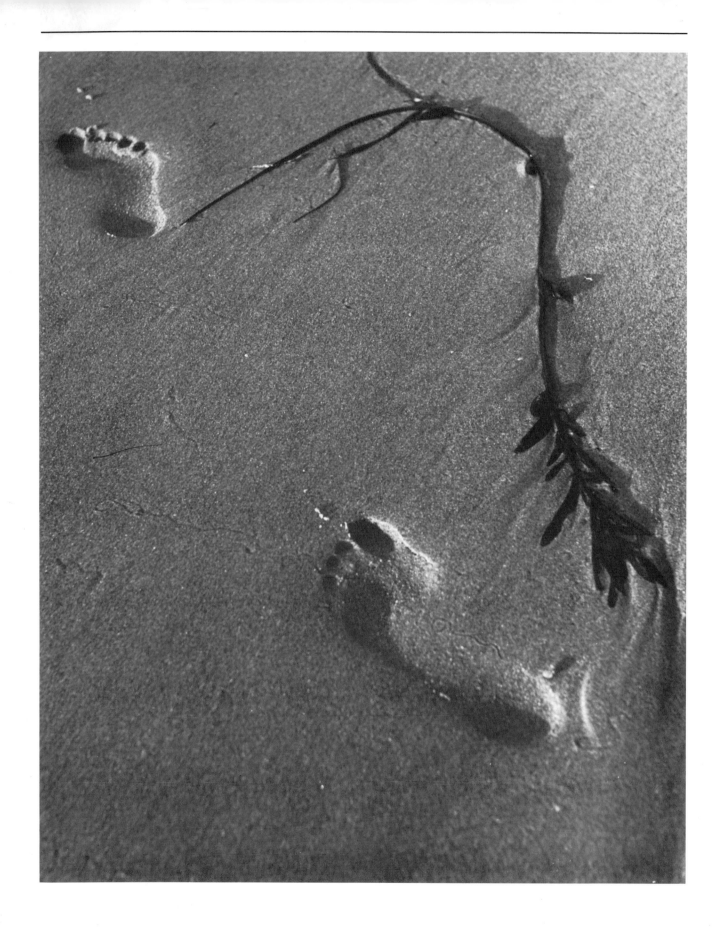

THE PHOTOGRAPHIC EYE
Learning to See with a Camera

Michael F. O'Brien & Norman Sibley

Davis Publications, Inc., Worcester, Massachusetts

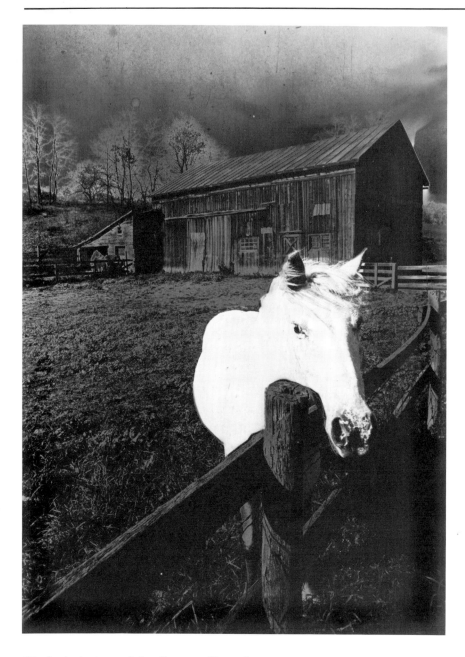

Student photograph by Gregory Conrad.

Copyright 1988
Davis Publications, Inc.
Worcester, Massachusetts U.S.A.

To the photography students of Seoul American High School, past, present and future.

Editor: Claire Mowbray Golding
Design: Greta D. Sibley
Printed in the United States of America
Library of Congress Catalog Card Number:
ISBN: 0-87192-193-6
10 9 8 7 6 5 4 3 2 1

Cover: Student photograph by Vicki Wai Kee Lee.

Contents

Introduction

Photography is both an art and a science. As an art, it expresses a personal vision. As a science, it relies on technology. This double nature is not unique to photography. Every kind of creative expression—such as music, dance or painting—has both a purely artistic side and a more scientific or techological side as well. For example, paints are a kind of technology, and using them well involves a considrable amount of technical skill. The main difference between photogaphy and more traditional visual arts, such as painting, is the *complexity* of its technology.

In any of the arts, the first step toward excellence is mastering techique—learning to use a specific techology skillfully and effectively. In photography, this means that you must learn to control the camera and darkroom equipment, rather than letting them control you.

No artist, however creative, can produce a masterpiece without a sound basis in technique. On the other hand, no amount of technical skill can make up for a lack of artistic vision. Both are essential. The goal of any artist is to use good technique creatively.

Simply speaking, a camera is a machine that produces a two-dimensional (flat) copy of a three-dimensional scene. The process by which this is done may seem like magic. (In fact, when cameras were first introduced, many people all over the world thought that they *were* magic.) Fundamentally, however, there's no magic in the camera. It's just a box with a hole in it. You supply the magic. When you, the photographer, use a camera creatively, it changes from a simple, mechanical machine into an artist's tool. Instead of making random copies of things, it begins to say something about them.

Here are some of the technical questions a photographer must answer for every photograph: How will the lighting affect the clarity and mood of the photograph? How fast should the shutter speed be? How large a lens opening should be used? What should be in focus? What belongs in the frame, and what doesn't? What lens should be used?

All these factors influence each other, and they all affect the final photograph. A photograph is "successful"—in the technical sense—when these factors all work well together and are combined with correct darkroom procedures. When a creative composition is added, the photograph becomes aesthetically successfully as well.

Eventually, you will learn how to control each of these factors to achieve the effect you want. But it will take time. As you may already know, it's often hard to keep all of them in mind every time you take a picture.

Fortunately, it is possible to begin more simply. This book is designed to help you do that. It begins with a brief summary of photography's past, present and future, including a discussion of photography careers. This is followed by an introduction to the camera itself. Chapters 3 and 4 provide a set of guidelines for composing and evaluating photographs. Chapter 5 explains a simple way to start producing correctly exposed photographs. As soon as you get that basic background behind you, you will begin your first photograph assignments. Chapters 6 through 11 deal with specific "elements" of photography. At the end of these chapters are exercises that will help you learn to recognize and use each element discussed.

The remainder of the book is composed of additional exercises (with examples) and an Appendix, covering most of the technical information (including a section on color photography). Finally, there's a glossary to clarify any confusing terminology and a bibliography to help you locate more detailed information.

part 1 Getting Started

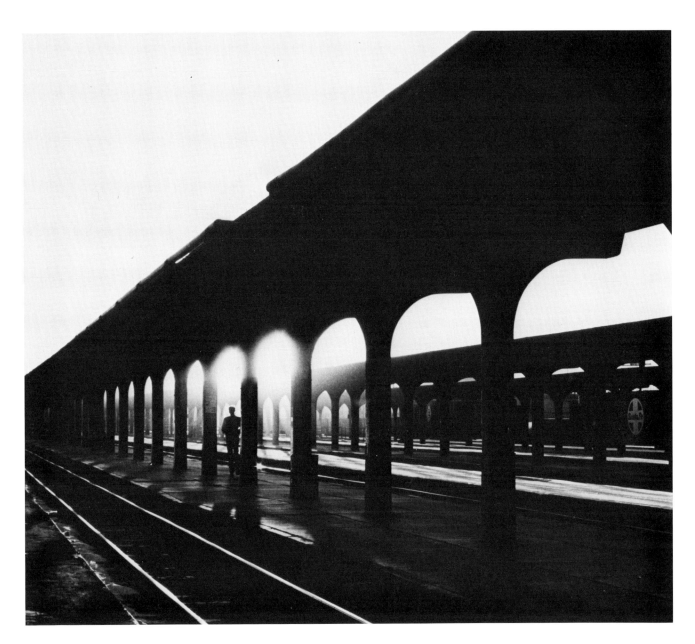

Student photograph by Edward Maresh.

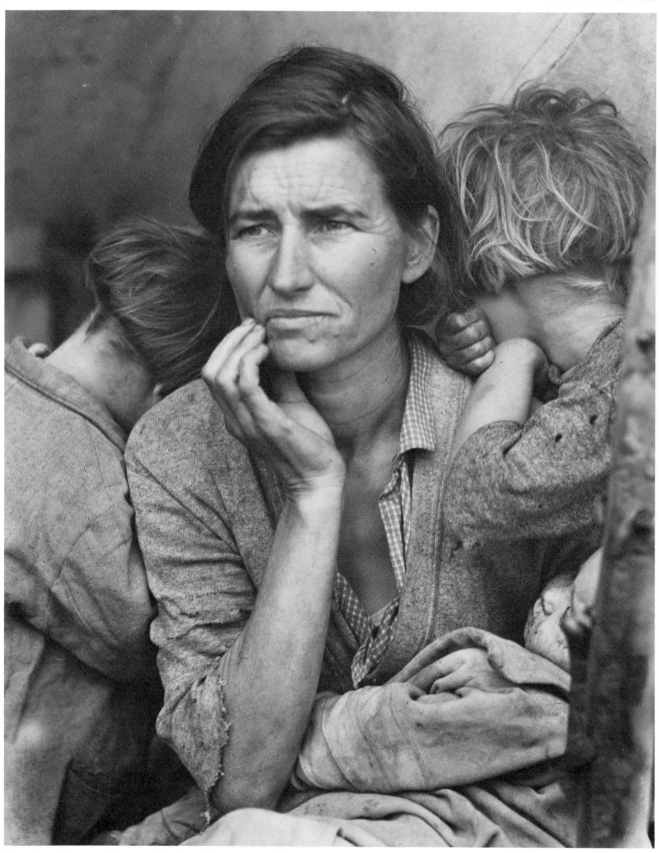

Dorothea Lange, Migrant Mother, Nipomo, California, *1936. Gelatin silver print. Library of Congress, Washington, D.C.*

chapter 1

From Blurs to Big Business

Photography began as a curiosity, a modest marvel with limited practical or artistic applications. It has since grown into a major influence on our society and culture. Millions of dollars are spent every year to produce millions of photographs. We all encounter hundreds of them every day, some with tremendous impact, some with none. We learn about the latest fashion trends from photographs — and about the latest famine or war. We also learn, over and over again, about the remarkable planet on which we live, and about the people with whom we share it. All of this has become possible because photography *was* a curiosity — because someone asked "How does this work?" and "What else can be done with it?"

HISTORY

How long do you suppose photography has been around? Fifty years? One hundred? One hundred and fifty? Two hundred years? Longer?

Any guess over 150 years would be reasonably correct, but there isn't any one correct answer. No one person can be credited with inventing photography. It didn't suddenly "happen." Instead, it was a long, slow evolution.

The first printed photographs were made between 1816 and 1840. The first recorded discovery that certain chemicals turned black when exposed to light was made in 1725. The basic design of the cameras we use today has been in use since the 1500s. The Chinese figured it out even longer ago than that — as early as the fourth century. So, photography is between 1,500 and 150 years old.

Prelude

The first stage of photography's evolution in Europe was the *camera obscura,* which is Latin for "dark chamber" (*camera* = chamber or room; *obscura* = dark). The camera obscura was a room, or a small building, with no windows. One tiny hole, fitted with a lens, projected images from outside the room onto the far wall inside it.

The image was upside down and not generally very clear, but it was good enough to become a useful tool for artists. The projected image could be traced, providing an accurate sketch, which might then be developed into a painting. Portable versions of the camera obscura were developed by the 1660s. The camera existed, but photography hadn't even been imagined yet.

In 1725, a German professor of anatomy, Johann Heinrich Schulze, attempted to produce a phosphorescent stone (one that would glow in the dark). He mixed powdered chalk into a nitric acid solution and was surprised to discover that the mixture turned purple in sunlight. After investigating, he discovered that his experiment had been contaminated with silver salt (silver chloride) and that this was causing the reaction to light.

Schulze was curious enough about this phenomenon to experiment with it. He covered bottles of his mixture with stencils so the light would "print" letters onto it, but the letters would disintegrate as soon as the mixture was disturbed. Evidently, he never thought that his discovery might have any practical application.

Early Prints

In 1777, a Swedish chemist, Carl Wilhelm Scheele, repeated Schulze's experiments. He also discovered that ammonia would dissolve the silver chloride and leave the image intact. With this second discovery, the basic chemistry of photography (exposing silver chloride to produce an image and "fixing" it with ammonia) was established, but — again — what it might lead to was not recognized.

Forty years later, the plot began to thicken. A number of people began trying to produce a photographic image on paper. In France, Joseph Nicephore Niepce developed an

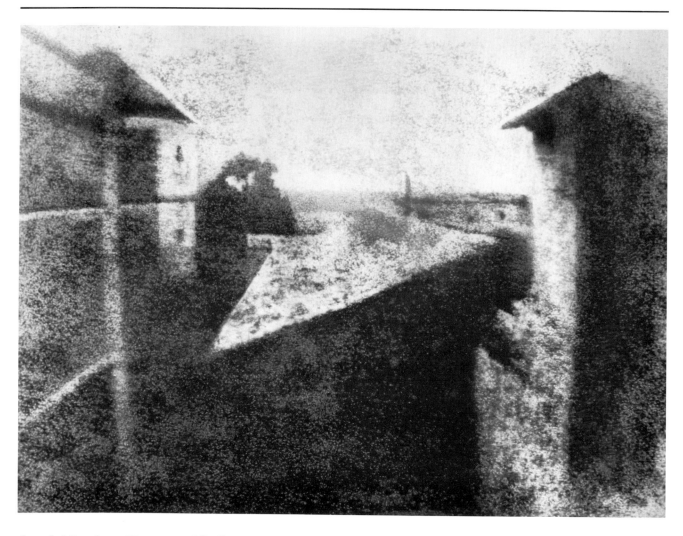

Joseph Nicephore Niepce, world's first permanent camera image. Courtesy Gernsheim Collection, Harry Ransom Humanities Research Center, The University of Texas at Austin.

emulsion (a light-sensitive varnish) out of bitumen of Judea, a kind of asphalt. Instead of turning black, this material is hardened by light. So, to produce an image, Niepce coated a glass or pewter plate with his emulsion, exposed it to light and then washed the plate with solvents. The solvents dissolved the unexposed (and still soft) emulsion, producing a print: the world's first permanent camera image. It was only some blurs of light and dark, and the exposure reportedly took eight hours, but it was a real image.

Meanwhile, a painter in Paris named Louis Jacques Mande Daguerre was also trying to produce a camera image. He got in touch with Niepce and the two worked together on the problem. Niepce died, poor and discouraged, a few years later, but Daguerre continued (with Niepce's son Isadore as his new partner).

Daguerre was convinced that silver was the key to producing a better image than Niepce's asphalt prints. In 1835, his conviction paid off. He discovered that if a silver plate were iodized (treated with iodine), exposed first to light and then to mercury vapor, and finally "fixed" with a salt solution, then a visible, permanent image would result. This discovery formed the basis for the first photographic process to be used outside of a laboratory: the **daguerreotype.**

In England, William Henry Fox Talbot was also experimenting with camera images. By 1835 he too had succeeded in producing a number of photographs. With his process, the first exposure produced a negative image on paper treated with silver compounds. The exposed paper was then placed over a second sheet of treated paper and exposed to a bright

light, producing a positive image on the second sheet.

Thus, Talbot's process—called a **calotype** or talbotype—enabled photographers to make multiple copies of a single image. This was not possible with a daguerreotype, which produced a positive image directly on a metal plate. Because the calotype's image was transferred through a paper negative, however, it was not as clear as the daguerreotype.

In 1851, another Englishman, Frederick Scott Archer, introduced the **collodian** wet-plate process, which offered the best of both worlds: a high-quality image and multiple copies. Talbot tried to claim credit and licensing rights for this new process as well. In 1854, the courts overruled him and followed Archer's wishes by making the process freely available to everyone.

The collodian process, like the daguerreotype, was difficult to use. First, a clean glass plate had to be evenly coated with collodian (a substance similar to plastic and containing potassium iodide). While still damp, the plate had to be dipped into a silver nitrate solution, inserted into the camera and exposed. It was then developed immediately, and finally allowed to dry. If the plate dried before the process was complete, the emulsion would harden and the photograph would be ruined. It wasn't easy, but it worked.

Photography Goes Public

Photography, dominated by the collodian and daguerreotype processes, began to take off. Cameras were set up in studios and loaded onto carts to photograph portraits, landscapes and battles. Tourists collected inexpensive prints of local attractions, called **cartes-de-visite**, by the

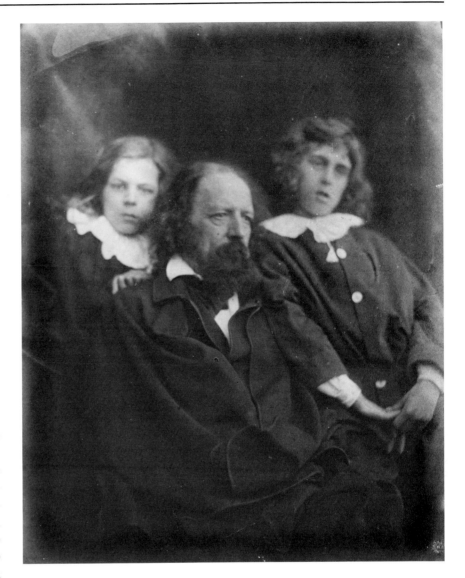

thousands. The stereoscopic camera (which produced a three-dimensional effect by combining two images) was introduced in 1849. By the 1860s, no parlor in America was considered complete without a stereo viewer and a stack of slides to entertain guests.

Photography had more serious uses as well. As early as the 1850s, books of photographs were published showing the harsh conditions of life in the streets, factories, mines and slums of England and the United States. Lewis Hine, a sociologist, produced powerful photographs of children who worked long hours in

Julia Margaret Cameron, Alfred Tennyson with his sons Hallam and Lionel, *1865–69. Albumen print, 10½ x 8¼" (27 × 22 cm). Gift of David Bakalar, 1977. Courtesy Museum of Fine Arts, Boston.*

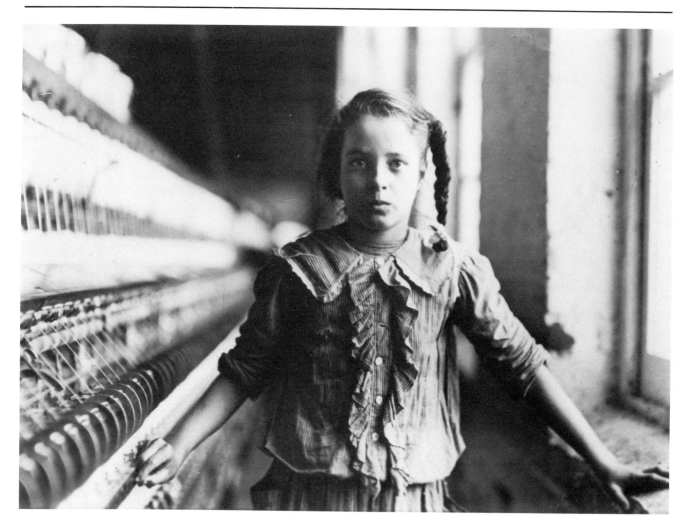

Lewis Hine, Doffer Girl in New England Mill, *c 1910.*

textile mills and other industries. His work helped to bring about new laws to protect children's rights.

At the start of the Civil War, a successful portrait photographer named Mathew Brady asked President Lincoln for permission to carry his cameras onto the battlefields. Permission was granted, and Brady and his staff compiled a remarkable record of that tragic period of American history. Like many of photography's pioneers, he paid for the project almost entirely by himself and died penniless as a result.

In the 1880s, Eadweard Muybridge invented a device called a **zoopraxiscope** which produced a series of images of a moving subject. It is said that he did so to settle a bet as to whether or not running horses lifted all four hooves off the ground at one time. By photographing a horse with his device, he proved that they do. He also contributed tremendously to our understanding of how animals (and humans) move.

These and other similar uses of photography often achieved a high degree of aesthetic quality—a high degree of art. Their primary purposes, however, were practical: to promote social reform, record historical events and aid scientific investigations.

Mathew Brady, Magazine in
Battery Rodgers, *1863. Library of
Congress, Washington, D.C.*

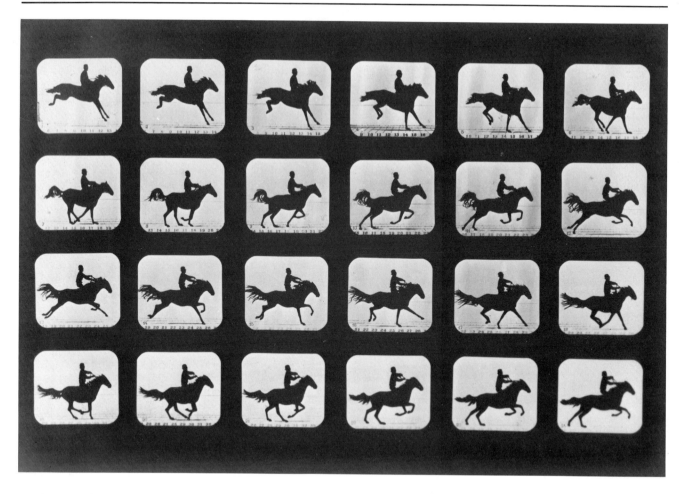

Eadweard Muybridge, Attitudes of Animals in Motion, *c 1881.*

But Is It Art?

At the same time, another group of photographers were dealing with the purely aesthetic issue of how photography relates to the traditional arts, particularly painting. Is photography an art at all? If so, how should it be used? What should "art photography" look like? These same questions continue to provoke discussion and argument even today. Photography is still defining itself.

By the 1850s, two opposing factions of artist-photographers had been established. The Pictorialists, led by Oscar Rejlander and Henry Peach Robinson, believed that a photograph should look as much like a painting as possible. Their idea of what a *painting* should look like was heavily influenced by the Romanticist painters (such as Delacroix). The Pictorialist photographers, like the Romanticist painters, believed that an artist should improve upon nature by using it to express noble ideas. Both favored elaborate illustrations of scenes from ancient mythology.

The other faction called themselves Naturalists. They were led by Peter Henry Emerson and George Davison. The Naturalists believed that a photograph should capture nature's own truth. They preferred the Barbizon painters, who took their easels out to the forests, fields and streams, and painted them directly. The Naturalist photographers did the same with their cameras, specializing in peaceful scenes of country life. They were also increasingly fond of using soft focus (blurred edges) in their photographs.

Despite the differences between them, both the Pictorialists and the Naturalists believed that a work of art ought to express a "correct sentiment" and that it ought to be decorative—pretty. This is what most set them apart from the "practical" photographers, like Brady and Muybridge, whose work showed the hard edges of reality, with all its flaws.

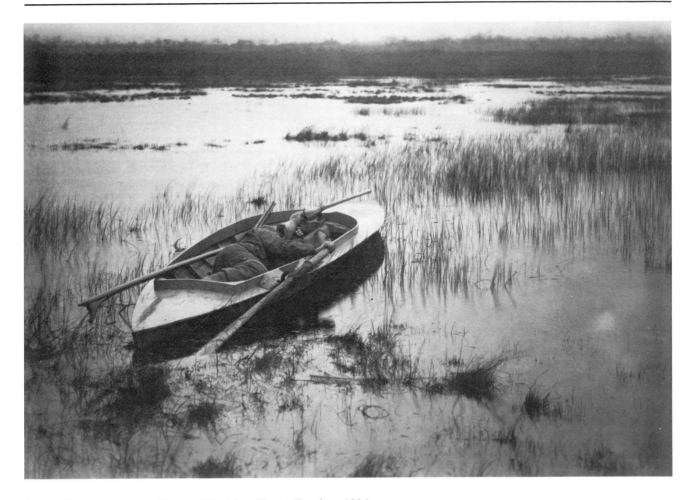

Peter Henry Emerson, Gunner Working Up to Fowl, *c 1886.*

New Tools & Processes

In the late 1880s, flexible film appeared for the first time, replacing clumsy and heavy glass plates. By the 1890s, George Eastman had introduced the Kodak camera, the first that was reasonably easy to use. The camera itself was simple: a box with a lens, a cord to cock the shutter, a button to release it and a crank to wind the film. What made this camera special was that it came loaded with enough film for 100 photographs. When the film was used up, the entire camera was returned to the Eastman Kodak Company. The film was then developed and printed, and the camera was reloaded and returned, ready for another 100 photos. Eastman's slogan was "You press the button; we do the rest." (The name "Kodak," incidentally, doesn't mean anything. Eastman selected it because he felt it would be easy for people to remember.)

In 1925, Leica introduced its "miniature" camera, the first to use 35mm film. Though not quite as simple to use as the earlier Kodak model, it was technically more sophisticated and quite a bit smaller As a result, amateur photography became an international passion.

Other technical advances continued to appear all the time. The first commercial color film, Autochrome, hit the market in 1907. Autochrome produced transparencies (slides) that could not be enlarged very much without showing the grain of the starch dyes used to create the image. It also took fifty times as long to expose as black-and-white film.

Then, in 1935, Kodak introduced Kodachrome, an improved slide film, followed in 1941 by Kodacolor, for making color prints. The family photograph album, which had existed for only 100 years, was now both widespread and increasingly in full color.

FOCAL POINT: Alfred Stieglitz, 1864~1946

Alfred Stieglitz was in many ways the first "modern" photographer. Though his early photographs were carefully manipulated to imitate paintings, he soon recognized that photography was an art in its own right—and deserved to be treated as one. He saw the need to free photography from the conventions and limitations of painting. Consequently, Stieglitz promoted what came to be known as "straight" photography—making prints with little or no cropping, retouching or other alteration.

He was a founding member and leader of the "Photo Secession," a group of photographers who were determined to break away from photography's past and to chart its future. Stieglitz was editor and publisher of the group's magazine, *Camera Work,* the first publication to deal seriously with photography as an independent art form. He worked with Edward Steichen to establish "Gallery 291" in New York City, which exhibited contemporary photographs along with paintings by Picasso, Matisse and Georgia O'Keefe (whom Stieglitz later married).

When photography was first invented, it was a scientific novelty. Soon, it evolved into an excellent record-keeping tool. Photographers could be hired to make a lasting record of a person, place or event. By the late 1800s, photographers were striving to elevate their craft into a recognized art. They did this by imitating the content and visual effects of paintings. Stieglitz' great achievement was to bring photography full circle: he merged its artistic potential with its ability to produce a factual

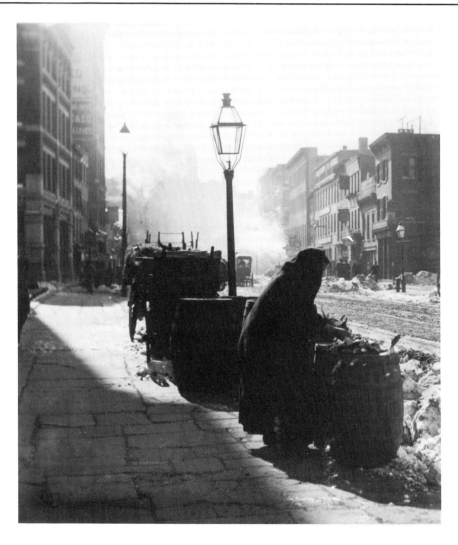

Alfred Stieglitz, The Rag Picker, New York, *1895.*

record. He returned to the straightforward approach of the early photographers, but he did so with the insight and confidence of a true artist.

Stieglitz was among the first photographers to produce work that, even today, does not look "dated." Though clothing and architectural styles have changed considerably since his time, his best work still looks thoroughly modern. The main reason for this is that he used the camera as

we use it today—as a familiar tool for exploring reality.

The attitudes and interests that Stieglitz brought to photography can be traced to his upbringing. He was born in Hoboken, New Jersey, the son of German immigrants. He originally intended to become a mechanical engineer. While in Berlin studying for this purpose, he happened to see a camera in a store window. He bought it and soon decided it was more interesting than engineering.

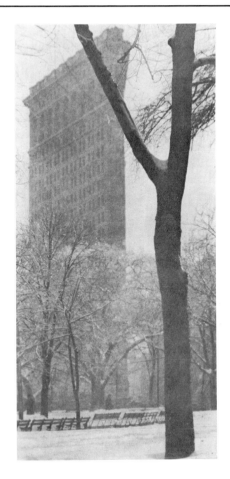

Alfred Stieglitz, The 'Flat Iron', *1902.*

When he returned to the U.S. at the age of 26, he was delighted to find that photography was extremely popular. But he was also dismayed by the lack of publications and galleries promoting it as an art. For the next 56 years, he devoted himself to correcting this situation. Along the way, he produced some of the finest photographs in history.

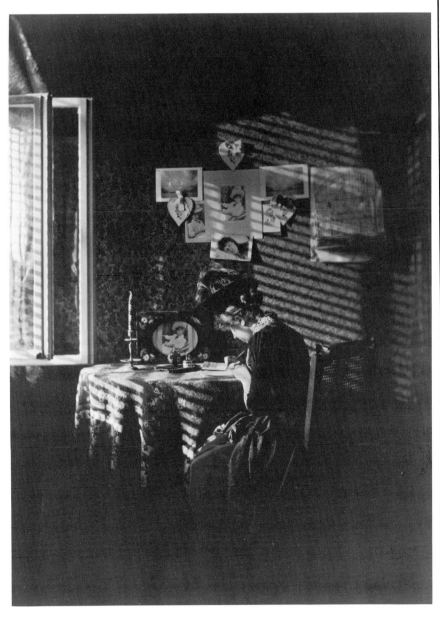

Alfred Stieglitz, Sun Rays — Paula — Berlin, *1889.*

FOCAL POINT: James Van Der Zee, 1886-1983

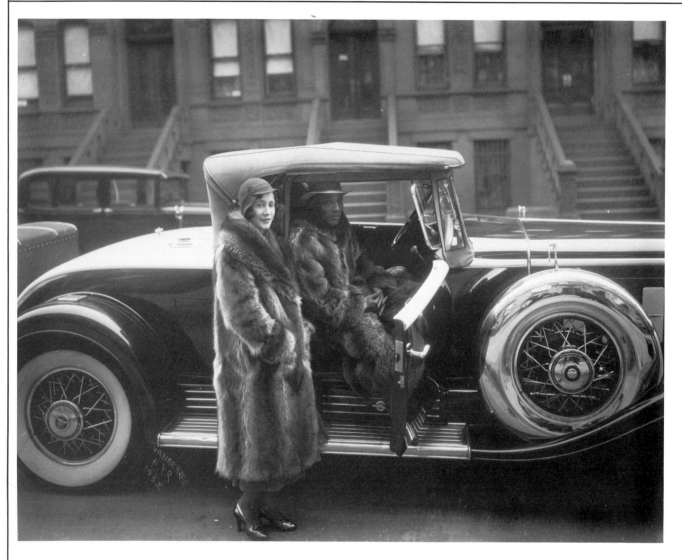

James Van Der Zee, Couple in Raccoon Coats, 1932. *Courtesy Donna Van Der Zee.*

James Van Der Zee was unique in many ways. First and foremost, he was perhaps the most accomplished black photographer in history, and is certainly the best known today. His record of Harlem in the 1920s is unsurpassed, in both quantity and quality. But he was unique in other ways as well.

Stylistically, he employed both stark realism and dreamy romanticism. Technically, he produced "straight" prints in the style of the Photo Secessionists (Stieglitz, Weston, Steichen, etc.) as well as heavily manipulated images, which the Photo Secessionists had rejected. Moreover, he used both approaches interchangeably, according to his interpretation of a particular scene. One day he might do a straight outdoor portrait of someone on the street. And the next day he might pose a newly-wed couple in his studio, and produce a double-exposed print showing their yet-to-be-born child as a ghost beside them.

Van Der Zee's photographic career was far from easy. Though he became interested in photography at the age of 14 (when he purchased a mail-order camera and darkroom kit), he was 30 before he was able to earn a living at it. In between, he worked as a waiter, elevator operator and even as a violinist in a dance or-

chestra. His first photographic job, in 1914, was as a darkroom assistant in a department store in New York City. Two years later, he opened his own studio in Harlem. Though he often had to change its location, Van Der Zee kept his studio in business until 1969.

In addition to skill and creativity, he was blessed with good timing. Black culture was flourishing in Harlem during the 1920s. Duke Ellington and others were redefining American music. Adam Clayton Powell, Langston Hughes, Countee Cullen and Marcus Garvey were helping to build a new black identity. And James Van Der Zee was the official and unofficial photographer for all of it. He photographed proud black couples in the streets of Harlem and in elegant clubs. Celebrities and "ordinary people" posed in his studio. He photographed weddings and funerals. All together, he compiled some 75,000 glass plates, negatives and prints. All of it revealing a world that was all but ignored by the better-known photographers of that time.

Van Der Zee received virtually no recognition outside of Harlem until 1967. At that time, he was featured in an exhibit, entitled "Harlem on My Mind," at New York's Metropolitan Museum of Art. For the last 14 years of his life, his photography was widely exhibited, published and praised. He died at the age of 97, while in Washington, D.C. to receive an honorary degree from Howard University.

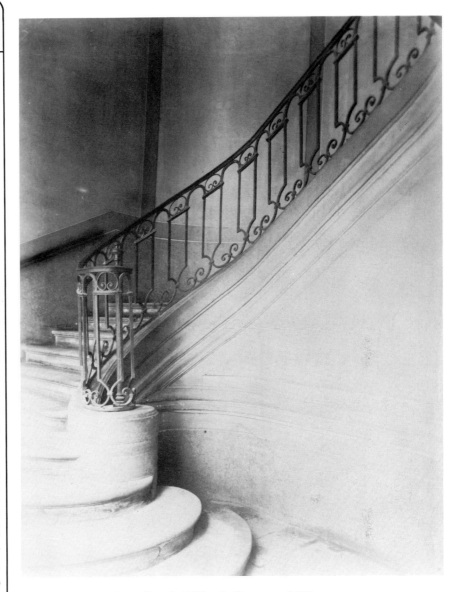

Eugene Atget, L'Escalier de L'Hotel Charron, *1900.*

A New Breed

Photography was coming into its own, both as an art and as a business. Alfred Steiglitz united photography and painting by opening "Gallery 291," which exhibited new work in either medium. In his own photography and in his critical judgment Steiglitz promoted a lively realism that eventually became the standard for art photography. From 1902 to 1917, he published *Camera Work,* the first magazine devoted to artistic ap-proaches to photography.

In Europe, André Kertesz, Eugene Atget, Brassai, and Henri Cartier-Bresson were among the most notable of the new wave of artist photographers. They each devoted themselves to capturing life as it really was, in the boulevards and back alleys and country lanes of Europe. Yet each did so with a distinct and original style, a unique "way of seeing." They saw that photography was a new and indepen-

Edward Steichen, Gloria Swanson, *1924.*

dent art, not merely a cheap imitation of painting. Because of this, they—along with Steiglitz and other American peers—may be thought of as the first modern photographers.

More practical applications of photography also continued. One of the most notable examples was a photographic survey, begun in 1935, of conditions during the Great Depression. Dorothea Lange, Walker Evans and other first-rate photographers were hired by this project by the U.S. government's Farm Security Administration and compiled hundreds of photographs that rank among the best ever produced.

The use of photographs in publications, a novelty as recently as 1900, was expanding rapidly. *Life* magazine started in 1936 and began a whole new kind of publishing: photojournalism. Alfred Eisenstat, Margaret Bourke-White and other photographers on *Life's* staff quickly became famous as they recorded the world's events with their cameras.

By the end of the 1930s, all the basic ingredients that continue to define photography were in place: Photography was increasingly ac-

1937	1938	1939	1947	1954
The SLR (single lens reflex) camera introduced to the U.S. by Exacta.	Automatic exposure initiated by Kodak with its 6-20 camera.	Electronic flash developed by Dr. Harold Edgerton.	First Polaroid camera developed by Edwin Land.	First high-speed film, Tri-X, comes onto market.

Yousef Karsh, Ethiopian Bride, *1963. Courtesy Woodfin Camp and Associates.*

cepted as an art in its own right. Photojournalists were a major source of information and insight for the general public (a role that has since been largely taken over by television reporters). Advertising had begun using photography to catch attention or communicate a message. Portable cameras had made snapshots a national hobby.

Where Now?

The list of technical advances in photography continues to get longer and longer (see the photographic time line), and the ranks of great photographers has expanded steadily as well. Edward Steichen, Minor White, Paul Strand, Edward Weston, Ansel Adams, Diane Arbus, Ernst Haas, Eliot Porter . . . the list is long and subject to fierce debate.

Photography is still a young art. Painting, sculpture, writing, dance, acting and music have all been around for thousands of years. Even they continue to change at an often alarming rate. This is all the more true of photography, which has

1959	**1966**	**1972**	**1985**
Development of first zoom lens, the Zoomar 36-82 mm.	Konica introduces first professional quality automatic exposure camera.	Polaroid adds color to its instant cameras.	Minolta introduces the first professional quality automatic focus camera, the Maxxum.

FOCAL POINT: Manuel Alvarez Bravo, 1902~

Throughout the world, photographers have used the camera to observe, interpret and record their own cultures and environments. In the process, some have also achieved unique styles that are particularly appropriate to specific times and places. Manuel Alvarez Bravo is among a select group of photographers who have gone a step further—discovering a way of seeing that seems to express the spirit of an entire culture.

Great works of art are rarely created in a vacuum. Instead, even the most gifted artist draws on a lifetime of experiences and impressions. The work of other artists is almost always an important influence. Additional influences may include one's level of wealth or poverty; the personalities and values of friends and family; the climate, colors, sounds and rituals that are part of daily life. By combining a variety of local and international influences, some artists are able to create art that breaks through cultural barriers without losing a sense of cultural roots. Bravo is one photographer who has done this.

In his case, the culture is that of Mexico. He was born in Mexico City, and has continued to be based there throughout his life. His father and grandfather were both artists, one a painter and the other a photographer. Before becoming interested in photography, Bravo studied literature, music and painting, beginning in 1917. In 1922, he began experimenting with photography. By 1926, he was using a camera to produce abstract images of folded paper. By the early 1930's he was among the

Manuel Alvarez Bravo, Retrato de lo Eterno *(Portrait of the Eternal), 1935. Courtesy The Witkin Gallery, New York.*

leaders of a creative surge in Mexican art.

His first solo exhibit was held in Mexico City in 1932. Soon after, he became acquainted with Paul Strand, Henri Cartier-Bresson, Walker Evans and other photographers who were gaining international attention. Bravo also met Andre Breton, who is credited with creating the Surrealist style of painting. Surrealism, which employs the symbols and imagery of dreams, became a major influence on Bravo's photographic style.

In his best work, Bravo combines the technical skill and confidence of photographers like Strand and Evans; the ability to capture a "decisive moment" that is characteristic of Cartier-Bresson; and the often disturbing dreamlike qualities of Surrealist paintings. To this mix of artistic influences, he adds a deep and proud understanding of Mexican culture and a keen awareness of light and mood. The result is a vision that is both highly private and universally accessible.

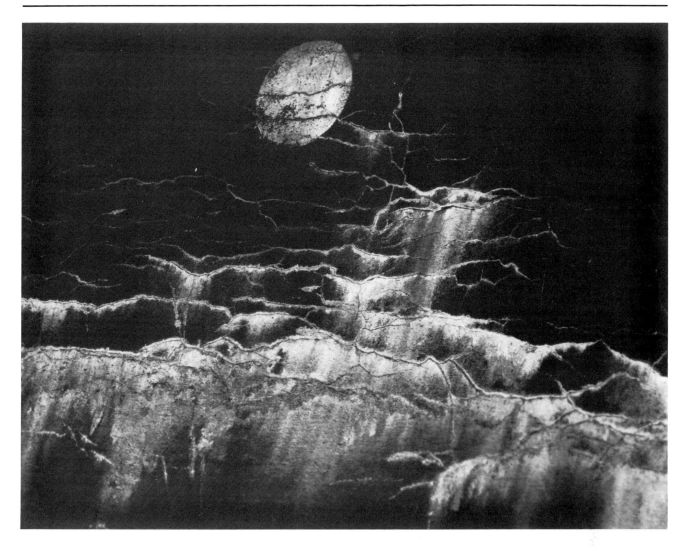

Minor White, Moon and Wall Encrustations, *1964.*

barely passed its first century of widespread use.

Technologically, the camera is already merging with the computer. Computer chips handle many automatic functions within the camera. Photographic images are increasingly being used as raw material for computer-generated art, which is even younger than photography. The first cameras to record images digitally on disk, rather than on film, have already appeared. The next step is a computer system that is a camera, darkroom, painting studio and printing press—all in one. Something like

this is likely to be standard equipment by the end of the century.

Along with this technological change will come changes in procedures, applications and taste. Photography will never again be considered proof of anything, since computers can alter any image—and do it so well that no one can tell. However, photographs will continue to be a vital tool for exploring and communicating our perceptions of things and events. Recent work by artist photographers is once again blurring the distinction between photographs and painting. David

Hockney's "mosaics" made from dozens of photographs are one striking example. Other artists are painting on photographs or inserting them into mixed-media creations. Meanwhile the traditional black-and-white print remains one of the most vital arts throughout the world.

Probably the safest prediction is that photographers will continue to find new ways of using the "magic box" that has evolved from a room with a hole in it to a computer that can make its own judgments about focus and exposure.

PHOTOGRAPHIC CAREERS

The number of people who earn a "living wage" from any art is always relatively small. Photography is certainly a case in point. Most photographers are hobbyists who take pictures for pleasure. Even many of the best-known art photographers pay their bills by doing commercial photography or other work on the side.

Unfortunately, being "good" or even "the best" won't necessarily make any difference. Many excellent photographers have died penniless. At least a few have made good livings without having much skill or creativity. That's the way of all art — timing, luck and who you know are at least as important as mastering your craft.

Fortunately, however, commercial photography can be a very rewarding career or sideline. Everything from weddings to wars seems to require a photographic record. Most commercial products rely on photography for packaging and advertising. And there is even a steadily growing market for photographs as pure art — though it's not likely to make you rich.

The basic categories of professional photographic work include: weddings and other social events, portraiture, journalism, product photography and fashion. Depending on the work you choose, the time you devote to it and your luck and skill, you could earn from a few hundred to over a thousand dollars a day.

In each of these categories, there are two ways of working: staff and freelance. A staff photographer is just like any employee, receiving a salary and clocking regular hours. A freelance photographer is hired for

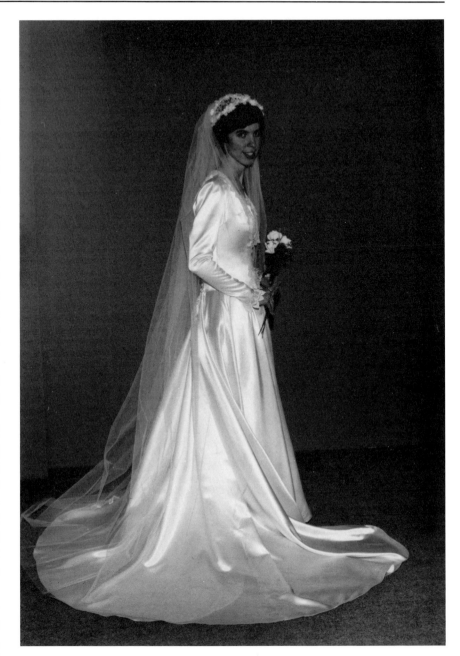

Wedding photography requires technical accuracy, good social skills and and the ability to quickly arrange natural poses for individuals and large groups. Photograph by Donald Butler.

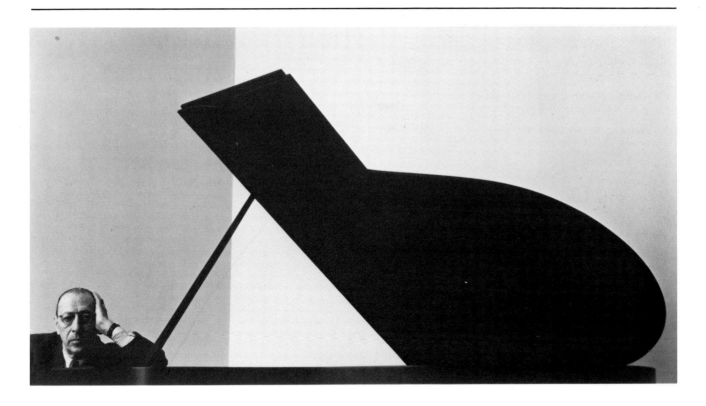

specific jobs and is generally paid by the day. Freelancers tend to earn more than staff photographers for each day they work, but staff photographers work more steadily. In other words, staff photographers are less likely either to get rich or to go broke. Freelancers take more risks and have a better chance of making it big.

Weddings and Portraits

Probably the largest number of professional photographers are primarily devoted to photographing social events, especially weddings. The pay can be quite good—several hundred dollars per day. Many wedding photographers are represented by an agent who sets up photo assignments for them. Many work only a couple of days each week, generally weekends (when weddings are most commonly held). Wedding photographers must be able to produce consistently good results, since there's no chance for re-shooting if things get messed up. They must be especially good at flash photography, since much of their work is done indoors on location. In addition, they must be skilled at interacting well with all sorts of people. By and large, wedding photography does not demand much artistry—most clients don't want art. It's a good line of work for anyone who enjoys the technical side of photography and who likes to socialize.

Closely related to weddings and social events is portraiture—photographing a single person or small group. Whether it's for a passport photo or a prom portrait, everyone needs a photographer sometime. Virtually every town in the country has at least one studio for just these kinds of things. Here again, the main requirements are technical consistency—particularly in terms of studio lighting—and social grace.

The best way to get started in both event and portrait photography is

Arnold Newman, Igor Stravinsky, *1946.*

probably to take a specialized course (in flash or portrait lighting, for example). Next, spend some time as an apprentice, and learn the tricks of the trade that aren't generally taught in schools.

Photojournalism

Journalistic photography ranges from covering a fire on Elm Street for the local newspaper to traveling to Tahiti for a major magazine. Photojournalists must possess good instincts above all else. Sensing when a photo opportunity is about to occur and knowing how to handle it are of vital importance. Being a first-rate photo-technician is helpful . . . but not strictly essential.

A more commercial field related to photojournalism is freelance location photography. Corporate annual reports, slide presentations, promotional brochures, in-house publications, trade magazines (*Plumbers' Digest* or *New England Beverage Retailer,* for example) all require professional-quality photography. Being able to handle any lighting or composition challenge quickly and accurately is the critical factor here. An ability to blend into the corporate environment is also essential.

In both these two fields, a freelancer can earn upwards of $500 per day, plus film and expenses. The best way to begin is to begin. An advanced degree in photo technique isn't likely to be much of an advantage, since you will seldom have the time or facilities for fancy lighting set-ups. If you plan to work on location, there's no substitute for old fashioned trial-and-error *practice.* A good first step is to try to sell some photographs to your local paper, especially if you happen to be present for a "news event" that was missed by

FOCAL POINT: Margaret Bourke-White

Today we take photojournalism for granted. We expect our magazine articles to be illustrated with photographs that add insights and impact of their own. But, like photography itself, photojournalism had to be invented. One of the people who played a major role in inventing it was Margaret Bourke-White.

While in college, Bourke-White discovered that she excelled at photography. After graduating from Cornell, she began working as a professional photographer. She was especially intrigued by the surge of technological developments at that time and used her camera to convey the power and beauty she saw in everything from clock parts to steel mills. From 1929 to 1933, she was an industrial photographer for *Fortune* magazine. Her work there was not limited to machine parts and construction projects, however. In 1934, she covered the drought known as the "Dust Bowl" that swept through the Great Plains, showing how that tragedy affected the lives of farmers and their families. This article was a milestone in photojournalism. Though other photographers, such as Lewis Hine, had done similar reporting on social issues, none had done so for a major magazine.

After becoming a staff photographer for *Life* magazine in 1936, Bourke-White continued to cover both technological progress and human suffering. The very first issue of *Life* featured one of her photographs on the cover: a dramatic image of a massive dam construction project. She provided extensive coverage of World War II, most notably the horrors discovered when the Allies liberated the concentration camps. She photographed the grandeur and starvation of India in the late 1940s, black South African Miners in 1950, and the Korean War in 1952.

By the mid-1950s, Bourke-White was suffering from Parkinson's Disease, which progressively reduces the body's ability to control its movements. She left the staff of *Life* in 1969 and died two years later.

Though she was neither a master stylist nor an exceptional technician, Bourke-White was among the first to clearly understand the camera's power to record "history in the making." She helped establish standards for commitment, concern and sheer energy that photojournalists have struggled to live up to ever since.

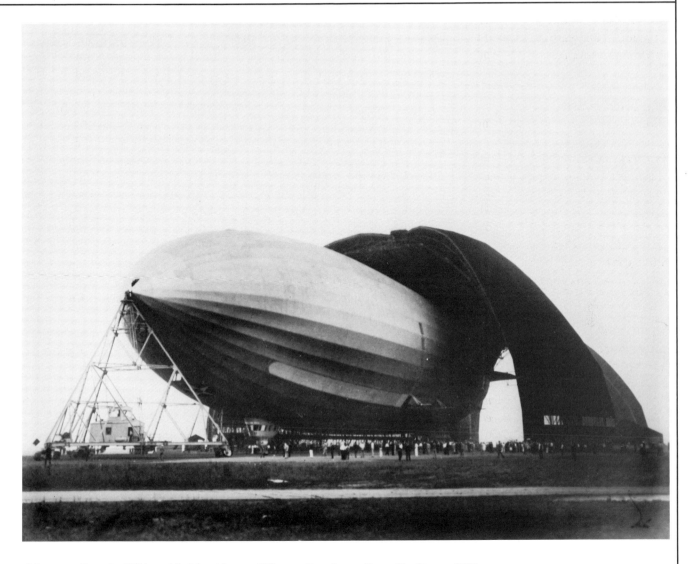

Margaret Bourke-White, Airship Akron, Winner Goodyear Zeppelin Race, *1931.*

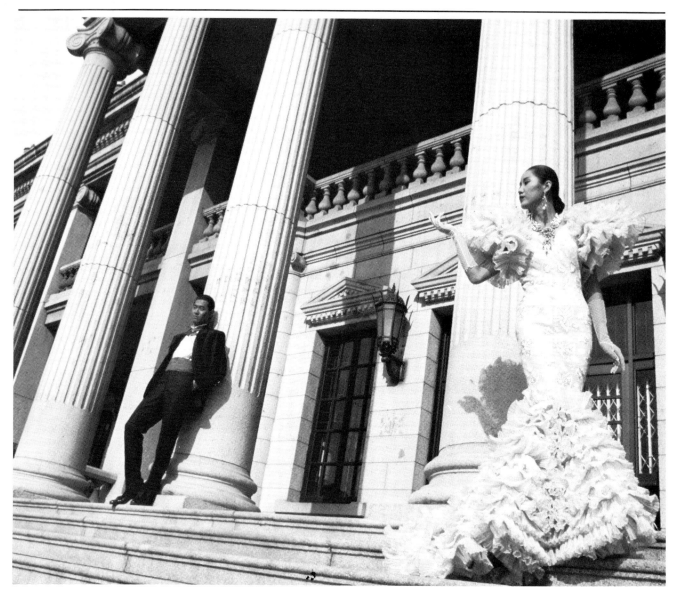

A flair for the exotic and a sophisticated sense of humor are important assets in fashion photography. Photograph by Bang Kapsu.

the paper's own staff photographers.

Alternatively, you might find a design agency that will give you some low-pressure assignments to get started (perhaps a brochure advertising some tourist attraction or event). Once you've acquired some local exposure, you can move on to "bigger fish." However you begin, the important thing is to build on your experience. Progress *gradually* from small challenges to larger ones. Do not jump in over your head. That will only earn you a bad reputation. Seek out work that demands just a bit more than you can easily do.

Razzle Dazzle

At the top of the career heap financially are illustration, product, food and fashion photography. This is where knowing the right people and being in the right place at the right time are of critical importance. A flair for style helps too. You also have to be very good if you expect to have more than a brief career. The competition is stiff because the rewards are high. A top-notch product, food or fashion photographer will charge $2,000 or more per day. A comparable illustration photographer might earn the same amount for a single photograph. Nice work if you can get it.

Unless you're lucky enough to move up step by step (starting with a local ad and ending up shooting pearls for Tiffany's), your best course is probably to work as a studio assistant. (Compile a substantial portfolio first.) If you perform well in that role, you may eventually graduate to handling some assignments on your own which may enable you to branch out. Before you go that route, however, you had better be sure that you care a lot about money and enjoy a hectic urban life. If photographic art is your primary concern, you may be happier with less money and less pressure.

Variations

Mixed in with these general categories are numerous photographic specialties: scientific, sports, underwater, travel, architectural, art reproduction, etc. Matching your skills and interests to one of these niches may be the most satisfying career path of all. By specializing in one particular aspect of photography, rather than competing in a broader category, you have a good chance of establishing a clear identity and of focusing in on a steady market. Word-of-mouth recommendation is always a photographer's best advertising. You stand to benefit most from it if you earn a good reputation for a specific set of skills.

If you enjoy photographing buildings, for example, you can make a career of it, hiring yourself out to architectural and construction firms or to design magazines. If you're very precise and detail oriented, you might get into photographing art for museums. If you like flying, you might consider aerial photography. If you prefer swimming, consider underwater photography.

There are career opportunities in photographic processing as well. Here again, developing a specific set of skills is recommended. Some photographers specialize in a photographic style that requires certain processes, such as antique style sepia-toned or hand-tinted prints. When someone needs that particular style for a magazine illustration or corporate annual report, a specialist will generally be selected. The same rule applies to those who offer processing services to other photographers. Retouchers, for example, are paid handsomely to fix mistakes or otherwise alter a photo's appearance. Skilled darkroom techicians, specializing in black and white or color, are highly regarded and well paid.

Finally, there are many other jobs that don't require regular use of a camera or darkroom but can, nonetheless, keep a photographer "in touch." These include selling and repairing cameras, maintaining photographic libraries or stock-agency files, curating in photography galleries or museums, or even helping to develop new designs, formulas and processes for cameras or film.

If you discover that photography is something to which you want to make a long-term commitment, you can certainly find a niche that will enable you to do so. The first step is to decide which aspect of photography interests you most. The only way to do that is to try a bit of everything.

part 2 Elements of Composition

Student photograph by Michael Grassia.

Student photograph.

chapter 2 Tools

A s a photographer, your primary tool is the camera. The key word here is "tool." A camera is not some mysterious device that will turn you into an artist overnight. It is a tool, a mechanical device, a machine.

In many ways, a photographer is similar to a musician. Both use machines—that's exactly what a saxophone or a violin really is—but the quality of their art depends on *how* they use those machines.

Choosing a camera is like choosing a musical instrument. In both cases, it is important to choose the right one for the effect you want to achieve. It is also important to choose one that will be instructive and challenging. A camera—or an instrument—that is too easy to use won't teach you very much. As a result, it will limit your creativity.

You may have heard of "player pianos"—the kind of piano that will play all the notes of a song for you. Even the keys move as if someone were really playing them.

There are cameras like that too. They will do everything except aim. Computers are built into these cameras that will meter the light and set the camera accordingly. They will automatically add extra light with a built-in flash if necessary. They will even measure the distance to the sub-

If you choose your camera carefully and practice with it often, you'll soon learn to use it with very little effort or conscious thought. It will become simply an extension of eyes and hands—responsive, accurate and comfortable. (Student photograph by Trevor Bredenkamp.)

ject and focus the lens.

Other cameras—and other musical instruments—demand years of practice. Just as it can take a lot of time and effort to produce anything other than a shriek from a violin or a trombone, some cameras are so complicated that only a professional photographer can use them well.

Not everyone needs the same kind

of tool—whether that tool is a camera or a musical instrument. A concert violinist may require the best violin money can buy, but a blues singer may make fine music with an old beat-up guitar. Similarly, some of the world's best photographers use the latest "high-tech" cameras; others use antiques held together with rubber bands and tape. The right choice

for most of us is somewhere between these extremes.

Like any tool, each camera has a "personality"—a mixture of opportunities and limitations that you control to express your personal vision. The goal in selecting a camera is to find one that does what you need it to do, no more and no less. In other words, the right camera for you is one with a "personality" that matches your own.

Any camera can produce good photographs. A better camera makes the job easier, but no more than that. And "better" does not necessarily mean fancier or more expensive. The skill and vision of the photographer are far more important than the technological wizardry of the camera. Don't let the gizmos fool you.

So, the first rule for choosing a camera is to make the best of what you already have or can easily afford. After you become more experienced, you'll be more able to decide exactly what features you need. That's the time to invest in your particular dream machine. For now, however, use what you have. If you don't yet own a camera, buy the least expensive one that meets your basic needs. The money you save can be spent on film and chemicals, which are far more important at this stage than the quality of your camera.

One thing that is important, no matter which camera you buy, is durability. Older cameras tend to be heavy, clumsy and *very* durable. So, if you're using an old clunker from the attic, you'll have a real advantage on this score. The newer plastic camera bodies are very lightweight, which makes them less of a burden to carry around. Unfortunately, some of them are also very fragile. No matter how careful you are, your

Manual cameras provide a greater amount of creative control, especially with lighting. This photograph would have been virtually impossible with most purely automatic cameras, since the lighting effect is not "normal." (Student photograph.)

camera is likely to get knocked around a bit. Get one that is strong enough to take abuse.

One of the most important differences among cameras is the lenses that can be used with them. An **interchangeable lens** can be removed from the camera body and replaced with another lens that produces a different effect. For example, a telephoto lens, which works like a telescope, may be used to make distant objects appear closer.

The most popular and inexpensive cameras have a **fixed lens.** A fixed lens cannot be removed and, therefore, cannot be changed. Though not essential, interchangeable lenses can be a great asset.

There is no need to rush out and buy a telephoto or any other non-standard lens immediately. For your first assignments, you will be using only the standard 50mm lens. Even-

tually, however, you will probably want to try other lenses, so it is a good idea to use a camera that will allow you to do this. Once again, however, it is *not* essential. If your budget restricts you to a fixed-lens camera, you will still be able to take perfectly good photographs.

Manual or Automatic

If you are buying a camera, you have two basic choices: manual or automatic. **Manual** cameras have been in use far longer than automatic cameras, and they are still preferred by many professionals. They require you to load and wind the film, select the shutter speed, set the aperture, and focus. **Automatic** cameras will do some or all of these things for you.

The big advantage of a manual camera is that you always control what it is doing. You make the decisions, and the camera does what you

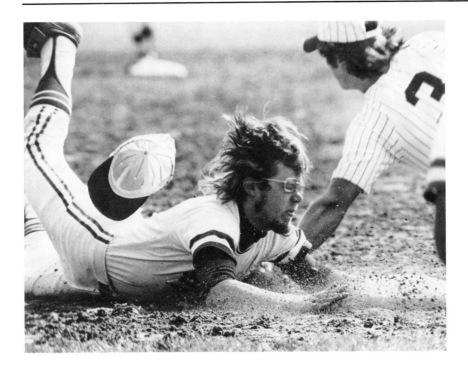

Automatic cameras are especially useful for "grab shots," when there's no time to fiddle with knobs and dials. By letting the camera make the technical decisions, the photographer is able to concentrate on getting the timing just right. (Student photograph by Lauren McDermott.)

tell it to do. As a result, you will learn what works and what doesn't. You will also make mistakes (which is how you learn). The main disadvantage of a manual camera is the amount of time required to set up a shot.

Most manual cameras now available in the 35mm format have a built-in light meter. The meter informs you of the lighting conditions, and you set the speed and aperture accordingly. Older cameras, and many studio models, require you to use a hand-held light meter to "read" the light, before you set the camera.

Cameras with automatic light metering also fall into two categories: full automatic and manual-override. A **full automatic** chooses the aperture or shutter speed, or both, according to a built-in computer that is programmed to make the decision you would *probably* make anyway. While

this may sound very appealing, there is a problem — and that problem is the "probably."

As you become a more experienced photographer, you will sometimes disagree with your camera's choice. You may want a picture to be a bit darker or lighter for effect, or the camera may be "confused" by a complex lighting situation. With full automatic, there's not much you can do to change the camera's decision. This is a poor choice for anyone who really wants to learn about photography.

Manual-override offers a solution. When you're sure the camera will make the right decisions (i.e. when you want a normal photograph in a normal lighting situation), you let the camera decide. When you disagree, you set the camera manually. If you make an effort to pay attention to

what the camera is doing, you can use the automatic light meter most of the time and still learn how to use light effectively. If you don't make that effort you won't learn much, and you'll end up taking a lot of "normal" and probably boring pictures.

If you are shooting a lot of "candids" (quick, unposed photographs), like most photojournalists, the automatic option can be a big help — since you won't miss a good shot or annoy your subject while you fumble with knobs and dials. If you're doing a lot of still-life or nature photography, or if you prefer to take your time, as most art photographers do, a manual camera will do just as well, and will teach you more.

All the other automatic features are far less important. Loading and winding the film manually will soon become second nature to you, so having it done automatically is not much of an advantage (unless you have reason to be in a real hurry). Auto-focus is another asset for the "grab-shooter," though focusing shouldn't take more than a split second once you get the hang of it.

What Format?

Most modern cameras use 35mm film. This is a relatively small format that allows many frames to fit on a single roll. As a result, it costs less per shot than larger formats. In addition, the smaller format means the camera can be smaller and lighter, so it's easier to carry and use.

There is one advantage to larger formats: the grain of the film. All film stores images in tiny dots. When the film is enlarged, the dots begin to show. This is grain. If you are making a large print (such as for an exhibit or a full page in a magazine), grain can be a problem. Too much

Each kind of lens has its own characteristics and uses. The wide-angle lens used for this photograph produced a slightly surreal effect. Much of the photograph's impact would have been lost with either a normal or a telephoto lens. (Student photograph by John Berringer.)

grain reduces the image quality. It begins to look "grainy."

For most uses, including most exhibit formats, the ease of using 35mm outweighs the drawbacks of grain. After you've developed your skill and style, you may want to move up to larger formats, but you can decide that later.

Choosing a Lens

In many ways, choosing the right lens or lenses is even more important than choosing the right camera.

Once you've selected some brand names you trust and can afford, you face another choice: which lenses to buy. Most cameras come equipped with a 50mm lens. This is the standard lens for 35mm photography, because it is closest to normal vision. What you see through the camera will

look the same as what you see with your own eyes. Whatever lenses you eventually buy, you will want to include the 50mm range. (By the way, if you find 50mm lenses and 35mm film confusing, don't worry. These and other terms will gradually become familiar to you as you use them.)

If you have a choice (and you often won't) you might consider buying the camera body and lens separately.

This will enable you to choose a **variable focal-length,** or **"zoom,"** lens instead of a **"fixed focal-length"** lens.

As explained in Chapter 11, the focal-length of a lens determines how wide an area you can see through it. In effect, the 50mm lens draws a box within which objects are normal in size and proportion. A shorter lens, such as a 35mm, draws a larger box, and makes objects appear smaller and somewhat "bent" or distorted. A longer lens, such as a 135mm, draws a smaller box, making objects appear larger and more compressed (with less space between them). With each fixed focal-length lens you have only one choice.

With a zoom (variable focal-length) lens, you have many choices. A zoom lens is essentially several lenses in one. For example, if a zoom lens ranges from 35mm to 135mm, you will have the same choices as you would if you bought the three focal-lengths just mentioned (35mm, 50mm and 135mm), plus all the focal-lengths in between.

Any good modern zoom lens will match the image quality of a typical fixed focal-length lens. (Early zooms produced poor image quality at "in-between" focal-lengths, such as 42mm. This problem has been corrected on most modern models.) You will, however, almost certainly lose some of the lower (larger) apertures offered by fixed focal-length lenses. Since a large aperture lets in more light than a small one, a zoom lens may limit your ability to photograph in low-light situations or at high shutter speeds.

If your budget permits, it is useful to have the three basic lens ranges: wide-angle, "normal" (50mm), and telephoto. However, the normal lens is the most important. Do not start your photo career with only a wide-angle or only a telephoto. It's perfectly all right to start it with only a 50mm. Once again, the best procedure is probably to start simply, with just a standard lens, and add others as you decide you need them. If you are thinking of investing in more than one lens, review Chapter 11 before making any decisions.

What Price?

How much should you pay for a camera? Well, it really depends on what you can easily afford. Good cameras are available for as little as $50. Top professional models can cost several thousand dollars.

If your budget limits you to under $100, buy the best manual camera you can find—perhaps a good second-hand model. If you can afford more, take a careful look at the $100 to $500 range, keeping in mind the features you care most about (automatic features, manual features, durability, lenses), and buy the one that best suits you. A fully professional camera system—which you absolutely do not *need* at this stage—is likely to cost over $1,000, depending on your choice of lenses.

Before buying any camera, read reviews of several in camera magazines (see the Bibliography for names of some good ones). Ask someone you know who does a lot of photography to give you some recommendations. Then make an informed decision.

Selecting a lens may be more difficult. The quality of the glass and construction varies considerably. A cheap lens may result in photographs that are always out of focus, blurry around the edges or grainy.

A good rule of thumb is to stick with the brand names you know. All camera manufacturers make lenses for their cameras that you can trust to be as well-made as the cameras. In addition, cameras with automatic features may require that you stay with the same brand when buying lenses. However, many companies produce lenses designed for use with a variety of cameras. These may be as good as or better than the camera manufacturer's own lenses and often cost less. Read the reviews in camera magazines and ask for the advice of experienced photographers before you decide.

One final note on lenses: Buy a UV (ultraviolet) or a "skylight" filter for each lens, attach it and leave it on at all times. Either of these filters will help a little to reduce haze under some lighting conditions, but their real use is to protect the lens itself from damage. Should you accidentally scratch the filter, it can be inexpensively replaced. Replacing the lens would of course be far more costly.

Summary

There are only three key points you need to understand at this point: First, start with the basics—a simple, relatively inexpensive camera with a 50mm lens. Ideally, your camera will permit you to use other ("interchangeable") lenses as well. You should have at least one lens that opens up to f/2.8, and all lenses should have UV or skylight filters attached. Second, choose a camera that includes manual controls for aperture and shutter-speed. Full manual is fine; automatic features are nice extras, but they are not necessary. Third, make sure that both your camera and lens are manufactured by a reliable company. If you begin with these essentials, you'll be well equipped to learn photography.

Additional Tools

Once you've selected a camera and lens (or lenses), you have taken care of the big decisions. Later, you may want to add other tools, such as a tripod and flash, but they can wait. Refer to Appendix 4 for more information on them when the time comes. There are, however, a few other inexpensive tools you'll need in order to get started.

As soon as you begin producing photographs, you'll want to store your negatives and prints, to keep them clean and organized. Plastic sheets specially designed for storing negatives are available that fit into a standard three-ring binder. Buy a box of these and a binder to file them in.

Immediately after developing and drying each roll of film, you will cut the roll into shorter lengths (five frames each) and slip them into the negative file. The next step is to place the film directly onto a piece of photographic paper to make a **contact print** (see Appendix 1 for explanation). With a plastic negative file, this can be done directly. Paper files are also available. They require you to remove the film to make a contact print, however, so are not as easy to use as plastic sheets.

Similar sheets are available for storing prints. If your photo store doesn't carry them, you can probably find them in an office supply store. Any plastic sheet that will hold 8½″ × 11″ paper, with holes for a three-ring binder, will do fine.

You will also want an ordinary grease pencil (yellow or white) to mark your contacts when you're deciding which frames to print. Grease pencil marks show up well in the darkroom, and they can be rubbed off if you change your mind.

Finally, be sure to have the instruc-tions for your camera available at all times. If you are buying a new camera, this will be easy. If not, you may have to search a bit, or buy one of the many books available describing different camera models. If you can't locate instructions, have some-one who knows the camera well show you how it works—and be sure to take notes.

Basic Tools Checklist

The following tools are all you will need to get started. Check to see that you have them, and that your camera and lens meet the key requirements listed here:

Camera Requirements
_____ Durability
_____ Manual Aperture & Shutter-Speed Controls
_____ Reliable Manufacturer
_____ Interchangeable Lens Capability

Lens Requirements
_____ Standard Focal-Length (50mm)
_____ f/2.8
_____ Reliable Manufacturer
_____ UV Filter

Additional Tools
_____ Plastic Negative Files
_____ Plastic Print Sheets
_____ Grease Pencil
_____ Operations Manual or Other Instructions for Camera

THE CAMERA, INSIDE & OUT

Most 35mm cameras are fairly similar in the design and placement of key controls. For example, the film advance lever (the "winder") is generally on the top right, next to the shutter release. Advances in electronics, however, are turning cameras into mini-computers. Many are utterly unlike the traditional models. Some new ones, for example, come with a built-in auto-winder and don't have a film advance lever at all.

So, the following pages are not intended as a substitute for your camera's manual. No one list can be correct and complete for all camera brands and models. You may have to hunt a bit to locate some of the components on your camera, since each model tends to have its little quirks. Check your own manual to be sure that you know where each compo-nent is located on your camera and how it works.

The following pages *are* intended as a summary of the basic com-ponents of a typical, traditional camera. This will give you an idea of how your camera compares to most others.

You may not find all of the com-ponents that are listed here, either because they are not included in your camera or because they have been replaced by an automatic feature. It is still a good idea to become familiar with all of them. Understanding each component of a traditional camera will help you understand how even the simplest or most automatic camera works. And knowing how a camera works is vital to using it well.

As you read this section, compare each description with your own camera. Be sure to have your own camera's manual on hand to clarify any questions. Look for each compo-nent as it is described, and try it out. Do not put film into the camera un-til instructed to do so.

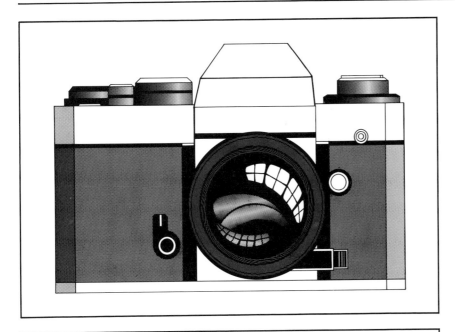

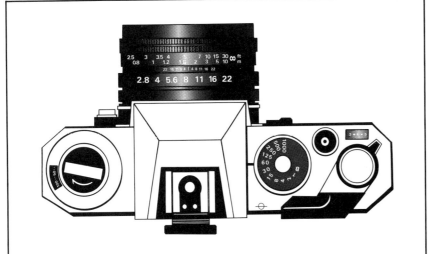

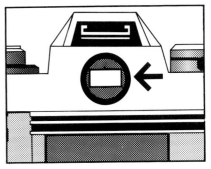

The Camera Body: Outside
• Viewfinder

The first thing to look at on your camera is the part that allows you to look *through* it. The viewfinder, in simplest terms, is just a rectangular window that shows you what will be in your photograph when you click the shutter. (Actually, viewfinders generally show you a bit less than you'll actually get. This is usually an advantage, as it gives you a little "slack" when you're making a print.)

Your viewfinder is probably quite a bit more than just a window, however. It certainly will include some kind of focusing aid. One common focusing aid is a split circle (called a split-image focusing screen) in which out-of-focus objects do not line up correctly. Another common kind is a series of circles (called a ground-glass focusing screen) that go in and out of focus as you turn the focusing ring on the lens.

The split-image screen is especially helpful if you're at all nearsighted. To use it, you simply adjust the focusing ring until both sides of the circle line up. It works best when the split is placed across a line of some kind, such as an eyelid or a branch, so you can see what you're lining up.

In addition, most modern cameras use the sides of the viewfinder to show you important information. This may include the aperture of your lens, the camera's shutter-speed,

whether the camera is in manual or automatic mode, whether your flash has recharged, etc.

Take some time to explore your viewfinder. If you aren't certain what everything in it means, consult the user's manual for your camera or ask an experienced photographer.

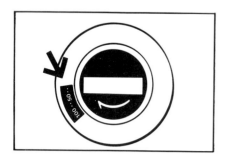

• ASA/ISO

The first step of any photo assignment is to set the correct **film speed.** This will be listed on the **film carton,** or box, (and also on the **canister,** the metal container holding the film) as **ASA** or **ISO.** These two terms are used to describe the same thing: the film's sensitivity to light. In fact they often appear together, as ASA/ISO. ISO is becoming the more common term, however, so we'll be using it throughout this book. (Both "ASA" and "ISO" are the initials of organizations—the American Standards Association and the International Standards Organization—that establish scientific measurements.)

The ISO indicator is generally built into the rewind knob, on the left side of the top of the camera. The ISO numbers are usually visible through a little window in the rewind knob. Each number is usually double the preceding number: 25, 50, 100, 200, 400, 800, etc. Dots between the numbers indicate settings in between these numbers. So, for example, ISO 125 is one dot above ISO 100.

You *must* remember to change the ISO setting every time you use a different kind of film. If you are using any automatic exposure system, your camera will base its decisions on the ISO setting you've selected. If it's wrong, all your photos will be incorrectly exposed.

The same holds true for the camera's internal light meter. If you're setting the shutter speed or aperture according to the meter, your exposures will only be correct if the ISO setting is correct. Even if you're doing everything manually, the ISO setting is an important reminder of what kind of film you're using.

To change the ISO setting, you generally turn a knob that moves the numbers through the indicator window. You may first need to press a button, lift the knob or otherwise release a lock designed to prevent you from changing the setting accidentally. On many modern cameras, you'll change the ISO by pressing a button until the right number comes up in a display panel. Some cameras will set the ISO for you automatically, reading the proper setting from a code on the film canister. (Film that has been coded for this purpose is labeled "DX.")

Locate the ISO indicator on your camera. Adjust the setting to see how low and high it goes. Professional cameras will provide ISO settings as low as 6 and as high as 6400. Many popular models have a range of 12 to 3200. Don't worry if yours doesn't go as high or as low as that. Most films fall between ISO 25 and 1200.

Once you've checked out the limits of your camera's ISO indicator, set it to ISO 125. This is the speed for Kodak's Plus-X film, which you will be using in your first assignment.

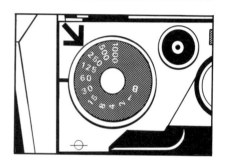

• Shutter-Speed Control

The shutter-speed control is almost always on the top right of the camera. It determines how long the shutter will remain open for each photograph. It is simply a timer. When you press the shutter release, the shutter opens, light enters through the lens, and the timer begins counting. When the shutter has been open for the amount of time you have selected, it closes again. The numbers on the shutter-speed control indicate fractions of a second (60 = 1/60 of a second, and so on), so the timer has to count very quickly.

The most commonly used shutter speeds are probably 60 and 125. Both are fast enough to stop most action with a 50mm lens, while allowing for a fairly small aperture in most lighting conditions.

Notice that 125 (or 1/125 of a second) is almost exactly twice as fast as 60 (or 1/60 of a second). The next speed above 125 is 250—twice as fast again. Depending on your camera, the highest speed may be 1000 or even higher, fast enough to "freeze" a bird in flight or a race car at the Indy 500.

Moving down from 60, the next speed is 30. Again depending on your camera, the shutter speeds may go as low as 1, for 1 second. Some cameras provide even longer automatically timed exposures, even as long as a minute or more.

The last indicator on the shutter-speed control should be a "B." This

stands for "bulb." In the early days of photography, the shutter was released by squeezing a rubber bulb, and it stayed open as long as the bulb was squeezed. The photographer had to decide when enough light had entered the camera, and then let go of the bulb to close the shutter. Since film was very slow in those days, that wasn't as hard as it sounds.

Today, although everything about the cameras we use is far more complex, this term remains the same. The "B" simply means that the shutter will remain open as long as the release is held down. This is useful for very long exposures, primarily at night. To use the "B" setting, you will almost certainly need to use a tripod and a **cable release,** which (like the old-fashioned bulbs) is used to avoid shaking the camera.

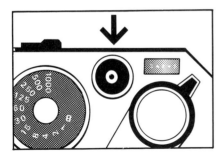

• Shutter Release

Next to the shutter-speed control (top right of the camera) you should find the shutter release. It is simply a button which, when pressed, triggers the shutter mechanism. (Note: On some cameras, the shutter release is pressed part-way down to measure the light or "freeze" the aperture setting.)

• Film Advance Lever

The film-advance lever (or winder) is generally located directly behind the shutter release, making it easy to click-and-wind quickly.

Try turning the winder (counter-clockwise). If it doesn't move more than an inch, press the shutter release. You should hear a sharp click. Then try the winder again. It should swing easily out to the side of the camera and snap back into place when you let go of it. If you had film in the camera, you would have just taken a photograph and advanced the film to the next frame.

• Rewind Release

As you wind film through the camera, it travels from its canister (on the left) to the "take-up reel" below the advance lever (on the right). When you reach the end of a roll, the lever will jam. You will no longer be able to turn it easily. The next step is to rewind the film back into the canister.

Before you can do that, you'll need to release the lock that keeps the film from slipping backwards by accident. Remove the camera from its case and look on the bottom of the camera body. You should find a small button directly below the film advance lever.

Pressing this button will release the lock, so you can rewind the film. (Until there is film in the camera, however, it won't have any effect, so don't bother testing it yet.)

• Rewinder

Once you've released the film lock, you'll need to crank the film back into its canister, using the rewind knob on the left side of the camera's top. Generally, a small crank is lifted out of the rewind knob for this purpose. There should be an arrow indicating that the crank turns clockwise, in case you get confused. As you rewind the film, it is a good idea to keep your finger on the rewind release button so it doesn't lock again and tear the film's sprocket holes.

• Battery Compartment

Another important component is generally located on the bottom of the camera: the battery compartment. If yours is there, it will probably have a round metal cover with a slit in it. To open the compartment, you place the edge of a coin (a penny works well) into the slit and turn it counter-clockwise. When the cover is removed, a small packet with one or two coin-shaped batteries should slide out. These batteries are very sensitive and may not work if you get dust or fingerprints on them. So treat them carefully. Fortunately, your batteries rarely need changing.

If you found a round metal cover with a slit in it, but did not find any batteries under it, then you've probably just discovered your camera's motor-drive connector. This is a gear that connects a separate motor-drive unit to your camera's film advance mechanism. (To learn more about

motor-drives, see Appendix 4.) In this case, your camera's battery is located elsewhere. Most likely it's in a compartment on the front of the camera body, on the right side. If so, it's likely that your camera uses batteries to run both the light meter and a variety of automatic features. The more automatic features your camera has, the more power it requires, and the more frequently you'll need fresh batteries. Check your manual to find out how to change them.

- **Battery Check**

The placement and operation of the battery check varies considerably from one camera model to the next. It may be activated by a button on the top or on the front of the body. It may cause a needle in the viewfinder to move to an assigned spot, or light up an indicator lamp. Or it may be fully automatic, activating an indicator only when the battery is low. Take a moment to locate the battery-check function on your camera, using the manual, and be sure you know how it works. Few things are more depressing in photography than discovering too late that your camera has dead batteries.

- **Hot Shoe**

Nearly all modern cameras come equipped with a "hot shoe." This is a small clamp right above the eyepiece, onto which a flash can be mounted. It establishes an electronic link between the flash and the camera. This link enables the camera to "trigger" the flash while the shutter is fully open. It may also enable the flash and camera to "communicate," so the flash can "tell" the camera what aperture to use, or the camera can "tell" the flash when it has received enough light. (See Appendix 4 for more information on flashes.)

- **Accessories**

The next three components are not essential and are not included in all models. If your camera has them, however, they can be useful.

Self-Timer The primary purpose of the self-timer is to permit you to take a picture of yourself. It usually consists of a lever that you turn before pressing the shutter release. The timer starts counting as soon as the shutter release is pressed, generally giving you a few seconds to position yourself in front of the camera and work on your smile. Most self-timers also include a little light that blinks to tell you it's working.

Multiple-Exposure Control This feature stops the film advance mechanism from working, so you can move the lever without moving the film. This enables you to cock the shutter for a new shot, while the film stays where it is. You can then put more than a single shot onto a single frame of film. If you want to play with multiple images, "ghosts" and related special effects, this mechanism will allow you to do so.

Depth of Field Preview Button Normally, your lens will stay open to the largest aperture available until you click the shutter. This gives you as much light in the viewfinder as possible to help you focus precisely. The depth of field preview button temporarily closes the lens down to the aperture you've selected, so you see exactly what the film will see. As explained in Chapter 9, the smaller the aperture, the greater the range of distance that will be in focus. This range is known as depth of field.

If you have selected a small aperture (say, f/16) pressing the depth of field preview button will cause the viewfinder to become dark (due to the small aperture). If you look carefully, you'll see that nearly everything is in crisp focus. If you've selected a moderate aperture (say, f/5.6), the background will be out of focus when the foreground is in focus, and vice versa. If you've selected your largest aperture, the depth of field preview button won't have any effect at all, since the depth of field stays the same.

The primary function of the depth of field preview button is to help you select the correct aperture when depth of field is of critical importance. You'll find it especially useful when shooting close-ups.

- **Camera Back Release**

Now comes the tricky part. Because you don't want your camera to open itself accidentally, the latch that keeps the back shut is often cleverly hidden. In addition, releasing it tends to require several steps. Generally, the release is connected in some way to pulling up the rewind knob (which

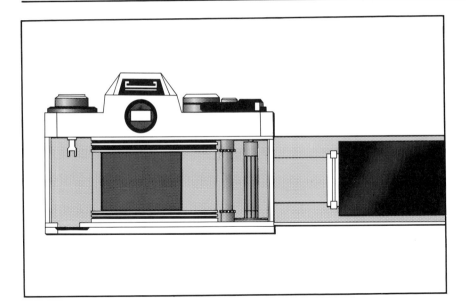

second.

The metal plate attached to the camera back (see it?) presses the film flat. (This is another of the camera's "don't touch" parts.) The shutter opens and closes, letting a very precise amount of light in through the lens. The light exposes one piece (or **frame**) of film, initiating the chemical reaction that produces a negative image. The film is advanced to a fresh (unexposed) frame and the process is repeated until the film has all been exposed. That, in very simplified form, is how a camera works.

also frees the film canister from its sprocket). If in doubt, once again, consult your manual.

The Camera Body: Inside

Before we explore the internal workings of your camera, a few general words of caution are in order. Though the outside of most cameras can stand a fair amount of abuse, the inside can't. Once you've opened the camera back, you have exposed some very delicate machinery. This is one time that strict rules *do* apply: Don't poke around with your fingers until you know what you're poking. Don't try to "fix" things, even if they appear to be broken. If you think something's wrong, take the camera to an authorized repair shop. Open the camera back only when absolutely necessary (to change film), and close it again as quickly as possible. Protect the interior from dust and moisture. If you're shooting in dusty or wet conditions, aim your back into the wind and cover the camera as much as possible. In short, *be careful!*

● Shutter

The first thing you're likely to notice once you open the camera back is also the most fragile and important: the shutter. This is a piece of cloth or a series of small metal plates covering the rectangular space directly below the viewfinder. It is as delicate as it looks, so do not touch it.

When you click the shutter, three things happen. The lens closes down to the aperture you've selected. A mirror between the lens and the shutter (which you'll see a little later) lifts up out of the way. Then the shutter slides open, stays open for the duration of the shutter speed you've selected, and slides shut.

Sound simple? In a sense it is, except that all this has to happen with absolute precision in a fraction of a

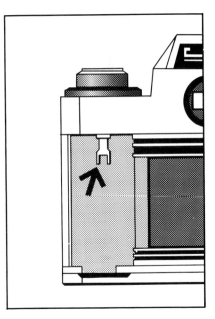

● Film Spool

To the left of the shutter screen is the film spool. This is where you'll insert a film canister. Notice the prongs that protrude from the end of the spool. These must be fitted to matching openings in the film canister. Notice also that the entire spool slides up out of the way when you pull the rewind knob. This provides just enough space for you to slip in the canister. You then push the knob back down, fiddling with it, as needed, to slip the prongs into their respective openings.

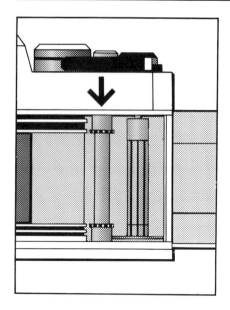

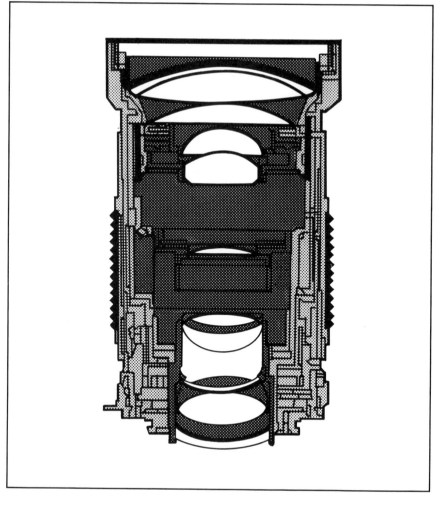

• Film-Advance Sprocket

Just to the right of the shutter screen there are two sets of sprockets (gears) on a reel. This is the next step in loading film. The small rectangular holes along the upper and lower edges of the film must be positioned over these sprockets. Each knob of the sprocket should slide easily into a hole in the film as they turn together.

• Take-Up Reel

The final step in loading film occurs at the far right, just past the film-advance sprocket. This is the take-up reel. In most cameras, this reel is simply a tube with slits in it. Your job is to insert the end of the film in one of the slits and then wind the reel until the film catches and holds tight.

On some newer cameras, the take-up reel is equipped with a special mechanism to make it easier to insert the film. Some even load the film automatically. Once again, if you have any questions, consult your manual.

The Lens

The lens is a camera's eye. Like a human eye, its opening expands and contracts (opens and closes) as the amount of light it is "seeing" decreases and increases. Also like a human eye, it focuses on some things and not on others. Unlike the human eye, however, a camera lens requires help to do these things. With most cameras, that help must come from you, the photographer.

You expand and contract the opening of the lens by adjusting the **aperture ring.** You use the **focusing ring** to select what is in and out of focus. The aperture and focusing rings are used together to determine how *much* is in focus. By decreasing the aperture, you increase the depth of field. In other words, a smaller lens opening means that more of your photograph will be in focus.

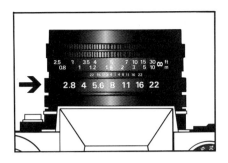

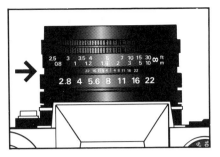

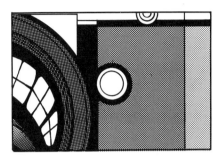

through the lens. The main use of the numbers is to give you the option of guessing at the correct focal distance. This can come in very handy if you want to sneak a shot of someone without being noticed.

• Aperture Ring

Let's start with the ring that is usually closest to the camera body and move outwards. On most cameras, this will be the aperture ring.

The aperture ring consists of a series of numbers—4, 5.6, 8, 11, etc.—that can be turned to line up with a marker. The lowest number will probably be 1.8, 2.8, or 3.5, depending on your lens. The highest is likely to be 16 or 22.

Each of these numbers stands for an **aperture** or **f-stop,** a different size lens opening. The lower numbers represent larger openings; the higher numbers represent smaller ones.

On cameras with automatic metering, you're likely to see an "A" or some other symbol indicating "automatic." If so, you may need to press a button to release the ring so you can turn it. In this case, the ring locks itself on automatic, so you don't accidentally bump it into manual mode (which can result in a lot of ruined photos.)

• Depth of Field Scale

Generally, there is another ring with the same numbers (usually smaller and sometimes colored) right next to the aperture ring. This one does not turn. It is the depth of field scale, and is there only to give information. The scale tells you what range of distance will be in focus at each f-stop. For example, at f/16 everything from 7 to 30 feet away from you will be in focus. At f/4, the depth of field is much smaller: from 7 to about 9 feet.

Basically, the depth of field scale gives you the same information as the depth of field preview button. The difference is that one tells and the other shows you.

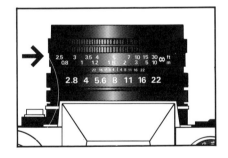

• Focusing Ring

If you've been checking out the depth of field scale, you've probably already figured out the focusing ring. The focusing ring is marked with distances, virtually always in both feet ("ft") and meters ("m"). You turn the ring to adjust the focus.

Normally, of course, you won't see the numbers, since you'll be looking

• Lens Release & Mount

Now that you know how the lens works, let's take it off. On most cameras, you'll find a button somewhere that you must press as you turn the lens (and some turn one way, some the other). Absolutely, positively, with no exceptions, do *not* attempt to remove a lens from any camera until you're sure you know how. This goes double for trying to put the lens back on. (One of the best ways to ruin a camera, outside of dropping it on concrete, is to force a lens on the wrong way—and there are *lots* of wrong ways.) Always check the manual first.

Once you have studied the manual carefully, practice removing the lens and putting it back on again until you can do it quickly and effortlessly. Before you do, make sure you have everything correctly lined up, and that you have a clean, safe place to put the lens when you take it off. Finally, never leave a lens lying around off the camera and out of its case, or a camera lying around with no lens on it. Either way, you're just asking for trouble.

Testing the Shutter & Aperture

By now you should be familiar with all the components that have an effect on the shutter. Let's take a look at them all in action.

Set your shutter speed to "B" and your lens to its largest aperture (remember, that's the lowest number). Make sure the film advance lever has been wound, to cock the shutter. Open your camera back. Aim the lens at any convenient light source. While looking at the shutter screen, press the shutter release button and hold it down.

You should find yourself looking through a hole about the size of a quarter, through which you'll be able to see whatever's in front of your lens . . . except everything will be upside down and probably out of focus.

Let the shutter close and then cock it again. Set your lens to its smallest aperture (the highest number). Look through again and press the shutter release.

This time you should see a much smaller hole, with five or more sides. The hole gets its shape from overlapping metal plates in the lens. The plates come closer together as the aperture decreases, and they spread further apart as the aperture increases.

Set the lens to its largest aperture again. Cock the shutter and set the shutter speed to 60. Click and watch again. Try the same thing at 125. Try it at 30. Can you tell them apart? Move up and down the shutter speed

dial to get a sense of how the speeds differ.

Do the same thing with all the different apertures with the shutter set at "B," so you can see the different sized openings.

Now close the back of the camera and remove the lens. Set it aside where it will be safe. Look into the camera from the front. If you have an SLR (or Single-Lens Reflex) camera, you should see a mirror set at an angle. Above the mirror you'll see the focusing screen. If you look very carefully, you may also be able to make out some of the other displays you saw in the viewfinder. The triangle on the camera's top is a prism that "bends" the image of the focusing screen around to the viewfinder so you can see it.

Aim the back of the camera toward a light source and look into the mirror. You should be able to see out through the viewfinder, though most everything will be blurry.

With the shutter speed still set at "B," cock the shutter. Press the shutter release and notice how the mirror swings up out of sight. The black rectangle you see at the back is the metal plate that holds the film in place. Let go of the shutter release and you'll see that the mirror drops right back into place. Now try the same thing at your camera's fastest shutter speed.

That concludes the testing exercises. Now it's time to do it all for real.

Loading Film

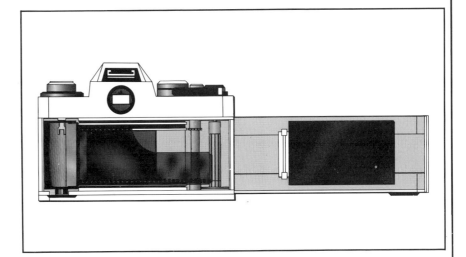

To start, open a box of film and remove the canister from its plastic case. It's a good idea to save the case to protect the film once you've finished shooting it. It's also a good idea to read over the instructions in the box if this is the first time you've used this kind of film.

Set the ISO as indicated on the film box or canister. (Always do this first, so you don't forget—and before you lose the box and hide the film inside the camera.)

Hold the camera securely in one hand, pin it between your knees or place it on a flat, clean surface. The lens should be pointing down and the top of the camera aimed away from you. Open the back. The film spool should be pulled all the way up and out of the way. Place the film canister into the compartment on the left side, so the film runs straight out of the canister across the shutter screen. Slide the film spool back down into place.

Tuck the end of the film into a slit on the take-up reel. Click the shutter and advance the film until it begins to stretch tightly across the shutter screen area. Check to be sure the sprockets are correctly aligned with the openings along the edges of the film. Click and wind once more to tighten the film, holding it tight with one finger at the canister's opening if necessary.

Close the camera back and check to be sure it is securely locked. Click and wind twice to advance to an unexposed frame.

Congratulations. You're ready to shoot.

Is a plastic hose interesting? It is if it is photographed well. Notice how composition and lighting can add impact to what could have been a very dull image. The hose is positioned slightly left of center, which accentuates its looping curves. The shadow that nearly touches the upper right-hand corner promotes a sense of balance. The "negative space" between the hose and the frame of the photograph creates unusual and intriguing shapes. What else makes this photograph "work"? (Student photograph by James Schmid.)

chapter 3 What is Composition?

A photograph is a rectangular frame with something in it. That, in essence, is all it is. Yet, within that simple definition, there are countless possibilities. Before you can begin to achieve some of those possibilities, you will need to learn how to make certain decisions with precision and creativity.

First of all, you'll need to decide what to place within that rectangular frame. Then you'll need to decide *how* to place it. Should it fill the whole frame or just a part of it? Should it be placed toward the top or bottom of the frame, to one side, or in the center? Should the frame contain a single object or several? These questions, and others like them, are questions of **composition.**

Composition is the arrangement of visual **elements** within the frame of a photograph. In photography as in chemistry, elements are basic units of composition which cannot be broken down into smaller parts. They are composition's raw materials.

The most important elements in photography are line, texture, shape, light, motion and perspective. In virtually all photographs, several of these elements combine to achieve a specific effect. A photograph achieves greatness when every single element in it contributes to one overall effect, and none is wasted.

You'll need a considerable amount of trial-and-error experience before you can expect to reach this goal, but it's a good idea to keep it in mind from the very beginning.

A good photographer is like a master chef who mixes a certain number of ingredients (or elements) together in just the right proportions to create a memorable dish (or composition). In both cases, following recipes is a useful way to get started, but soon you'll want to be more creative and try new things. A true master breaks the rules a bit and creates something unique. Before the rules can be broken creatively, however, they must be understood.

Understanding is very different from memorizing. You've memorized something when you can repeat it. You've understood it when you can apply it.

You already know that composition is the arrangement of elements within the frame of a photograph. Now let's poke at the idea of composition to see if we can achieve a genuine understanding of it.

SNAPSHOTS vs. PHOTOGRAPHS

Perhaps the best way to do this is to consider the difference between a "snapshot" and a "photograph." You know what a snapshot is and what it generally looks like: Aunt Molly sitting by the pool, grinning at the camera. A snapshot is a casual record of some event or person or object.

When you look at a snapshot, the main thing you're looking at is a memory: "Oh, so that's what Aunt Molly used to look like." It doesn't matter if part of her head got cut off or if she's slightly out of focus. All that matters is that the picture is clear enough to preserve some memories.

A lot more matters in a true photograph. A photograph is, or should be, an artistic interpretation of an event or person or object. Its purpose is to tell the viewer—any viewer—something about its subject. It should show not just what the subject is, but what it is like. And it should do so with impact and style.

To accomplish this, a photograph must be **composed.** All its elements must be selected and arranged to work together toward some unified effect.

The main difference between a snapshot and a photograph is the care with which each is produced. Taking a snapshot involves little more than pointing the camera in the right direction and clicking the shutter. Taking a photograph requires paying attention to every detail within the frame, and getting all of them just right,

before the shutter is clicked. That's what composition is basically all about: paying attention.

No matter how interesting your subject may be, you have not really photographed it until you have placed it carefully within the frame, gotten rid of anything that distracts attention from it, made sure that all the various elements are working together, and set the camera to the correct aperture and shutter speed for the effect you want. In a broad sense, the subject of a photograph is far less important than its composition. Absolutely anything can be photographed well—or poorly.

This in itself is a valuable lesson. Once you've begun seeing with a photographer's eye, you'll discover that there are wonderful images all around you—far more than you could ever hope to capture on film. Whether you continue to practice photography or not, the way you look at the world around you will probably be changed forever.

Photography is an art of discovery. It is an exploration of the endless variety of line, texture, shape, light, motion and perspective—all the fundamental elements of composition. Not many people have an opportunity to learn to explore the world in this way. You have now become one of the lucky few who do. Enjoy the exploration.

Before focusing in on each separate element, it's important to develop a sense of how they all work together. So, though each element will have its turn, we're beginning with the "big picture": composition. We've already discussed what it is, and provided some clues as to why it is important. Now let's look at how it works.

Attention to detail is the primary difference between a snapshot and a photograph. In the snapshot *(below) the head and feet of the taller girl are poorly cropped and the background is distracting. The girls' expressions are stiff and unnatural and the composition doesn't "do" anything. In the* photograph *(above) the same two girls have been posed in a more interesting way. Their expressions convey a real mood, the background is less distracting, and the composition is much stronger. Snapshot and photograph by Mike Wiley.*

As an example of the fact that a photograph can be "about" absolutely anything, here's one that is pure structure. Notice how the three structural elements—position, line and shape—can make even the simplest image come alive. (Student photograph by Augustine Go.)

STRUCTURE, BALANCE, DYNAMICS

These three things—structure, balance and dynamics—define the composition of a photograph as a whole. They provide a visual framework, a **context,** within which the various elements of the photograph find their proper places. Without structure, balance and dynamics, a photograph would only be a jumble of random objects. It would have little impact and might not make much sense.

Structure

Structure in photography works in much the same way as it works in architecture. The structural elements in a building are the posts and beams that hold it together. Non-structural elements are the walls, doors and windows that determine how the building looks and what it is for.

In a photograph, the basic structural elements are line, shape and position (the placement of an object within a composition). These three elements hold the photograph together. Non-structural elements—

texture, light, motion and perspective—are added to complete the image, altering its appearance and effect.

In a building, the design may require a generally non-structural element, such as an interior wall, to become structural. In this case, some other part of the building, such as the floor above it, depends on that wall for support. If the wall were removed, the building would probably collapse.

It's the same with photography. Occasionally, texture or light (or any of the other elements that are generally "non-structural") become so important to the composition that it, too, would collapse if they were removed.

In practical terms, this means that a photograph may, for example, be "about" texture, so much so that line and shape are irrelevant. This is, however, an exception. By and large, composition is determined by line, shape and position.

How do they do this? Primarily by breaking the photograph up into smaller frames within the main one. Each of these smaller frames, which we'll call **zones,** is in effect a picture within a picture. Ideally, each zone will produce some particular effect on its own, as well as producing with all the others one overall effect.

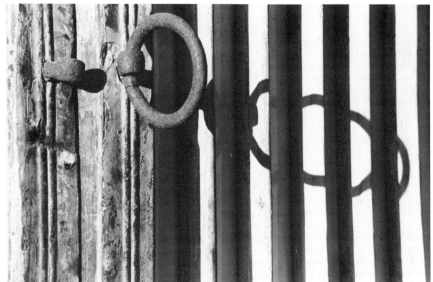

Weighting this photograph over to the left side is one element that makes it interesting. What other elements contribute to its impact? (Student photograph by Renee Adsitt.)

• The Nine-Zone Grid

Examine the composition grid diagram. It contains nine zones. These zones are produced by dividing the frame into thirds vertically (the two gray lines) and horizontally (the two dotted lines). By thinking about composition in terms of these zones, you may find it easier to get a sense of how it works.

Each zone need not produce a different effect in order to be doing its job. Most of the zones may be exactly alike, with only one or two doing something different. When that is the case, the zones that are different stand out more clearly in contrast to their surroundings: a lighted area in a photograph that is mostly dark, for example, or a figure standing in the midst of blank space.

Sometimes, on the other hand, there's so much happening in a photograph that it's hard to decide what to look at first. In this case, it helps tremendously to "anchor" the most important objects by placing each one in its own zone.

However you decide to use each zone, it's good to check all of them to be sure they are all doing something. If a zone is not adding to the effect you want, it should be corrected or cropped out. Usually, correcting a zone involves nothing more than shifting your angle, moving around a bit or waiting patiently for the composition to change on its own. Waiting for—and catching— just the right moment is especially important when you're photographing people. When you're photographing a small object, of course, you can always move it to improve the composition.

• Position

If you examine the grid, you'll see that you have three choices for positioning a subject vertically: top, center and bottom. You also have three choices horizontally: right, center and left. This gives you a total of nine choices (3 × 3 = 9).

Most photographs have a domi-

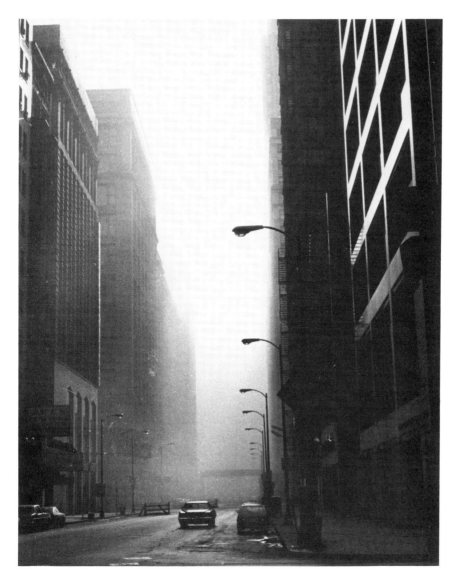

photograph will generally seem to press down on the subject. The feeling this may convey ranges from heavy and trapped to free and liberating, depending on how the other elements are employed. For example, if the upper part of the photograph is filled with massive, dark buildings, the feeling is likely to be heavy and oppressive. If, instead, the photo is dominated by clear sky, the feeling will be quite different.

A photograph that is strongly center-weighted tends to look static, as if the subject is "frozen" in place. Placing a subject in the exact center of the frame is against the "official rules" of composition. It can, however, be very effective.

Finally, strongly weighting a photograph to either side tends to suggest movement. If a subject faces the same side it is weighted toward, it will seem to be moving out of the frame. This is especially true if it is weighted toward a corner as well. If the subject is facing the opposite side, it will seem to be moving into the frame. In most cases, moving into the frame is preferable.

In most of your photographs, you'll probably want to place the main subject near where the lines dividing the zones cross each other. In other words, you will usually want your subject to be a little off-center, slightly weighted toward the top, bottom or one side. This produces a more subtle effect. The subject will

nant subject: an object or person that attracts the most attention. Usually, but not always, the dominant subject is the largest object in the frame. Sometimes it is a relatively small object that is carefully placed to command the most attention. It may also be a cluster of several objects or people.

Positioning the dominant subject of a photograph in a zone is called **weighting.** A photograph may be **weighted** toward the top, bottom, center or to either side. It may also be weighted toward any combination of these directions—for example, the upper right-hand corner.

If the subject of a photograph is strongly weighted toward the top of the frame, it will appear far away and may, as you might expect, appear top-heavy. Though this can be very effective, it produces an unusual and often disturbing effect. It should be used sparingly and only with good reason.

A photograph that is strongly weighted toward the bottom tends to appear very firmly grounded. Whatever is in the upper part of the

still seem to be interestingly distant, grounded, static or mobile, but not too much so. Later on, you will be encouraged to test the extremes. Even though you probably won't use them much, it's good to understand the effects they produce. This will allow you to use them skillfully if and when you want one of those effects.

One thing you may have noticed is that the "rules" of composition sound more like suggestions. That is entirely intentional. Some photographers employ these rules very strictly. Most, however, bend and break them as they please. You should feel absolutely free to do the same — once you've understood what the "rules" are, why they exist and how they work. After you've reached that point, they are indeed only suggestions, or guidelines.

• Line

Weighting is generally achieved by positioning. It is often reinforced with line. For example, if you decide to weight a photograph strongly by positioning the dominant subject near the top of the frame, the impression of distance you create will be strengthened if lines starting in the foreground converge (get closer together) as they get nearer to the subject. One example is a photograph of a person walking along a sidewalk. The person will seem more distant if the receding lines of the sidewalk are emphasized. Fortunately, you don't have to do anything to the sidewalk to achieve this effect; the lines will converge naturally as a result of perspective. (Perspective will be examined in greater detail later.) All you need to do is to keep your eyes open for the effect when it may be useful.

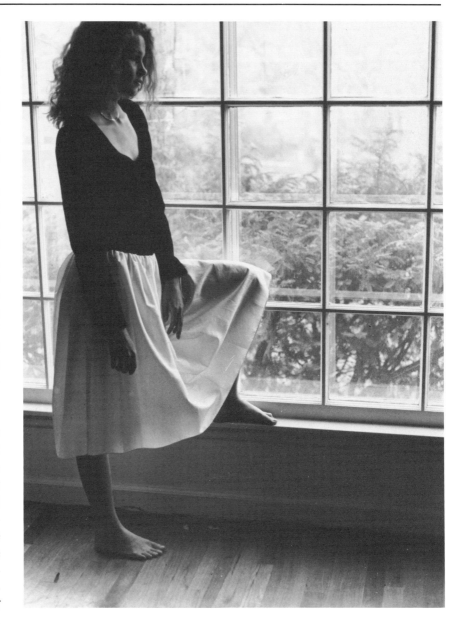

In this photograph, weighted toward the upper left-hand corner, the empty space of the window contributes to the dreamy quality of the image. (Student photograph by Kristin McCauley.)

How does line affect this centered, top-weighted photograph? Where do the perspective lines converge? Does that tell you what the photograph is about? What is the photograph about? (Student photograph by Kenneth Griggs.)

How does this photograph's composition fit on the 9-zone grid? How is it weighted? How do the shapes in it work together? (Student photograph.)

FOCAL POINT: Composition Tips

As you continue to practice photography and begin discovering your own style, you'll also begin defining your own approach to composition. The guidelines that follow will, however, help you get off to a good start. If you pay close attention to these guidelines, many of the photographs you produce now will look pretty good even after you become a master photographer.

Get in close. The most common mistake made by beginning photographers is staying too far away from the subject. Admittedly, a distant shot can sometimes be very effective. As a general rule, however, the closer you are to your subject, the more interesting your photograph will be.

Why? Well, first of all, the larger the subject is within the frame, the more detail it will have. Detail tends to add interest. Making your primary subject large also helps the viewer understand that it *is* the primary subject. (It's very frustrating to "wander around" in a photograph trying to figure out what the photographer wanted you to look at first.) Finally, getting in close reduces the size of the negative space, making it more interesting.

A good way to practice this tip is to shoot a subject several times, moving in closer with each shot. See how close you can get and still produce an understandable image. You may be surprised.

Pay attention to negative space. Keeping negative space relatively small is half the battle, but not all of it. In addition, it's important to experiment with the placement of your subjects until you achieve an effect that is not merely interesting, but

Student photograph by Janice Pata.

exciting.

Get into the habit of scanning the edges of the frame—before you click the shutter—to see what the negative space looks like. If it doesn't excite you, change your position or camera angle until it does. This will get easier, even automatic, with practice.

Edit your image. You don't score points as a photographer merely by being present for a photograph. You have to work at it. Anything within the frame that doesn't contribute to the whole image doesn't belong in it. Edit it out.

Once again, this is done by mov-

ing closer or to one side, or by shifting your camera angle until everything that should be in is in and everything that should be out is out. Never let yourself mutter, "That thing just got in the way." It's up to you to get it out of the way.

Watch your edges. While you're shooting, printing or critiquing a photograph, look carefully at the borders, especially the corners. Lines that cut through the corners, random flecks of light or shadow and little bits of confusing detail along the edges will draw the viewer's eye away from the point of interest.

Keep verticals vertical and horizontals horizontal. Buildings that appear to lean or horizon lines that tilt are likely to make your viewers nervous or queasy. Avoid them by holding your camera level, or correct the print by cropping. Receding lines in the background are rarely a problem, but be sure the central image looks steady, unless you have a good reason to do otherwise.

Place your subject in its environment. As another general rule, it is helpful to give the viewer some sense of the subject's surroundings. This does not mean, for example, that you need to pull away to show the entire neighborhood where a person is standing. A little bit of background detail may be all that's needed to provide a suitable context. Even clothing can provide an environment for a person's face.

Here's an excellent example of a highly structured photograph. Notice how the lower hand forms a downward triangle with the two girls' heads. The hands of the girl on the right form a second triangle (pointing up). What lines emphasize the triangles? How does the sweater of the girl on the left relate to the background pattern of the jungle-gym bars? How does the position of the girls relate to the vertical lines of the 9-zone grid? How do the bars relate to the horizontal lines? (Student photograph by Jun Hwang.)

Line can also contribute to the structure of a photograph without being directly involved in the position of its subject. The most common way it does this is by literally dividing the frame up in some kind of grid pattern. The grid produced by lines in a photo may or may not be the same as the compositional grid we have just been looking at. The lines may make a different grid of their own. In this case, the grid produced by the lines is added to the basic compositional grid. The rules concerning the compositional grid, however, remain the same.

In fact, as you experiment with line, you will probably discover that the compositional grid corresponds quite accurately to the best placement of the most important lines in the frame. For example, horizon lines are generally most pleasing, and seem most natural, when they are placed very near one of the two horizontal lines in the compositional grid. Similarly, a key vertical line, such as the edge of a wall, will generally work best when it is placed near either of the two vertical lines of the grid. This observation leads to another: in most photographs that employ lines, the lines have merely weighted the photograph in one or another direction, depending on how they have been placed within the compositional grid. In other words, lines work within the grid just as any other objects do.

An unusual kind of balance is produced by composing a photograph so that it "pulls" in opposite directions. This photograph is weighted toward both the upper-right-hand and lower-left-hand corners. What effect does that have on its impact and mood? (Student photograph by Brian MacMillan.)

• Shape

Shape affects structure in two ways: by where it is . . . and by where it isn't. Though the idea may be hard to grasp until we explore it further (in the chapter on Shape), every object in a photograph actually has two shapes. The first shape is the obvious one: the space an object takes up within the frame, known as **positive space.** The second is less obvious: the space that surrounds an object. This second shape is called **negative space.** Because careful composition is required to make negative space interesting, it is one of the main differences between photographs and snapshots.

Negative space is defined by borders—the borders of an object and the borders of the photograph's frame. The closer those borders are to each other, the more effective the negative space will be. If the subject

of a photograph is surrounded by too much negative space, the overall effect may be weakened. In this case, the borders of the frame may be too far away from the object to interact with it in an interesting way.

So, when you position a shape within the frame of a photograph, you need to pay attention to two things:

First, is the shape itself interesting? If not, you can usually improve upon it by either altering the shape (asking a model to change position, for example) or by changing the angle from which you are photographing it. It is not enough simply to find an interesting subject; anyone who takes a snapshot does that. The photographer's job is to make an interesting photograph of an interesting subject, which is quite a different thing.

The second point you need to think about when you position a shape is

how it fits within the frame. Does it do something interesting in relation to the other objects and the frame? If not, you probably need to move the object or move your camera.

Balance

Balance is an equal relationship between two or more things. If you place two objects on a balancing scale, they are balanced when both sides of the scale are of the same weight. It's no different in photography. A photograph is balanced when the various elements "weigh" the same. This does not mean that they must take up the same amount of room. What it does mean is a good deal more complex.

Let's say you are taking a photograph of a tree. You can balance the photograph in several ways, depending on the tree's surroundings and on the effect you want. If the tree stands alone against a blank sky, you'll probably want it to nearly fill the frame—in which case the negative space will interact well with the frame. In this case, the photograph has a single subject: the

tree.

If the sky is interesting, you may choose to weight the tree toward the bottom of the frame. In this case, there are actually two subjects in the photograph: the tree and the sky. If the ground under the tree is interesting, you might weight the tree toward the top of the frame. Again, you have two main subjects: the tree and the ground.

If there is a person standing off to the right side of the tree and if the sky behind is interesting, you might weight the tree to the lower left of the frame. You now have three subjects: the tree, the sky and the person.

In all these examples, you achieve balance by making sure that the subject or subjects are placed in an interesting relationship to each other and to the frame of the photograph. Each should take up exactly the right amount of room it needs to achieve this relationship.

To make things clearer, let's see what happens when a photograph is unbalanced. Go back to the photograph of the tree isolated against a blank sky. If you photograph it so the tree is small and weighted toward the bottom, what happens? First, the tree itself loses interest simply because it is small. Second, the sky loses interest because it is too big to create much negative space. There's so much negative space that the eye gets lost in it. This effect, which is almost always undesirable, is called **dead space.** Space that doesn't do anything is dead.

The photograph we've just described is uninteresting because its subject is not balanced with the negative space. Make the tree larger and move it further up into the frame, and the photo begins to generate interest.

Dynamics

Dynamics are about movement, specifically the movement of a viewer's eye as it explores a photograph. When you look at a photograph, your eye naturally moves from one object within the frame to another. Ideally, that movement begins with the most important object, the **primary subject,** and then proceeds to less important ones,

Two kinds of dynamics are at work in this photograph. First, the viewer's eye naturally follows the eyes of the subject, to see what he's looking at (which, in this case, is beyond the frame). Second, the curved lines of the subject's jacket collar and hair create a sort of "funnel" that reinforces the dynamic flow. (Student photograph by Jeff Frye.)

secondary subjects. Finally, it comes full circle back to the primary subject again.

In a poorly composed photograph, on the other hand, one of several things can happen to the dynamics. The viewer's eye may get stuck on one of the secondary subjects, which weakens the impact of the primary one. It may get distracted by something that wasn't supposed to be a subject at all (such as an annoying white space near one corner), in which case it may not really "see" the photo at all. Or it may find so many secondary subjects competing for attention that it just bounces around the frame until it gets tired and looks away.

Part of your job as a photographer is to arrange the objects in a photograph so the eye naturally moves around it in a way that strengthens the photograph's impact. Generally, this means that the objects are arranged so the eye first notices the primary subject, then begins to explore how it relates to the secondary subjects, and finally comes back to the primary subject before going around one more time. The more interesting these relationships are, the more often the viewer's eye will repeat its path around the photograph. This is what dynamics are all about—generating and holding in-terest by directing the eye around the photograph.

Dynamics can be enhanced through the use of lines. Actual lines, as in the sidewalk mentioned above, may connect two or more subjects. This creates a sort of road map of the photograph. The eye finds its way around by following the lines.

Implied lines can achieve the same effect. If, for example, a person in a photograph is looking at another subject in it, the viewer's eye will nat-

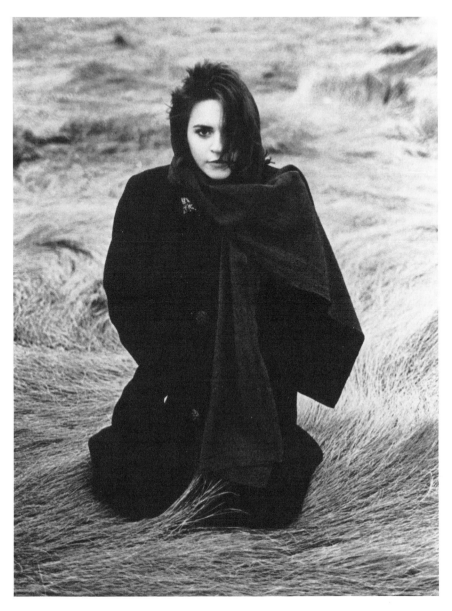

Take a few moments to test the theory of dynamics we've just outlined. Look at any photograph in this book and pay careful attention to how your eye moves about within the frame. Try this with several photographs. Which ones are most dynamic? Which hold your interest longest? Which contain distracting elements that interfere with the dynamics?

While they may work alone, balance and dynamics often work together. A photograph conveys **static balance** when its subjects are of equal weight and appear immobile, "frozen." Static balance is essentially balance without strong dynamics. In a statically balanced photograph, the viewer's eye tends to take in everything all at once, without moving around the frame. This can be effective if the subject and composition so interesting that they hold the viewer's interest on their own. Portraits of people with especially interesting faces or expressions often employ static balance.

A photograph achieves **dynamic balance** when its subjects are positioned to encourage the eye to move around within the frame.

urally look to see what that other subject is. There is an implied line between the person's eye and the subject it is looking at. Similarly, many objects can, in effect, point at others. A fence, for example can point at a tree, even if the fence doesn't actually touch the tree. The viewer's eye will naturally tend to follow the line of the fence. When the fence ends, the eye will keep on going until it reaches the tree. This is another implied line, and another example of dynamics.

EXERCISE

Mat Frame

Turn to the back of the book and locate the "Mat Template." Trace the template onto sturdy paper and dry-mount it onto a piece of dark mat board. (See Appendix for instructions on mounting.) Then carefully cut through both the mat and the template along the dotted lines. For best results, use a sharp knife (such as an X-acto) and a metal straight-edge.

You have now constructed a mat frame with roughly the same proportions as your camera's viewfinder. Hold the frame an arm's length away, with the dark side toward you, and look through it. Wherever you happen to look, you'll have some kind of composition within the frame. Evaluate it. Is the composition interesting? Is it well-balanced? What kind of dynamics does it have?

Next, shift the frame to either side, up or down, and observe how that changes the composition. Move it closer to you to fit more into it, or further away to crop more out of it. Rotate the frame so it goes from horizontal to vertical and back again. Try as many adjustments as you can think of until you've made the best composition you can. Then turn around and try the same process in another direction. Select an object near you and experiment with it. How many interesting compositions can you produce with a single object? Can you make an interesting composition out of absolutely anything, or do only certain kinds of things work well?

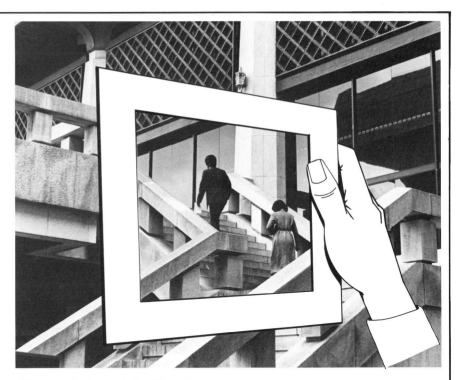

Student photograph by Han June Bae.

This exercise is, in a sense, a photographer's "warm-up" exercise. Its purpose is to loosen up your photographic "muscles" before you actually go out to shoot photographs. By exercising with just a frame, you may find that you notice things that you might miss with all the complications of a real camera. This is likely to be true whether you've already used a camera for years, or are just getting started. It's a good exercise to come back to at regular intervals, just to "freshen up" your eye—so keep the template handy and use it often.

EXERCISE
Cropping

This exercise begins much like the previous one. First, locate the "Cropping L's" template at the back of this book. Trace it, dry-mount it onto mat board and cut out the L's. (They are called L's because they're shaped like L's.)

Place the L's on top of the photograph on this page. See if you can find a better or at least different composition within that photograph by adjusting the L's.

Try cropping in on one small detail. Try trimming out any unnecessary details or background. Try shifting the balance to one side, up or down. See how many good photographs you can find in this one.

Then turn to any other photograph in the book (the larger the better) and try the same thing. Continue experimenting with a variety of photographs.

Try working with a partner, taking turns cropping the same photograph.

Is there only one good composition within each photograph? Is there one best composition in each? Does everyone tend to agree on which is best?

Keep your cropping L's handy, and use them often to evaluate compositions. Try using them during critique sessions (see the next section) to show the class how you would crop a photograph differently. Locate or obtain some magazines with a lot of large photographs (Life, National Geographic, Smithsonian, fashion magazines, etc.) and see how many of the photographs you can improve by cropping.

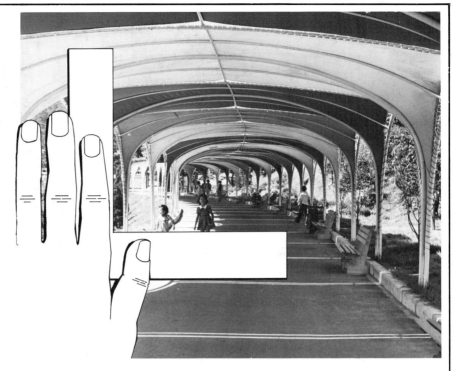

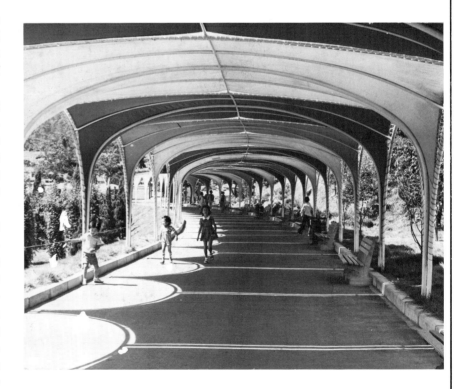

Student photograph by Frank Hall.

Student photograph by Jay Le Claire.

chapter 4 Developing a Critical Eye

Before you begin doing something, it is generally helpful to establish some goals. If you have some idea of where you're headed — or where you *should* be headed — you're likely to arrive more quickly. You'll also be able to measure your progress more accurately.

The best way to start setting your own photographic goals is to critique the work of other photographers. Once you begin begin producing your own photographs, you'll progress more rapidly if you let others critique your work as well. When a photograph is critiqued, all the various elements of it — good, bad or indifferent — are evaluated. Critiquing is *not* the same as criticizing, which only involves pointing out flaws. In a true critique, positive and negative comments are balanced. This is an essential skill that every photographer must develop.

CRITIQUE SESSIONS

The critique session — or "crit," as it is popularly called — is one of the most valuable tools for developing skill as a photographer. In simple terms, a crit involves a group of people looking carefully at a selection of photographs, such as those you will be producing for the exercises in this book, and analyzing or judging them.

Though a crit session does usually involve ranking the photographs, its primary purpose is group analysis.

There are three basic questions to ask yourself about each photograph you critique: What is good about it? What is not good? How could it be better? The primary goal is to train your eye — to learn to see clearly as a photographer, when looking at others' photographs and when taking your own.

You'll probably find that it's a bit less threatening to critique someone else's work, rather than your own. You won't be so close to it and, therefore, will be able to spot its strengths and weaknesses more objectively. This is one benefit of a group crit. Another benefit is that you can learn from each other's comments.

EVALUATING A PRINT

Take a look at the photograph to the left which we will use as an "example photograph" for the next few pages. Like most of the photographs in this book, it was taken by a student. Ask yourself the three questions mentioned above: What's good about it? What's not good? What could be better?

As you ask these questions, a fourth one may come to mind: Where do you start?

Most people, when asked to judge

a photograph, will start by saying whether they like it or not. People tend to like a photograph when they like what's in it, and to dislike a photograph when they don't like what's in it. And many will stop there.

Your first goal, as a photographer, is to move beyond your own likes and dislikes; to identify the technical, objective factors that define a photograph and to evaluate them. The essential distinction here is between **style** and **standards.**

Style is largely a personal matter. In time, every photographer develops an individual style, a unique way of seeing things and expressing them — just as a singer or a writer develops an individual "voice." This does not mean that all of that photographer's work will look the same — far from it — but there will be certain stylistic themes that connect all the images in that photographer's portfolio.

Similarly, each photograph has a style of its own, a mood or an interpretation of the subject. In the best photographs, that style is consistent — everything in the photograph contributes to the overall impact. The result is a single clear image, rather than a collection of random details.

Liking or disliking that style is a matter of opinion — a subjective judgment. It has very little to do with whether the photograph is skillfully

produced. Skill is the key ingredient of standards, and standards can be judged objectively. They are, by and large, matters of fact, not opinion.

The place to start in your critique is to determine the facts about a photo. Once you've done this, you have a good basis for determining your opinions about it.

Four basic factors determine a photograph's standards: **value, clarity, composition** and **presentation.** Ideally, a photograph will score well on each of these factors, but one or another factor may be so well represented — or the image so striking — that the photograph will be successful as a whole even if one (or more) of the other factors is lacking.

Value

Value, in a photograph, concerns light — not price. Specifically, it refers to the **range** of light in the photograph: from black through shades of gray to white.

As a general rule, the more **contrast** a photograph has — or the wider the range between its darkest and lightest elements — the greater its visual impact will be. (As with any rules, there are exceptions; a photograph that is all grays, with no whites or blacks, can be very effective. But, in general, it's good to aim for contrast.)

If, however, everything in a photograph is either black or white, with no grays, it may have a lot of impact, but will generally lack interest. Once the eye has taken in the bold image, there is not much reason to keep looking. So, in addition to a good balance of black and white, it's desirable to have a range of grays to define shapes and provide shading.

When evaluating a photograph's value, it's important to distinguish

A photograph of normal value contains black blacks, white whites and a variety of grays. (Student photograph.)

between good and bad grays. The former are consistent and clear; the latter are best described as "muddy." Muddy grays may result from underexposing when shooting, underdeveloping the film, using an incorrect paper grade, over-exposing the print or removing it from the developer too soon.

Take another look at the "example photograph." Evaluate its values. You'll probably notice right away that this is an exception to the rule

about contrast. There is not much range between the photograph's lightest and darkest elements, yet the man's face is so expressive that the photograph works. If you look closely, you'll also notice that the one area with good contrast is the eyes — and the eyes are what grab your attention when you look at the photograph. So, while value in the overall image is limited, it is strong at the most critical point — the eyes. In fact, it is largely because the rest of the

Student photograph.

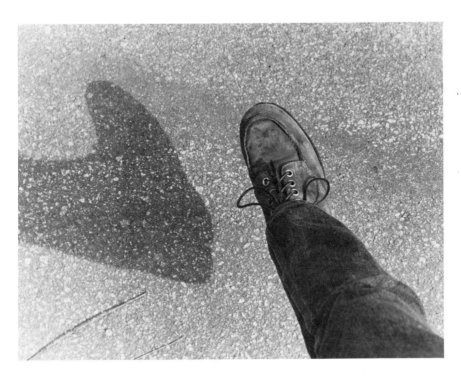

A low-contrast or "monotone" photograph has a very narrow range of value. And notice how this one is dominated by mid-range grays and contains virtually no white or black. (Student photograph by Charles Stuart Kennedy III.)

A high contrast photograph contains predominantly blacks and whites, with few grays in between. (Student photograph by Jon Portis.)

image is so subdued that the eyes are so penetrating.

Improving Value

When you have determined that the value of a photograph is weak, the next question is: How could it be better?

Assuming the subject was reasonably contrasty to begin with, there are many possible causes for poor value. The most common is incorrect exposure when taking the photograph. Too little light will result in a dark, "muddy" print. Too much will cause highlights (white areas) to be "washed-out" or "burned out"—so white that no details are visible in them. (The upper corners of the "example photograph" are an example of this—though, again, the image works despite this flaw.)

How the film is processed will also affect its values. The longer the film stays in the developer, the more contrasty it gets. Gray areas continue developing, getting blacker and blacker on the negative and, therefore, lighter and lighter on the print. If the film is removed from the developer too soon, its contrast will be low; the resulting prints will be weak and gray. Special chemicals are available with which you can re-develop film to increase or reduce the contrast.

Additionally, the kind of paper used to make the print has considerable effect on its contrast. Paper grades, which range from low to high contrast (generally numbered 1 through 5) allow considerable oppor-

Another "rule breaker"—this time without any real whites and few blacks. Notice how the grays are crisp and varied—not muddy. (Student photograph by Michele Dearing.)

tunity to adjust the contrast up or down when making a print.

Other causes include paper that is accidentally exposed to the light, exhausted chemicals and improper developing of the print. Even slight amounts of light leaking into a darkroom can "fog" the paper, resulting in an overall gray tone. Chemicals that have been over-used or left out too long can become exhausted (or weak), resulting in unpredictable results. Too much or too little exposure of the paper under the enlarger and too long or too short a developing time will also distort the values of the final print. In all these cases, careful and consistent darkroom habits are the cure.

Clarity

The second key factor is clarity. The primary key to clarity is focus—not just whether or not the photograph is in focus, but whether it is correctly focused. There is a difference.

In a correctly focused photograph, a subject may be either sharp or soft. With sharp focus, all edges are very clearly defined. With soft focus, the edges blur a bit. When something is out of focus, the edges blur more than they should. Here's another case in which personal style varies considerably. For some photographers, any blurring at all is unacceptable; others deliberately shoot with extremely soft focus to achieve a particular effect.

Often, the best way to treat an image is to choose some elements that will be sharp, leaving others in softer focus so they are less distracting. This helps direct the viewer's eye to the focal point of the photograph, and it also makes your photograph more closely resemble normal sight. (Test this yourself: look at an object close to you and notice how the background goes out of focus.)

So, the questions to ask are: What's in focus? What should be in focus? Generally it is the center of interest—what the photograph is about—that should be in focus.

Then look at what is not in focus. Why is it not?

Soft focus throughout a photograph may be effective, especially in portraits (to obscure blemishes or enhance the mood) or in landscapes (to achieve a dreamy effect). Special filters are available for this purpose, which work better than shooting out of focus.

In addition to appropriate focus, clarity depends on an appropriate shutter speed and an appropriate degree of contrast between the sub-

"What to leave in, what to leave out . . ." is the critical decision regarding focus. Notice that the helicopter in the background is just clear enough to be recognizable. This helps to keep our attention focused on the man in the foreground. (Student photograph by Trevor Bredenkamp.)

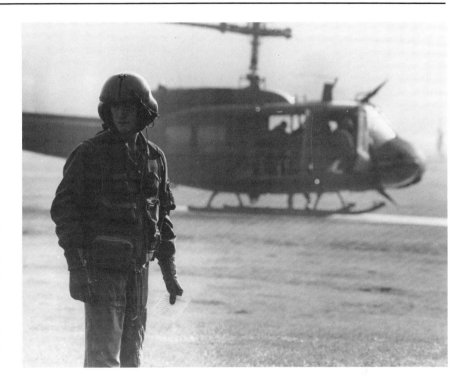

ject and background. If the shutter speed is too slow, the subject will be blurred—either because it moved or because the photographer did. Blurs can be effective . . . if they are done on purpose. If the shutter speed is too fast, it may reduce the photograph's impact. For example, a race car that should look like it's zipping past may instead look like it's standing still.

The relation between the subject and background in a photograph has something to do with light and value, with line and with composition. Common mistakes include photographing a dark subject against a dark background (causing the subject to vanish mysteriously), composing a photograph so trees are growing out of the subject's head, and placing a complex subject in front of a complex background (causing another vanishing act).

Returning to the "example photograph," the lines on the face, the mouth and, especially, the eyes are quite sharp. This reinforces their impact. The fur hood, zipper and button of the jacket are softer. They are clear enough to provide a **context**, or setting, for the face, but not so sharp as to compete with it for the viewer's attention. The nose is also a little soft, adding depth to the face. The shutter speed was fast enough to prevent any blurring, and the white background (what there is of it) sets the whole figure off nicely.

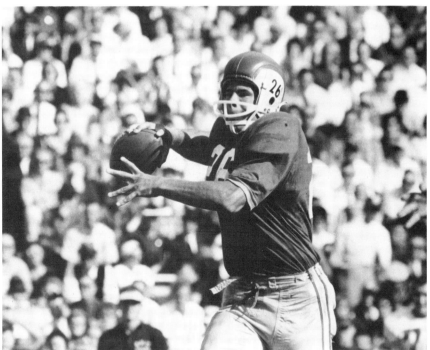

Selective focus works again in this photo, in which the crowd is reduced to a suggestive blur—keeping our eyes on the quarterback. (Student photograph by Jerry Wisler.)

Placing everything in sharp focus
helps to accentuate shapes and
patterns, as well as giving the
viewer's eye "permission" to wander
about the composition. (Student
photograph by Lena Aiken.)

Occasionally—very occasionally—a
poorly focused photograph can
work just fine . . . even better than
if it were focused "correctly."
Notice how the soft focus on this
woman affects the photograph's
mood and meaning. What does the
photograph seem to be about?
What feelings does it convey to
you? (Student photograph by
Jonathan Serenius.)

Wide depth of field can provide the viewer's eye with plenty of entertainment after a photograph's initial impact (in this case, the visual joke of the balloon) has worn off. How does this photograph make use of the 9-zone grid? Of weighting? Of value? (Student photograph by David Chmielewski.)

always be in focus . . . but it may not be in the frame of the camera. The trick is to focus more carefully as you use larger apertures. After focusing, do not move forward or backward. When the subject is relatively close and the depth of field is very shallow, this can be crucial. (Depth of field will be covered in Chapter 9.)

A third cause of poor clarity concerns the other half of the shutter-aperture equation: As the shutter speed decreases, the chances of blurring a picture increase. This may be caused by a subject that moves, or by "camera shake," particularly in low-light situations.

You have little control over the movement of a subject (other than asking it to sit still), but you can control camera shake. Try pressing the camera tight against your forehead and cheekbone, holding your breath while you shoot, or bracing yourself against a wall — or all three at once. Another good technique is to prop your elbows on a solid surface or, in a pinch, on your knees.

You will soon learn how slow a shutter speed you can safely use, which (as we'll discuss in Chapter 10) will vary according to the length of the lens you're using. For photographs that require a lower speed, use a tripod (see Appendix 4).

In addition, a print may be fuzzy because the enlarger was incorrectly

Improving Clarity

There are, again, a number of causes for poor clarity. Focus is the most common problem. It is generally caused by a failure to set the correct distance on the focusing ring. A less obvious, and slightly less common, cause is using too large an aperture.

As the available light decreases, a photographer can make up for this lack of light in two ways (assuming no flash is being used). The shutter speed can be decreased, or the aperture can be increased. As the aperture is increased — as the lens opening gets larger — the **depth of field,** or range of distance that will be in focus at any time, decreases. Something will

focused. Use a focusing aid (see Appendix 1) to correct this. If the problem persists, have your eyes and your lens checked. Your eyesight may be poor or your lens may be either faulty or dirty.

Presentation

The third factor to look for is the care and skill with which the final print has been produced. In addition to the contrast and focus already mentioned, one telltale indication of a print's quality (and, therefore, of the photographer's commitment to standards) is how clean it is. Look for white flecks, variously known as satellites, glitches, scuzz, hickies or glop—stuff on the negative that shouldn't be there. Other categories include fingerprints on the negative or print (keep your fingers out of the chemicals!), scratches, and dark circles caused by poor agitation when developing the film. In general, following instructions carefully, using anti-static brushes and other cleaning tools and keeping the darkroom as dust-free as possible will do the trick. It is possible to produce flawless prints, though at first it may not seem to be.

Other aspects of presentation to look for include neatly trimmed edges (use a good sharp cutter), squared corners and proper adhesion to the mat board.

Composition

You already know something about composition. Of the four basic factors of "standards," it is the trickiest to define, because it is the closest to "style." There are, however, a number of aspects of composition that you can evaluate objectively. We'll review them quickly to refresh your memory.

Where is the point of interest in this photograph? Is it cropped effectively? Is there wasted space in it? What would happen to the mood and impact of the photograph if it were cropped more tightly? Student photograph.

• Point of Interest

First and foremost, is there a **point of interest?** Does it stand out or is it lost in the surrounding confusion? With rare exceptions (and there are always exceptions), a photograph should have one clear point of interest—a single dominant element. Generally, the point of interest should be near the middle of the frame, though not usually right at the center.

• Cropping

Once you've identified the structure of the photograph, consider its **cropping,** or the way it is framed. Is it "tight"—is the frame filled with important elements, or is there wasted space? Blank areas, or **negative space,** can enhance a photograph's impact, but should interact with the central image in some way or the photograph will instead have less impact.

As a general rule, it is good to keep the "idea" of the photograph "clean" and simple. The frame should narrow in on what's important, leaving out unnecessary details.

What about the overall **balance** of the composition? Is it top-heavy, lop-sided, boring? A composition may be balanced in two ways: **static** or **dynamic.**

Static balance just sits there, but that can be quite effective. The most common way of achieving static balance is to **weight** the composition, or concentrate its point of interest, near the center.

Dynamic balance suggests movement. Generally, this is achieved by weighting the composition away from the center, toward one side or the other, or toward the corners.

• Lines

Lines and curves within a composition often have a tremendous effect on its impact. Sometimes this will be obvious, as in a photograph with a crisscross pattern in the background. Often, however, you'll need to look

more closely to locate the straight and curved lines.

Even a single line can "pull" or "point," drawing the viewer's eye toward or away from the point of interest, increasing or reducing the photograph's drama.

Examine the lines of the "example photograph." Look for curves: the hood, the lines on the man's face, the circles under his eyes, the button, the slope of the right shoulder. All these add to the visual impact of the composition, creating a complex pattern which, in turn, creates an appealing "visual tension" in contrast to the eyes. In addition, the curves of the zipper help to anchor the composition, giving it a base and opening up into the face.

Aesthetics

Finally, we come to "style"—that elusive something that makes the difference between a skillful photograph and genuine art. Often, a photograph will have all the right elements but still not work. Sometimes, however, a photograph will lack many critically important elements, yet work very well. And, of course, all the right elements may combine to achieve an effect that is greater than the sum of its parts. Something special happens, a certain spark ignites, and the result is . . . magic.

It's difficult to pinpoint what makes this difference, but it is precisely what all photographers strive to achieve. As you progress, you'll become increasingly aware of which photographs have that something, and which don't, and why. And you'll begin to make it happen in your own photographs. A very good way to start, probably the only way, is to master the techniques of producing consistently good photo-

How does the presentation of this photograph (using lith film to produce a high-contrast print) affect its impact? Do you think it probably improves the photograph? Is the presentation appropriate? Student photograph by Christopher Moiles.

graphs, and to train your eye to recognize the great ones when they come along. Eventually, they will.

Sample Crit

Describe the dynamics of this photograph. What elements contribute to them? Assess the value of the photograph. The composition (9-zone grid anyone?). How does it make you feel? What sort of person do you suppose the subject is? What sort of person do you suppose the photographer is? (Student photograph by Alison Sheehy.)

Now it's your turn. Evaluate each of the photographs on the following pages, applying the criteria we've discussed in this chapter: value, clarity and composition. (Presentation is a bit hard to apply to photographs in a book.) Notice the use of negative space in each photograph. Can the cropping be improved? Is the primary subject well placed on the nine-zone grid? Is the photograph well balanced? How about its dynamics? Does it work?

As you explore these and other questions, try to determine why each element of the photograph does or doesn't work. Ask yourself how you might improve each element. Would the photograph be equally or more effective if it were shot from a different angle? What changes in lighting might increase the photograph's impact? In some cases you're likely to see a number of possible alternatives or improvements. In others you may decide that the photograph is close to an ideal treatment of its subject.

Take some notes as you evaluate each photograph. Jot down what you like about each photograph and what you think could be improved: "Good value range and mood; negative space could be enhanced by cropping in closer to face"; etc. Discuss your observations to see how others respond to the same photographs. Keep your notes on file and check them again in a few months to see if your perceptions change.

How does this photograph fit on the 9-zone grid? How would you rate its value? What about the cropping (i.e the missing head)? Is it annoying? What, if anything, does the photograph say *to you? What sort of person do you suppose the subject is? (Student photograph by Jeff Frye.)*

The value of this photograph is restricted to black and a very narrow range of grays. Is it appropriate and effective? How is the composition structured? Do you suppose the starfish was found where it is or placed there by the photographer? Does it matter to you? What elements do you consider most important in it? How does the photograph make you feel? What thoughts or memories does it provoke? (Student photograph by Amy Christine Zorovich.)

Does this photograph have any composition? (Look carefully and remember the grid.) What do you think of it? How about its values? Its focus? What, if anything, is it about? (Student photograph by Jon Portis.)

How would you evaluate this photograph? (Student photograph.)

How would you evaluate this one? (Student photograph by Chong Street.)

Used correctly, the "point of departure" setting will produce consistently good results in bright sunlight. (Student photograph.)

chapter 5

Point of Departure (f/16 at 1/125)

Now that you are familiar with your camera, and have begun to evaluate composition, it's time to start putting your knowledge to work — by actually taking some photographs. In order to help you begin taking good photographs immediately, technical concerns will initially be kept to a minimum. At first, you will be doing little more than aiming your camera, focusing and shooting. As you proceed through the various exercises, however, you will gradually add on new techniques, learning new ways to express your own vision. By the time you reach the end of this book, you will have a solid foundation of skill and the beginnings of a personal style. Later, as you continue to progress on your own, you'll be able to push your skill and style to the limit. But for now, we'll stick to the basics.

STARTING SIMPLY

Your first assignments will be based on a "point of departure" that will enable you to produce technically successful photographs without getting bogged down in details. You will be using a standard aperture and shutter-speed setting: f/16 at 1/125 of a second.

By using one standard setting, you'll be able to concentrate on learning how to "see" with a camera. In addition, starting with this setting will help you learn how the camera works. This, in turn, will provide a basis for all your future photography. Once you've had some experience with the standard setting, you'll be able to make informed decisions about how to handle a variety of other lighting situations.

You will be using black-and-white film with an ISO of 125, such as Kodak's Plus-X. Your shutter will be set at 1/125 of a second, fast enough to "freeze" most action. Your aperture will be small — f/16 — so almost everything will be in focus. After loading the film, you'll adjust your camera controls to these settings — and leave them there.

You may find yourself tempted to change the settings if your light meter disagrees with them. (After all, that's what the light meter is for, right?) But for now, just pretend the light meter isn't there.

There are several good reasons not to rely on your light meter at the beginning. First, if you learn to shoot without it, you'll be better equipped to do so when necessary — such as when your batteries die on you, 100 miles from the nearest camera shop. (Many cameras can be used manually without batteries, though some modern ones cannot.) A second good

reason is that your light meter is not always accurate. Light meters assume you want the average value in your photograph to be gray. Usually you do. But when you don't, or when unusual lighting conditions "confuse" the light meter, then it's vital that you know how to work without it.

When you start shooting your first assignments, you will need to pay attention to only one technical concern: make sure your subject is well lit. This means that you will need to shoot outdoors in sunny weather. A day with some clouds is okay, but a heavily overcast or rainy day is not. It also means that you will generally want the sun to be behind you — so it is shining on your subject, not in your lens.

So long as your subject is well lit, and you stick to f/16 at 125, you will produce correctly exposed photographs. That's a promise. Try it.

DOING IT RIGHT

The need for good light brings up another important point: Don't wait till the last minute. For each of your assignments, take the time to locate interesting subjects and to shoot them well. Keep an eye on the weather, and be ready to make use of it when it's good. (Bear in mind that overcast skies, rain and snow can be "good,"

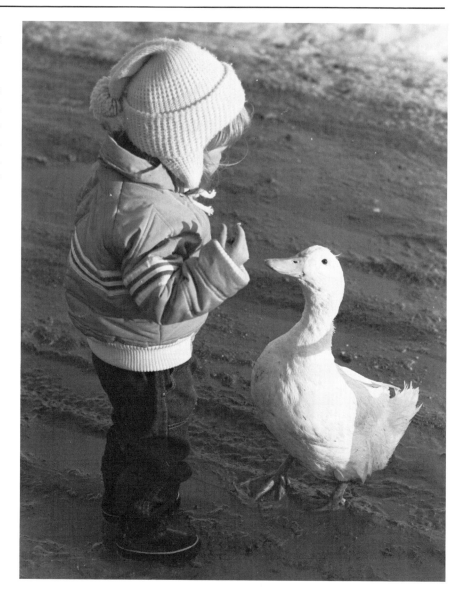

once you've learned how to use them.) Do some exploring before you start shooting. Don't just step into your back yard and grab a few quick shots. Sometimes you will find a great subject there, but even so, give yourself enough time to really see it.

Every time you photograph a subject, try to take several shots of it from several completely different angles. Use your camera to explore the subject, to learn about it, to discover how it interacts with other objects, with light, with space. Never allow yourself to take just one shot and call it quits. Who knows what you might have missed?

Though it is important to reserve time to devote to your photography assignments, try to keep them in mind at other times as well. When you're out walking, shopping in town, travelling — anytime you're doing anything — keep your eyes open for photographic possibilities. Even if you don't have a camera with you, or never go back to make use of those possibilities, it's good practice to look for them. Photography is essentially a way of seeing, a way of sorting through all the images that rush past you every day and noticing the special ones. The more you train yourself to see in this way, the better you'll do when you set out to capture some of those special images on film.

On a more practical level, you'll find that you enjoy your assignments more if you've already compiled a mental list of interesting places to explore with your camera. You may even want to write that list down, so you'll have a ready source of inspiration when you need it. If you do, you won't waste time later wandering around in search of something to photograph.

Great shots are very rarely quick and easy. Usually, they require patience and imagination. The more time you devote to each assignment, the more you will learn — and the better your results will be. There's a special sense of accomplishment that only comes from working slowly, carefully and creatively. Making that your goal, from the very beginning, is well worth the effort.

Finally, as you're shooting each assignment, keep reminding yourself of its theme. It's easy to get so caught up in a subject that you forget to look for line or texture or whatever else the assignment is supposed to be about. While such enthusiasm is commendable, it is important to stick to the themes of the assignments, and to seek out subjects that are specifically appropriate to them. Once you've done that, you can always take a little more time to just shoot whatever interests you.

Student photograph by Jon Ginsberg.

Student photograph by Kenneth Griggs.

There are three basic line effects in this photograph. What are they? (Student photograph by Wendy O'Connel.)

chapter 6

Line

T he "point of departure" camera setting (f/16 at 125 of a second) provides an uncomplicated introduction to the mechanics of photography. We'll now do the same thing with composition. The first subject in photographic theory is, quite simply, line.

PATTERN, STRUCTURE, DIRECTION

You may recall that in geometry a line is a one-dimensional series of points. Several lines are required to define a three-dimensional shape.

You could say that a line is an edge, a border between one thing and another. It can also be the connection between two things, like a clothesline tied between two trees. Straight, curved, bent or zig-zagged, it goes from one place to another.

Understanding lines is one of the primary requirements of photography. Virtually every photograph, of course, has lines in it. Some of these lines do more than merely divide or connect objects. They may also suggest moods and rhythm, create patterns, indicate directions and structure. The various *qualities* of the lines in a photograph combine to produce an overall impression, called **line.**

How do your eyes react to this highly linear shot? Does it hold their interest? If so, why? (Student photograph by Jean Ann Hall.)

Line is not passive. Instead, it is a strong visual force that pulls the viewer's eye around in a picture. Used well, it suggests movement, conveys impact and helps to focus attention on the key points of the composition. Used poorly, it distracts attention and weakens the composition's effect. It may be simple, but is also powerful. It is a bit like electricity. And like electricity, it must be controlled to be useful.

Line may be a subject in itself (as it will be in your first assignment), or it can play a supporting role for another subject. Lines may be connected in a larger pattern or isolated from each other, evenly distributed across the frame in an orderly manner, or scattered at random. A photograph may be dominated by just one line or packed with many. A line need not be "real" to have its effect. Objects of the same height (such as a

How many basic line effects are in this photograph? (Student photograph by Robert Muller.)

How many basic line effects are there in this photograph? Notice how the lampshades and the several open windows add "punctuation" to the overall pattern. (Student photograph by John Pang.)

What "instructions" do these lines give to your eye? How does your eye move around the photograph? Where, if anywhere, does your eye come to rest? (Student photograph by William Roche.)

row of fence posts) and the border between a building and the sky both produce an *implied* line that works just as well.

All of these possibilities boil down to three basic functions: pattern, direction and structure.

As **pattern,** line is often a photograph's primary element. The lines themselves interact in some interesting way that is more important than any other elements within the frame. A photograph of buildings or cornfields or blades of grass is likely to emphasize pattern.

As **direction,** line helps the viewer's eye travel around the picture. Visually, the lines say, "Go here. Look at that. Stop. Move on." A photograph with many different kinds of objects especially needs strong directions to help the viewer understand it. Without directing lines, the overall image can simply seem like chaos (which, of course, may be the photographer's intention).

As **structure,** line divides a photograph into smaller areas, providing a skeleton to support the other elements and link them together. A strongly structured photograph will often seem to be several photographs in one. A photograph of several faces peeking out of windows is one example of this.

Line also conveys movement, or the lack of it. A rigid grid of straight lines tends to make an image appear static, flat, immobile. Lines that converge (that are closer together at one end than at the other) or that shoot off toward the corners of the frame tend to suggest motion. Straight lines suggest the full-speed-ahead motion of a train, or the up-and-down of a piston. Curves tend to suggest movement that is more like dance.

Similarly, lines can increase or

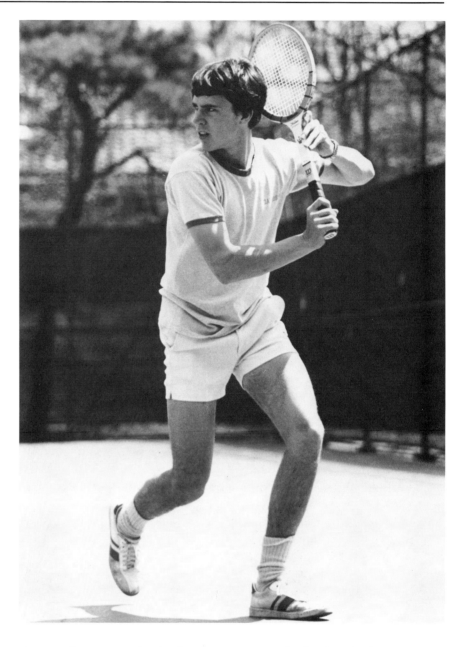

Notice the soft-focus lines behind the tennis player. What instructions do they give to your eye? What effect do they have on the photograph's composition? On its impact? (Student photograph by Jon Portis.)

decrease the apparent depth of an image. If you shoot a flat surface from an angle, the lines in it will be closest together at the point where the subject is furthest away from you. This creates the illusion of three-dimensional space, or depth. If you shoot it straight on, so the lines remain parallel, you reinforce the impression of flatness. You decide which effect you want.

You can even make a round object appear flat by shooting it straight on, right at its exact center, and using a small aperture. Any lines that would normally indicate its roundness will appear straight and flat. This appearance will be strengthened by the extreme depth of field (almost everything in focus) provided by the small aperture.

Finally, different kinds of lines express different moods or emotions. Straight lines tend to seem rigid,

What's the "tune" of this woodpile? (Student photograph by Frank Hall.)

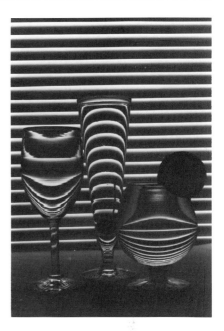

What sort of musical sounds do the bent lines in each of the glasses suggest? What about the background lines? What instrument might play them? (Student photograph by Tyler Smith.)

harsh, intense. Curved lines and circles are more inviting, calm and soothing. Zig-zags seem busy, conveying excitement or confusion. Thick lines seem imposing. Thin ones seem delicate.

To get a sense of how these effects work, look at different kinds of lines and see what sounds and rhythms they suggest to you. What sort of musical instrument or tune reminds you of wavy lines? Zig-zags? Circles? Straight lines in a row? It may seem odd to think of listening to lines, but with a little experimentation you'll probably discover that it comes very naturally. Different kinds of lines do have different characters.

The key point is that lines are expressive tools. As a photographer, you'll need to learn to use them effectively.

Before you can use them, however, you have to find them. Where should you look? Well, just about anywhere. Here's a short list: sidewalks, streets, telephone poles, buildings, bowls, wheels, trees, grass, rivers, forks and spoons, cracks, mountains, pencils, curtains, clothing, hands, arms, chairs, fields, tennis courts, bleachers and jungle-gyms.

Once you start noticing lines, you'll find them everywhere. And that is exactly the point. It is because they *are* everywhere that lines are so fundamental to photography. They are the basic vocabulary of the photographic language.

It may seem odd to think of photography as a language. But that's exactly what it is. Both a sentence and a photograph ought to have a subject. And just as a sentence may have verbs, adverbs, objectives and prepositions, a photograph may have movement, mood, perspective and relation. Understanding line is the first step toward learning to express yourself in the photographic language.

EXERCISE
Pattern

Your assignment is to find and shoot patterns. Any series of lines creates a pattern.

Look above your head, down at the ground, as well as straight ahead. Try to find subjects that are primarily patterns, not just ones that have some pattern in them. So far as possible, have the pattern fill the frame of the photograph. Try to have nothing in the photograph except pattern.

Though your assignment is to shoot pattern, you may want to consider some of the other qualities of line as well, such as direction or structure. See if you can add them into a photograph without losing sight of your primary goal. Use these other qualities to strengthen the pattern, not to detract from it. For example, you may want to use perspective so your pattern recedes into the distance, suggesting direction. Or you may find a series of small patterns contained in a large one, creating structure.

Remember to keep your camera on the point of departure setting (f16 at 1/125 of a second), and to shoot in open sunlight. The rest is up to you.

Student photograph by Allison Page.

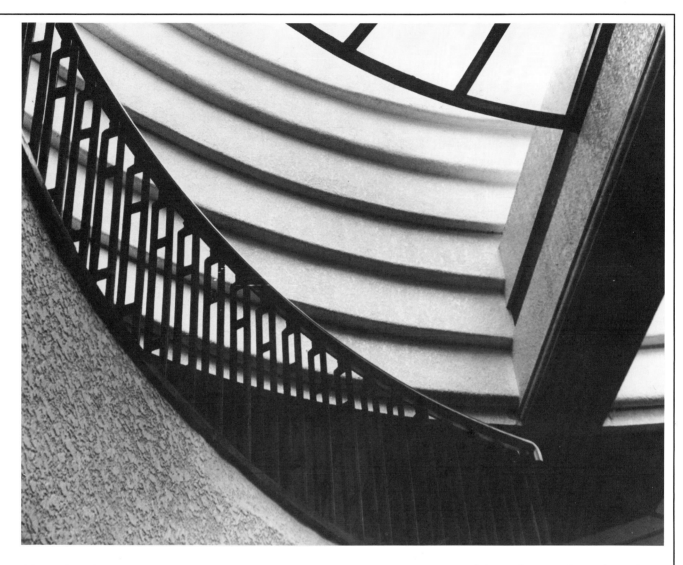

Notice how line (straight lines, waved lines) and pattern create impact in each of these photographs. What other elements contribute? (Student photograph by Han June Bae.)

Can you distinguish line from texture in this shot? (Student photograph by Han June Bae.)

chapter 7 Texture

N ow that you've begun to develop an eye for line, it's time to complicate things a bit by adding **texture.** Actually, you've probably already done this on your own. The photographs you shot for the pattern exercise almost certainly included texture as well. Like line, texture is hard to avoid. Almost everything has some texture: rough or smooth, patterned or irregular, dramatic or subtle.

One thing you'll begin to notice is that the various elements of photography tend to overlap. Though you will be exploring them separately, it is often difficult, even impossible, to separate one element from another. You may not always be able to say, for example, "This is line; that is texture."

Don't worry about this lack of precise categories. The important point is to recognize and understand all the different elements. It is far less important to always be able to tell them apart. Learning to notice them separately, however, will help you learn to combine them effectively.

EXPRESSING THE "FEEL"

Texture mainly concerns the surfaces of things. In the previous section, we saw how line can convey the impression of three-dimensional realism by

Many photographs have more than one "level" of texture. The undulating surface of the cloth is one level of texture. The smaller variations in the weave of the cloth is another. (Student photograph by Evelyn Wight.)

suggesting depth or height. Texture strengthens that impression by providing visual clues to the "feel" of a subject. In a sense, texture enables the eye to "touch" the subject.

A photograph, like a painting, is two-dimensional. It reproduces a three-dimensional image on a flat surface. To break through the limitations of that flat surface, a photog-

rapher, like a painter, has to employ visual "tricks." These tricks create the illusion of three-dimensional space.

Depending on the angle from which you take a photograph, you can use line to represent an object three-dimensionally, or to flatten it. With texture, however, you are always working in three dimensions. Flattened texture is simply pattern,

Student photograph by Marc McCoy.

and pattern is simply a combination of lines.

Look at the photographs of a brick wall on this page. The first thing you're likely to observe is the *pattern* produced by the lines between the bricks. If you look more closely, however, you'll see that the bricks stick out beyond the lines. This creates one kind of *texture*. If you look even more closely, you'll notice variations in the surface of the bricks. That's another texture.

If the wall is evenly lit from the front, the strongest element will be line. The wall will look like a flat surface, divided into a grid pattern. Variations in the surface of the wall will not show as much.

If, however, the wall is lit from one side, the element of texture will be strongest. The most noticeable thing about the wall will be the variations in its surface. The line grid will still be there, of course, but it won't stand out as much.

Once again, you'll notice that line and texture are similar. The difference between them depends primarily on the angle of light.

Texture is far more sensitive than line to shifts in lighting. If you continued to look at that brick wall throughout the day, you would see the texture constantly changing as the sun passed over it. It would be most dramatic early and late in the day, when the sunlight strikes it at a low angle. This has the effect of stretching out all the small shadows created by variations in the surface of the wall. As the shadows get longer and more exaggerated, they appear more dramatic.

One of the most important tasks for a photographer is to observe and make use of changing light. This is especially vital when shooting for

texture.

In addition to enhancing the impression of reality in a photograph, texture adds visual interest. Pure line or pattern can be very impressive, but may fail to hold the viewer's interest. Texture, particularly if it is irregular or complex, gives the viewer's eye more to play with. It creates little nooks and crannies for the eye to explore. It invites the viewer to linger a while and look around. It also provides information about the subject — its age, condition and other qualities.

The photograph of a building on this page is a good example of the different effects produced by line and texture, and of how they can be combined to increase impact. The first thing you're likely to notice about this photograph is the strong lines of the building. As you look more closely, however, your eye will probably be caught by the complex texture of the foreground. Finally, you might notice how the glass distorts the reflection of another building, in the center of the frame.

The first impression, then, is line. The second is texture. The third is shape, which we'll cover in greater depth in the next section. Each provokes a different kind of interest.

As you continue to examine the

Student photograph by Kenneth Griggs.

photograph, your attention may also focus on the small wedge in the lower lefthand corner: line again. By combining several elements, and contrasting two linear effects, the photograph gains interest that would be lost if it had concentrated only on line.

You can test this idea yourself, by covering up the foreground so only the lines are visible. How does that affect your interest in the image? How does it change your impression of the building?

This does not mean that texture necessarily improves a photograph. How you use it, and whether you use it at all, is strictly a personal choice. It is, however, one of your basic tools as a photographer. Learning to notice it is one step toward mastering technique.

Used creatively, texture can provide enough information so that even a very abstract photograph makes perfect sense. Do you have any trouble recognizing the subject of this one? (Student photograph by Lynne Mattieli.)

Texture itself can be an effective subject for a photograph. (Student photograph by Bjorn Goldis.)

Texture can be very effective as a context for another subject. Notice how the highly textured vegetation sets off the shape and the soft fur of the rabbit. (Student photograph by Craig Hurst.)

EXERCISE

Leaves

Your next assignment is to shoot leaves. Not just any leaves, but leaves with texture. As noted previously, it is important to keep the theme of the assignment in mind, as well as the subject.

Look for as many kinds of leaves as you can find. Leaves on trees, or on the ground. Even pine needles are officially acceptable, though they are not strictly leaves.

In order to fulfill the texture requirement, you'll want a good amount of contrast. This means that the leaves should be in open sunlight. Try to do your shooting in the morning or afternoon, not in the middle of the day. That will ensure that the light is striking your leaves at an angle, enhancing their texture. Once again, use the point of departure setting f/16 at 125.

Keep an eye out for interesting effects of light and shadow: one leaf casting a shadow on another, or on the ground or branch beneath it. Finally, unless you're lucky enough to find a single leaf of extraordinary interest, you'll probably do better shooting several together. Notice how they interact with each other and with the frame of the picture. Crop in close enough so there's no wasted space, but don't forget that space can be a useful compositional tool.

Student photograph by David Kleinfelt.

Student photograph by Alexandra Berg.

Student photograph by William Roche.

A series of similar curves, an interesting juxtaposition of two objects (the sunglasses and the BMW hood ornament) and effective use of negative space all lend impact to this simple still life. (Student photograph by Trevor Bredenkamp.)

chapter 8

Shape

In the two previous exercises, you've begun training your eye to see line and texture. Both are vital, but relatively simple, compositional elements. The next one, shape, is more complex. To apply it well, you will have to pay particular attention to the relationships between objects within the frame of each photograph.

You've already done a "test run" on this in the framing exercise. The next step is to take the lessons learned in that exercise and translate them effectively and consistently into actual photographs.

As we've mentioned earlier, the photos you produce in the exercise on shape will probably contain line and texture as well. That's precisely what should be happening. While each element can be effective by itself, it's likely to be most effective in combination with others. The goal of this entire section is to provide compositional "building blocks" that you will assemble in new and interesting ways.

MASS, PROPORTION & RELATION

When we look at something, its shape tells us what it is. There are, of course, other ways of figuring this out—by smell or touch or sound— but shape is the way that is most familiar. If someone asks you to describe something, you would probably start with its shape.

For a photographer, however, shape is something more than a means of recognition. Shape helps convey the *nature* of a subject; not just what it *is,* but what it is *like.* Is it heavy, light, big, small, beautiful, ugly, interesting, plain? Shape answers questions like these. It also answers questions about the way an object interacts with its surroundings: Which object is biggest, closest, most important?

So, the functions of space in a photograph can be grouped into three categories: mass, proportion and relation. **Mass** has to do with the amount of space an object fills up, how big and heavy it is. **Proportion** has to do with how the mass of one object compares to that of another, and how the various parts of a single object "hang together."

Relation is probably the most complicated aspect of space, and the most important. Relation is primarily concerned with how objects interact. This can mean physical factors, such as whether they are close, touching, far apart, similar, different, etc. Interaction between objects can also be extended to include *interpretive* factors, such as which object is more attractive, which is more important, which is dominant, whether they seem to belong together, and so on.

Relation tends to require some degree of judgment. For a relation to be clear, somebody usually has to decide what that relation is. You, as the photographer, for example, may make value judgments. You may decide that object "A" is more attractive or interesting or important than object "B," and you may compose a photograph to indicate that relation. Or someone in your photograph may be making the decision, by looking at an object in a certain way, or touching it, or using it. Even the physical relationships of objects in a photograph often depend on how one is looking at them. Two objects photographed from a distance may appear close together. The same objects shot close up may appear far apart.

Like the relation between two people, the relation between two shapes (called a **spatial relation**) tells us more than just that they happen to be together. It asks us to consider *why* they're together.

Imagine two people you've never seen before, walking into a room. What do you notice about them? What do you want to know? You're likely to observe them first as individuals, noticing each of their faces, clothes, mannerisms, etc. Then

In this high-contrast print, shape is all there is . . . but it's enough. The chair shape is clearly a chair and the person shape is clearly a person's shadow. The spatial relation between the two is also clear. The shapes in the photograph don't just convey information, however, they also convey a mood. This photograph is "about" more than its graphic impact. (Student photograph by Amy Thomas.)

you'll probably start wondering why they're together. If they seem to be an obvious pair, like two businessmen or two athletes, you may not wonder very long. If, on the other hand, you notice something odd about them, you might keep wondering. What if the businessmen were both dressed like circus clowns, or the athletes were singing an opera? Wouldn't your next question be: "What's going on here?"

These are examples of how people tend to respond to seeing odd personal relationships. The same thing holds true for spatial relationships. If two objects are seen together that don't normally *belong* together, they are likely to catch our attention and interest. In addition, they may tell us something—about themselves, about space, about relation—that we didn't know before.

In the best photographs, spatial relations are used to tap us on the shoulder and say "Look, isn't that interesting!" We may be entertained, amused or saddened, but we will have learned something new about the world.

Perhaps the best way to summarize this is to say that spatial relationships (and, therefore, shapes) are rarely without meaning. What that meaning is—and who decides—is an open question. It is perhaps *the* question that photographers are most concerned with answering. You can use your camera to express your own interpretation of objects and events. You can use it simply to explore relationships, without imposing any specific interpretation. You cannot, however, avoid interpretation altogether. As soon as you make the

decision to include one thing and not another, you are interpreting. That's what photography is all about.

USING NEGATIVE SPACE

As mentioned in the chapter on composition, a photograph is simply an image of something within a frame. That thing actually has two shapes. The first is the contours (the outer shape) of the thing itself. The second shape is the effect that those contours have on the surrounding space, including the rectangular box of the frame. This kind of shape is called negative space. For a photographer, it is every bit as important as the first kind of shape.

Think of an apple. In your mind's eye, draw a box around it. Then draw a line around the apple, tracing its contours. Finally, erase the apple, leaving the line. Negative space is what you have left. It is everything except the apple.

In this case, because there's nothing but the apple in the picture, the negative space is everything between the apple and the frame. If there were other objects in the picture, like a banana, the negative space would be everything between the apple and the banana *and* everything between them and the frame.

To make things a little clearer, let's look at an actual picture, the photo-

Notice how the large expanse of negative space in this photograph of a stadium establishes the visual "theme" of semi-circles (semi-ellipses to be precise). How many times is that theme re-stated in the photograph? (Student photograph by Michael Rodgers.)

Student photograph by Michael Grassia.

Negative space can be black (or gray) as well as white. This photograph of a construction site would be very bland without the dramatic angular frame of black space. (Student photograph by Mina Murphy.)

graph of a teakettle. Where's the negative space? If you're not sure, draw an imaginary line around the teakettle and imagine that the teakettle has been erased. Everything else is negative space.

Now, look more closely and pick out areas where the negative space is interesting. You might notice the area between the handle and the top of the kettle. It creates a circular shape that resembles the opening in the teakettle, just below it. This kind of recurring (repeating) shape is often used to create *visual harmony* in a photograph. It makes the photograph interesting because the human eye automatically looks for such similarities.

As you continue to look for shapes and to point them out in critique sessions, you will become increasingly aware of these visual harmonies. Your brain will decide that they are worthy of notice and, as a result, you'll begin to see them directly. Most people only sense visual harmonies vaguely, because they don't need to do more than that. As a photographer, however, your job is to use these and other composition tools, so you must learn to recognize them.

At first you may need to make an effort to train your brain to take note of visual harmonies. The way to do this is to ask yourself questions. For example, how many circular shapes do you see in the photograph? There are at least five. Can you pick out all of them?

What other areas of negative space are interesting in the teakettle photograph? Look at the tip of the spout. Notice how it almost touches the

frame of the photograph. Like visual harmonies, this also generates visual interest. Anytime an object comes near another or comes near the frame of a photograph, it creates visual tension. It's almost as if the object is pressing against the space between. Oddly enough, the tension is strongest when objects almost, but don't quite, touch. Michelangelo's painting of the hand of God reaching out to the hand of Adam is a famous example of this effect. The effect would be weakened if their fingertips actually met.

Where else in the teakettle photograph is a similar effect achieved?

Now, what about the rest of the negative space? You may notice that the sides and bottom of the teakettle (not counting the spout) are all just about the same distance from the edge of the frame. What effect does this produce?

If you're not sure, take a moment

to study it. Compare it to the effect of the protruding spout. The spout creates tension. The placement of the teakettle within the frame has the opposite effect. It centers the teakettle. This conveys a static sensation. The teakettle "feels" like it is sitting very solidly on the ground. It appears to be firmly placed, or grounded, within the frame.

If you've been looking closely, you might have observed that the top of the handle is also about the same distance from the frame as the bottom and sides are. This increases the sense of stability.

The main part of the teakettle is closer to the bottom of the photograph than it is to the top. It is weighted toward the bottom. Once again, this reinforces the sense of stability. If it were weighted toward the top, it would appear "top heavy," and would tend to convey the impression that it might roll right out of the

As with line and texture, a photograph can simply be "about" shape. Here, a nicely balanced series of irregular shapes creates a satisfying landscape. (Student photograph by Mark Pry.)

frame. In this case, weighting toward the bottom helps to promote the impression of realism. The teakettle looks like it "should" look, and the tension produced by the spout adds vitality and, therefore, interest.

Welcome to the world of negative space. Learn to use it effectively and you'll be well on your way to mastering photography.

One more thing should be said at this point. In order to explain compositional elements like shape and negative space, we are discussing them as if a photographer must be *objectively* (consciously) aware of them before taking a photograph. Photography may seem like some kind of visual mathematics. You may

suspect that a photographer goes around measuring everything and making all sorts of mental diagrams before taking any pictures. In practice, most photographers work far more *subjectively* (relying on intuition). Once they understand the various elements of composition, they stop thinking about them. They see a subject and intuitively arrange the elements into an effective image.

In essence, the purpose of discussing these elements objectively is to train your intuition. Once that is accomplished, you will be free to shoot what you see without a lot of calculation. The math will become automatic. You won't have to think too much about it, because you'll feel it.

Developing that inner sense of proportion and relation is one of the keys to learning to see as a photographer. Don't worry if it takes awhile. It will come to you if you just keep at it.

Before we leave the teakettle photograph behind, take a minute to notice how line and texture work in it. As indicated above, elements can be combined to produce an effect that is greater than the sum of its parts. For line, look at the step behind the teakettle. Notice the corner of the doorway above it and the subtle lines of the bricks below. For texture, look at the surface of the teakettle, the step, the ground, the wall, the grip of the handle. What effects do these elements have on the

whole image? What do they tell you about the objects? How do they work together?

Now let's get back to the usual meaning of shape—the contours of objects. In the discussion of the teakettle photograph you may have noticed that circles kept showing up. As you probably know, a circle is one of several basic shapes. Others include squares and triangles, plus a variety of polygons (which literally means "many sided shapes"). Then there are the less regular shapes, from oblongs to "blobs."

In certain cases, the negative space can be larger than the subject of a photo without losing its impact. While the wall behind this woman has some texture to it, it functions essentially as negative space, surrounding her and providing a dramatic setting that seems fully appropriate. (Student photograph.)

EXERCISE
Circles & Ovals

Use at least one roll of film to shoot *only* circles and ovals. You may have other shapes in the photographs as well, but be sure that each frame is dominated by one or more circular shapes. You may want to set up some of the shots (try experimenting with a cup and saucer, with spoons, plates or bowls), but at least half of your shots should be of "found" circles or ellipses (i.e. ones that you just happen to see in your yard, neighborhood or town).

Try to find a variety of compositions using circles or ovals. Try some with just one circular shape, some with lots and some with a few. Try some shots in which one or more circular shapes interact with squares or other shapes. Shoot in bright sunlight at the point of departure setting.

Keep in mind the various functions of shape and spatial relation as you do this assignment. Without losing sight of your primary theme (circles and ovals), see if you can use shape to indicate mass, such as the "bigness" of a pumpkin or a boulder. Try to produce interesting examples of proportion and compelling spatial relations. In addition, try to come up with a few shots that express what you think or feel about a subject.

All these shapes are available to you as a photographer, just as they are available to any artist. You just have to find them.

This is not as hard as it may sound. Once you begin keeping an eye out for interesting shapes, you'll probably be amazed at how many are out there, just waiting for you to capture them on film.

Start by looking for individual shapes. Then pay attention to how

Student photograph by Scott Olson.

those shapes may repeat themselves and establish visual harmonies. Finally, allow interpretations to emerge as you experiment with different compositions, different combinations of objects, different viewing angles. Allow space and spatial relation to tell you something about your subjects . . . and then try to pass that "something" on to others through your photographs.

Don't be at all surprised if the

"something" that you learn and want to pass on can't be expressed in words. If it could be, you could just say it or write about it, and you wouldn't need to photograph it. The best photographs present an image or idea or feeling in a way that only a photograph can. Strive to notice those things that *need* to be photographed, rather than spending time on those that simply *can* be.

Student photograph by Charles Gibbs.

(Student photograph by John Pang.)

Student photograph by Bruce Cakebread.

Y ou don't really have much control over the compositional elements we've discussed so far: line, texture and shape. For the most part, they're just "out there" in the world, waiting for you to notice them. You can change their positions within the frame of your viewfinder, by moving forward or back, or to one side or the other. You can make one element more dominant than the others, and you can edit out distractions. Outside of that, however, you don't generally have any real control over them.

The next three elements (light, motion and perspective) are more "interactive"—they allow (and may require) more choice on your part. They are, of course, also "out there" waiting for you, just like line, texture and shape. But there's an important difference.

You can choose whether to accept the light that's "given" to you—or you can change it. You can, if you choose, make daylight look like midnight, and vice versa. More subtly, you can choose whether an object that's in shadow will simply be darker than its surroundings or utterly invisible. In fact, you have to choose. Following the recommendation of your light meter is a choice, especially since you must decide what source of light the meter is reading.

The soft, indirect light of open shade is more subtle and moody than straight sunlight. It tends to convey a pleasant, rather dreamy, thoughtful or wistful quality. This is the sort of neutral gray tone a light meter assumes you want. (Student photograph.)

CONTROLLING EXPOSURE

You have now used the "point of departure" setting for several photo assignments. If you've followed instructions carefully, you should already be producing consistently good results. It has probably occurred to you, however, that you can't count on the sun to provide enough light for this setting to be correct all the time. You may already

have missed some good shots because the light wasn't bright enough. It's time to start putting your camera's aperture ring to work.

Before we do that, we'll need to review shutter speed as well, to gain an understanding of how aperture and shutter speed work together.

Set your camera at the point of departure setting. Your aperture ring will be on f/16, and your shutter speed dial will be set at 125.

Change the aperture setting to

Bright sunlight is best suited to cheerful "ordinary life" photographs . . . though it can be used to suggest that ordinary life is pretty strange. (Student photograph by Dick Waghorne.)

f/11. You have just doubled the amount of light that would enter the camera if you clicked the shutter. Remember that increasing the aperture by one "stop" always doubles the size of the lens opening. (Also remember that a lower number indicates a larger opening.)

Now change the shutter speed to 250. Since 1/250 of a second is half as much time as 1/125, the amount of light reaching the film has just been cut in half. So you're back at the point of departure exposure again. In other words, so far as the amount of light is concerned, f/11 at 250 will produce the same exposure as f/16 at 125.

These two settings will *not* produce exactly the same photograph. Both

time you moved from one aperture to another. If so, the first click indicates a **half-stop,** a lens opening halfway between two standard apertures.

If, for example, you started at f/16 at 125 and opened the lens half a stop, you would be letting 50 percent more light into the camera. The resulting photograph would be lighter, but not twice as light. Half-stops are very useful for fine tuning an exposure.

the depth of field and the visible motion in the photograph will be slightly different, as will be explained later on. The amount of light in each photograph, however, *will* be the same.

Set your camera on the point of departure setting again: f/16 at 125. Now change your shutter speed to 500. What aperture will give you an exposure that matches f/16 at 125? Adjust the aperture ring to this f-stop.

What aperture will give you twice as much light as f/16 at 125? Again,

adjust the aperture ring to this f-stop.

What aperture will give you half as much light as f/16 at 125? If you've ended up with your aperture ring at f/11 (with your shutter speed still at 500), then you're getting the idea. An aperture of f/8 and a shutter speed of 1/500 of a second will match f/16 at 125. An aperture of f/5.6 at 500 will give twice as much light, and f/11 will give half as much.

As you've been going through this exercise, you may have noticed that the aperture ring clicked twice every

An unlighted subject against a light background produces a very graphic silhouette. With luck and skill, the shape of the figure will convey all the basic information needed to make sense of the image. (Student photograph by Mark Bissel.)

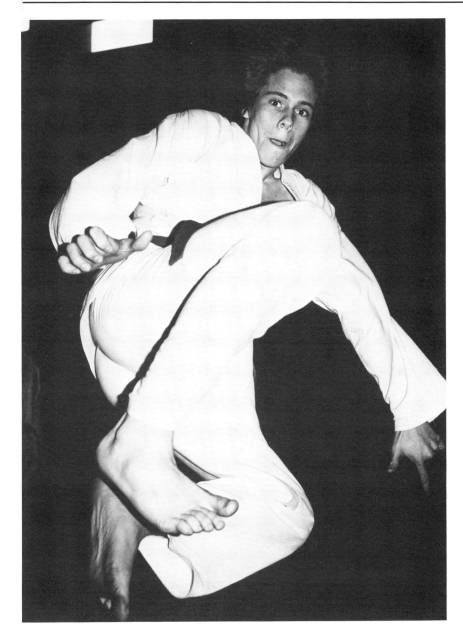

A well-lit subject conveys additional information—in this case, primarily facial expression and three-dimensional shape. (Student photograph by Melanie Fernandez.)

INFORMATION & MOOD

By now you know that light is what makes a photograph possible. Without light bouncing off of objects and into your lens, you wouldn't be able to photograph anything—or see anything. Beyond this, though, light has two primary photographic functions: It provides information and it influences mood.

Information is facts. Your eyes convey facts to your brain, which the brain then translates into understanding. "That is a building." "That is a person." "The person looks larger than the building." "Aha!" says the brain. "The person is standing in front of the building." That, more or less, is how visual information works.

But it gets more complicated than that. Variations in brightness and shadow, the intensity of textures, the way in which shading may exaggerate shape, and other factors all contribute to our visual perceptions of things. And they are all influenced by light.

For example, compare the two photographs of a person kicking at the camera. The first is a **silhouette.** Because there is far less light on the subject than on the background, the subject appears black. How much information does the photograph provide about the person in it?

Now look at the second "kick" photograph. How much information does this photograph provide? As you can see, the two photographs are similar in content and composition— but very different in lighting.

In extreme cases, light may determine whether a photograph is confusing or clear. More commonly, the way you handle light may make the difference between immediate and delayed recognition of what some-

Low-light tends to be very somber, even sinister. It is difficult to use, since the subject must be placed in exactly the right spot in order to be visible. Used well, however, it can be highly dramatic. (Student photograph by Chris Jacobs.)

thing is or what it means. This, in turn, may make the difference between a strong emotional response or none, between sustained interest or boredom.

Mood is another vital ingredient provided by light. We tend to respond to lighting in much the same way as we respond to weather. Bright light, like a sunny day, tends to make us feel cheerful, relaxed. If the light is harsh, however, as it is on a bright hazy day, the mood will tend to be stark and unfriendly. Soft light, like mist, tends to make us nostalgic, wistful, dreamy. Darkness, like night or an approaching storm, makes us feel worried, frightened, serious.

You can use these natural reactions to heighten the effect of a photograph. By filling a photograph with a lot of darkness and shadows, you'll increase the impact of such "dark" emotions as fear and foreboding. By filling it with bright light, you'll increase the sense of well-being.

Sometimes, however, you'll want contradictions in your photographs: a sad face or scene in bright light, or a cheerful one in shadows. This is another way that light can be useful, by "playing against" the prevailing tone of a subject. Though such contradictory impressions may create confusion, if they are handled well that confusion itself will be interesting. The viewer will want to figure out what's going on.

To apply light effectively you must keep information and mood in bal-

ance with each other. If you concentrate too much on information and choose lighting that is bright throughout the frame, your photograph may lack emotional impact.

On the other hand, it is equally possible to emphasize mood so much that the photograph loses its ability to convey information. You've probably seen photographs in which, for example, people's faces are lost in shadow. It may be moody, but it also

tends to be annoying.

Fortunately, you have two chances to modify the light in a photograph: when you shoot it and when you print it. While you're shooting, you may choose an exposure that is based on either the highlights (brightest areas) or shadows (darkest areas), or for a mid-range of grays ("average" areas).

Imagine that you are photographing someone who's wearing a white shirt and a dark jacket. If you expose

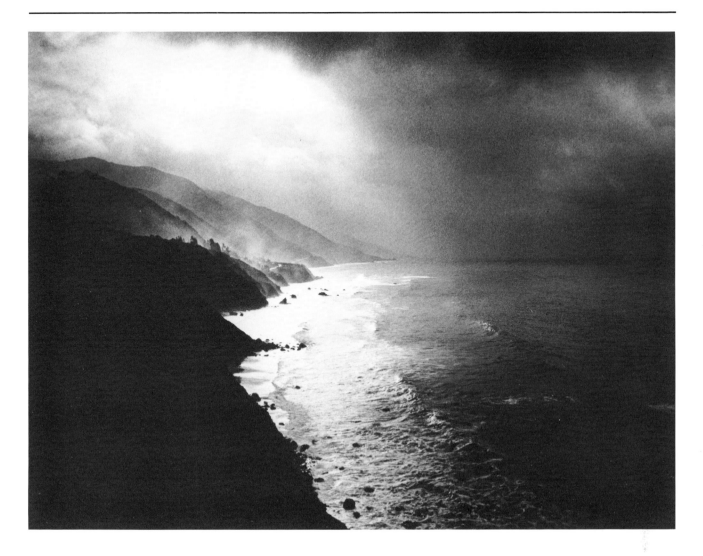

By intentionally reducing the light entering the camera, dramatic climatic effects can be enhanced, adding mood and impact. (Student photograph.)

for the highlights, then all the details in the white shirt will be clear, but some shadow detail—such as the texture of the jacket—may be lost. If, on the other hand, you expose for the shadows, the jacket will look great, but the white shirt may disappear.

The reason for this is **film latitude.** Every kind of film is sensitive to a specific range of light. Very few films can handle all the variations in lighting that our eyes can see. In black-and-white photography, this limitation is most evident when you're trying to capture a wide range

of grays. If the lightest and darkest grays are so different in value that they exceed the film's range, or latitude, then you have to compromise. (Review value, if necessary, in Chapter 4.)

This is where the second chance to modify light comes in. When you shoot the photograph, you can choose to stress one part of the value range. Then, when you print it, you can re-adjust the balance—but only to a certain extent. If certain information (such as the texture of the shirt or jacket) did not get recorded

by the film, there's nothing you can do to bring it back.

The safest approach to exposure, therefore, is to aim for the middle: **average gray.** This is exactly what a light meter does. Any light meter, whether built into a camera or hand-held, assumes that the average light in any scene is predominantly gray. (Note: If you're using a hand-held light meter, refer to the Appendix. The rest of this section deals with in-camera meters.)

FOCAL POINT: Light Meters

If your camera is less than 15 years old, then you will almost certainly be using a light meter that is built into your camera (internal). If your camera is not equipped with a built-in meter, then you will need to use a hand-held model.

Depending on the brand and model, you may be informed of the light reading by a needle that moves up and down, a series of lights, or a numerical display showing the current recommended aperture. With only a little practice, you should be able to respond to your camera's light meter and achieve the effect you want quickly and accurately.

Before you can do this, however, you'll need to know what the light meter is actually trying to tell you. A light meter may "read" either **incident** or **reflected** light. Incident light is the light that is generally available in a given lighting situation. Imagine, for example, a black cat sitting in a white chair in an evenly lit room. The incident light reading will be the same for both. That means the amount of light on the cat is the same as the amount on the chair. Reflected light is the light that actually enters the camera. This is the light that is *reflected* by a given subject. If your meter is measuring reflected light, it will give a much higher reading for the white chair than for the black cat. This is because the chair, being brighter, will reflect far more light.

Light meters that are built into cameras measure only reflected light—the light that enters the camera's lens. There are two kinds of reflectance meters: averaging meters and spot meters. An averaging meter gives you the average light reading

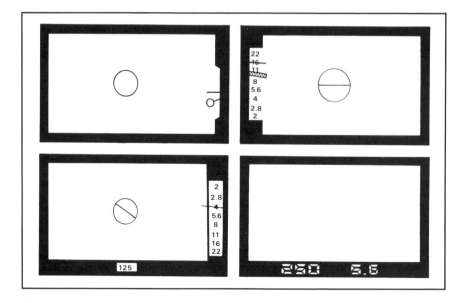

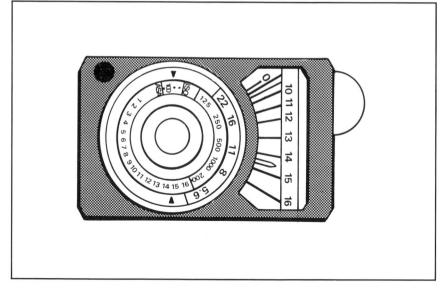

for a large area. A spot meter focuses in on a small area. Some cameras are equipped with a switch that lets you choose either kind of meter. Most, however, compromise by giving you a "center-weighted average" reading. This means that the light meter averages the light throughout the image area, but pays special attention to the center of the frame. (The center is often indicated by a circle of some kind.) If the image area is generally bright, but dark at the center of the frame, a center-weighted averaging meter will indicate a larger aperture than an ordinary averaging meter would. If you aimed a spot meter at the dark area at the center of the frame, the reading would be lower still.

Most of the time, an averaging meter works adequately, since high-

lights and shadows tend to balance each other out. A center-weighted meter usually works better, because the main subject tends to be near the center of the frame. A spot meter can be very useful, however, when you are photographing a scene in which the light is quite different in different parts of the picture. It can be especially useful when large areas of the picture are either very bright or very dark. When the sun is behind your subject, for example, making the sky very bright and leaving your subject in shadow, you will need to make a spot reading of the subject to be sure that it is correctly exposed.

Fortunately, there's an easy way to do this, even without a spot-meter. Simply move close enough so your subject fills most of the frame. Then step back and compose your shot, setting the exposure as indicated by your close-up reading. Some cameras permit you to "lock" the exposure where you want it by pressing a special button. When you use this technique, be sure that you don't create any shadows on your subject when you move in for the close-up reading.

Hand-held meters read both reflected and incident light. For the reflected light reading, you aim the meter's lens at your subject, just as you would with a built-in meter. For the incident reading, you place a translucent cover over the meter's lens, stand near your subject and aim the meter toward your camera or toward the light source. If you're shooting outdoors in even light (either all sunny or all cloudy, for example), you can obtain an all-purpose average reading by taking an incident reading from the sun.

Hand-held meters have one additional advantage. If you attempt to take any photographs in very low light (at night, for example), you may discover that your camera's light meter doesn't work at all shutter speeds. It may shut off when you get down to 1/8 of a second, perhaps, or 2 seconds. A decent hand-held meter, by contrast, will give you a reading for shutter speeds of 4 minutes or more (depending on the ISO of your film).

One final point: as noted in this chapter, reflectance light meters assume that your subject is neutral gray in tone. If you want to photograph a subject that is brighter overall (such as a snowy field) or darker overall (such as a black cat), you'll need to change the aperture accordingly. If you don't, both the snowy field and the black cat will turn out gray . . . which is probably not what you want. For the snow scene, you'll need to use a larger aperture than indicated, and for the cat you'll need to use a smaller one.

USING A LIGHT METER

The specific gray that a light meter assumes you want is one that reflects only about 18% of the light it receives from the sun. (Pure white reflects close to 100%; pure black close to 0%.) This figure—"18% gray"—has been scientifically calculated to represent average lighting for most scenes.

So, if the average light reaching the light meter is darker than an 18% gray, the light meter will recommend a larger aperture or a slower shutter speed, to let more light in. If the average light reaching the meter is brighter than an 18% gray, the meter will call for a smaller aperture or faster speed, to let less light in.

Nine times out of ten, this is precisely the kind of advice you want. The light meter will recommend the camera setting you'd choose yourself, if you took the time to figure it out.

Ah, but what about that one time out of ten when the light meter's advice is *not* what you want? Suppose you're photographing someone who is standing between you and the sun. Because the sunlight is coming right at you, it is very bright. Unless the person is filling up most of the frame, your light meter will react to the bright sunlight and urge you to select a very small aperture or a very fast speed. What will it do to your photograph?

By letting only a little light into the camera (just enough so the sunlight shows up as a nice gray), the person you intended to photograph will look like a black blob. This is probably not the effect you hoped for.

Here's another example: You're photographing a black cat on a black

couch. The average light in the scene is quite a bit darker than an 18% gray. Your light meter will tell you to use a very large aperture, or a slow shutter speed, or both. The result? A washed-out looking gray cat on a gray couch.

None of this means that a light meter is a bad thing. A light meter is a great tool. Its primary drawback is that it wants to make everything gray. Knowing this can help you use it more effectively. If you're shooting under tricky lighting conditions (any conditions in which precision is important), take a meter reading off something that is close to an 18% gray, and set your camera accordingly. Your blacks will be black, and your whites will be white. If you want to make the photograph darker or lighter than "normal," you can then adjust your aperture or shutter speed accordingly. If, for example, you decide that you'd like the whole scene to appear darker than it actually is, you can take a reading for an 18% gray and then decrease the aperture by one or two stops.

Fine, but how are you supposed to find a sample of 18% gray when you need it? You can buy a **18% gray card** that is scientifically produced to be exactly 18% gray. Or you can use the gray card you already have: the palm of your hand. Whether you're black, white, hispanic or oriental, you can obtain an acceptably accurate midrange reading simply by holding the palm of your hand in the light and aiming a meter at it.

When you do this, be sure that the lighting on your palm is the same as the lighting on the subject of your photograph. Your hand should be held so that the light strikes your palm at the same angle as it strikes

By metering off the subject's face, rather than averaging the entire scene, a rich black context was produced for this striking portrait. (Student photograph.)

your subject. Don't let the camera cast a shadow on your palm. Also be sure to hold your camera close enough to ensure that other light is not confusing the reading. Most modern cameras have **center-weighted averaging** meters. This means that they read light from several points around the image area, but give more importance to the

reading at the center. Therefore, your palm should fill most of the image area, and should especially cover the center.

(Note: To increase the precision of your "palm readings," compare them to readings from a gray card. Place it in open shade and take a light meter reading from it. Be sure that the card fills your view-finder. Then

Shadows, produced by angled light, help to "anchor" objects solidly as well as adding visual interest. (Student photograph by Joshua Noble.)

take a reading from your palm in the same light. The difference between the two readings indicates how far your palm varies from an 18% gray. You should add or subtract this amount whenever you take a reading off your palm. For example, if the gray card reading was f/5.6 and the reading for your palm was f/4, then you should always open your lens up one stop more than indicated by a "palm reading.")

There are more sophisticated theories and techniques for obtaining ideal lighting, but this one is certainly the easiest. Most of the time, it'll do just fine.

Another common way to avoid the pitfalls of a faulty light reading is called **bracketing.** When you bracket a shot, you shoot several frames at different exposures. By doing this, you are simply improving the chances of getting a correctly exposed image. If, for example, your light meter called for f/8 at 125, you might bracket by shooting one frame at that setting, plus one at f/5.6 and one at f/11. Or you might shoot five frames within that three-stop range, using the half-stop settings on your aperture ring. You can also bracket by adjusting the shutter speed. For example, f/8 at 60, 125 and 250.

OTHER FUNCTIONS OF LIGHT

Light has some additional functions that it shares with other compositional elements. Like line, light can

promote rhythm. Alternating bands of light and shadow, for example, or isolated spots of light surrounded by darkness may create very strong and interesting visual rhythms.

Similarly, light and shadow can reproduce or enhance many of the effects of shape. Even a small object can appear quite massive if it produces a large shadow.

In addition, the shadow of an object often indicates how that object relates to its environment. Test this yourself. Close one eye and look down at your foot. (By closing one eye, you're losing depth perception, and seeing things the way the camera sees them.) Now lift your foot off the floor. Can you convince yourself that it is still touching the floor? If you can't, it's probably because the shadow cast by your foot is providing clear relational information: it is showing you the relative positions of your foot and the floor.

Try this in several lighting situations, viewing your lifted foot from several angles. (You can alter the lighting without moving by using a notebook to shade your whole foot.) Experiment until your foot looks like it is still touching the floor. Then continue experimenting until no amount of imagination can fool you—until the relation between your foot and the floor is unmistakable.

DEPTH OF FIELD

There's one other way that light affects relation: depth of field. As we discussed in Chapter 2, depth of field is the range of distance that is in acceptable focus at one time. If you have small, or "narrow," depth of field, whatever you have focused on (the **focal point**) may be the only thing in focus. If, instead, you have

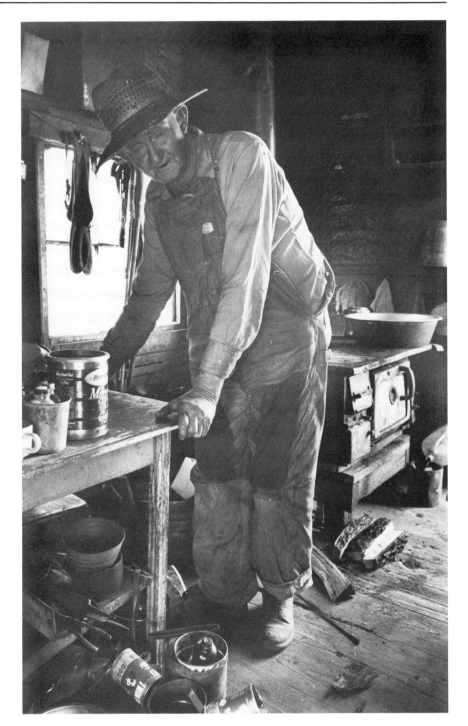

The depth of field in this photograph is sufficient to provide a clear visual context for the elderly farmer. Notice how the old tin cans in the foreground and the woodstove in the background contribute to the photograph's effectiveness. (Student photograph by Robert Lewis.)

FOCAL POINT: Depth of Field

To understand how depth of field works, it is important to understand how focusing works. What determines whether or not a subject is clearly focused?

Let's say you're photographing an apple. Rays of light from the sun are constantly bouncing off that apple in all directions. When you click the shutter of your camera, you allow some of those rays to travel through the lens to the film inside the camera. The rays of light react with the film to produce an image of the apple composed of a series of "points"— or dots of light. Ideally, a point of light striking the apple would reproduce as an identical point of light on the film. In reality, it is more of a circle. If this circle is 1/200 of an inch in diameter, it will appear to be a sharply focused point to the human eye. If most of the circles that make up the image of an apple are larger than that, the image will appear fuzzy.

When you focus the lens, you are increasing and decreasing the size of these circles on the film plane. Light from one point of the apple spreads out to fill the lens and then tapers back to a point (see diagram), making the shape of a cone. When the subject is in focus, the tip of that cone is right at the film plane. When the subject is out of focus, the cone comes to a point in front of or behind the film plane.

Now, how does depth of field fit in with all this? Since the light spreads to the edges of the lens opening, the base of the cone of light is as wide as the aperture. The width of the base of the cone determines the angle at which the light will travel toward the film plane. If the aperture is large, the light will come to a point more gradually than it will if the aperture is small. The same degree of error in focus will produce a more out-of-focus image with the large aperture because the circle produced by each

point of unfocused light will be larger. With the smallest apertures, a considerable range of focal error will still convey a crisp image. If you examine the diagram carefully, you'll see how narrowing the cone of light produces this result.

So, if you have focused accurately on the apple and are using a small aperture, the cone of light will probably be narrow enough for the banana behind the apple and the orange in front of it to also appear to be in focus. If you are using a large aperture, both the banana and the orange are likely to be represented by oversized circles and, therefore, to appear fuzzy.

That, in essence, is how depth of field works. (Aren't you glad you asked?)

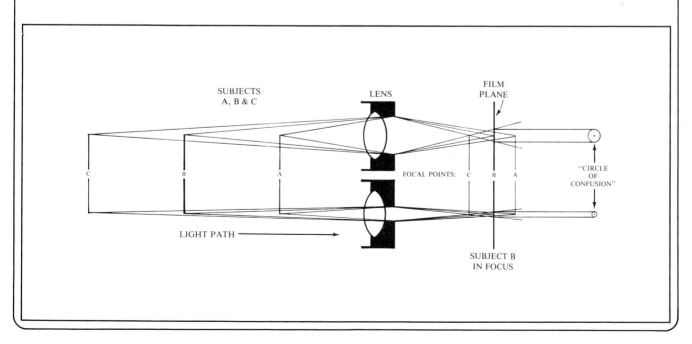

long, or "wide," depth of field, then objects behind and in front of the focal point will also be in focus.

Depth of field is primarily determined by two factors: the aperture and the focal length of the lens. Since aperture concerns light, we'll deal with its effect on depth of field in this section. Focal length is discussed in more detail in Chapter 11.

For now, just bear in mind that depth of field decreases as focal length increases. In other words, if you set a 50mm and a 100mm lens at the same aperture and focus them on a subject at the same distance, the depth of field will be greater with the 50mm lens. Objects in the foreground and background will be in focus for the 50mm lens that are out of focus for the 100mm lens.

Aperture, as you'll recall, is the size of the opening through which light enters the camera. A smaller aperture, like a shorter lens, increases depth of field. For a partial explanation of why this is so, consult "Focal Point: Depth of Field." Fortunately, you don't really need to understand the reasons for this fact in order to make use of it.

With a small aperture, therefore, the range of *acceptable* focus will extend beyond whatever is in *precise* focus. Only one exact distance will be 100% focused. (This distance is called the focal point.) However, objects in the foreground and background will seem to be in focus as well. As the aperture of the lens *increases,* this range of acceptable focus (depth of field) *decreases.*

The distance between the focal point and the camera also affects depth of field. The greater this distance is, the greater the depth of field will be. For example, a standard 50mm lens set at f/8 and focused at

6 feet will have a depth of field from 5 to 7 feet. The same lens at the same aperture, focused at 20 feet, will also have a depth of field from 10 to 30 feet. In the first case, relatively close to the camera, the depth of field extends only 2 feet. In the second case, at a greater distance, it extends 20 feet. If you focus on something 2 feet away, the depth of field will only be about 1 inch.

You may, of course, *want* less depth of field. This brings us to how depth of field "works" in a photograph.

Two objects in a photograph that are both in focus will seem close together, because that's the way you're used to seeing things. Your eyes provide you with very selective focusing, so two objects that aren't close together are not both in focus at the same time. Your brain expects a photograph to work the same way.

Depth of field, therefore, can do two useful things in a photograph. First, it can convey the impression of depth. As you may recall, a photograph is a two-dimensional image of three-dimensional objects. It needs all the help it can get to *seem* three-dimensional. By reproducing some objects in focus and some out of focus (imitating normal vision), depth of field helps to create the illusion of a three-dimensional image.

Depth of field can also tell the eye where to look, and help it tell different objects apart. You've probably seen photographs in which a tree seems to be growing out of someone's head. That's one common result of too much depth of field.

Used creatively, limited depth of field helps to single out one object or one part of an object. The viewer's eye automatically aims for what is in focus. If that also happens to be the primary subject of the photograph — the thing the photographer *wanted* us all to notice — then the photograph is likely to attract interest and attention.

Too much depth of field can have another undesirable effect. By bringing too many images to the viewer's attention, the emotional or aesthetic impact of the primary subject may be watered down or destroyed. Instead of concentrating on one subject, the eye will get busy checking out all the others.

Sometimes, of course, that's precisely the response you want. A photograph of a bustling city, for example, may best capture the bustle by having many details in focus. With a photograph of a single rosebud, on the other hand, you'll probably want to be more selective.

EXERCISE

Bracketing

Select a subject with a wide range of values—from black through various grays to white—and shoot it several times, at one shutter speed, but several apertures.

Before shooting, take a light reading of some part of the subject that is in the mid-range of grays (or meter off your palm).

Shoot one frame at the setting recommended by your meter, then shoot another at each f-stop above it, while keeping the same shutter speed.

Then shoot one frame at each f-stop below the one selected by the light meter.

For the most interesting range of lighting effects, try to shoot in lighting that is just a bit less than broad daylight. Your meter reading should be around f/8 at a shutter speed between 250 and 60.

You should produce at least two different exposures of a single subject to be critiqued. However, you may want to try the same procedure on several subjects to find one that produces the most interesting variations. If you use only one subject, try to find several angles to shoot it from, so you can compare effects. Different angles will produce the most variety when the subject is dramatically lit. This means that your subject needs to receive some direct light, and that you'll want to shoot early or late in the day.

Student photographs by Marc McCoy.

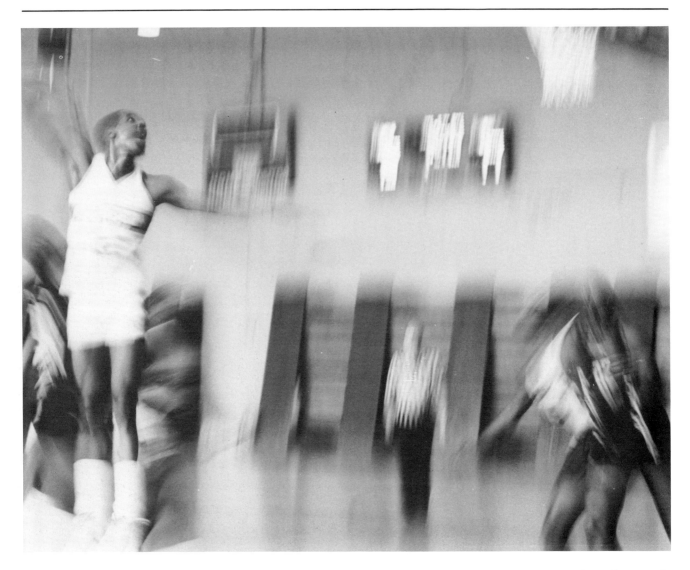

A skillfully handled blurred motion shot can convey a sense of being caught up in the action. (Student photograph by Sheri Allen.)

chapter 10 # Motion

Just as variations in depth of field can make a photograph look more or less three-dimensional, motion can be used to assert or disguise the fact that a photograph captures only a tiny slice of time. Allowing a moving subject to blur during an exposure "stretches" time a bit, emphasizing the subject's movement. "Freezing" the subject emphasizes the camera's ability to "grab" an instant of time and hold it still. Each approach can be very effective. Neither is exactly lifelike, however, because your eyes record movement as a series of instants (the way a motion picture does).

THE SCIENCE OF BLURS

An object in a photograph will appear blurred if it moves while the shutter is open. If the object moves across only a very small portion of the image area, it will seem only slightly blurred. If it moves over a large portion, it will blur considerably.

How far an object moves through the image area depends on three things: its speed, the speed of the shutter, and the angle of view.

The **angle of view** can be imagined as a triangular or funnel-shaped wedge extending from inside the camera out into space. The edges of

A limited amount of blur can add sparkle to a simple gesture, making a photograph more lively and expressive. (Student photograph by Sonja Gray.)

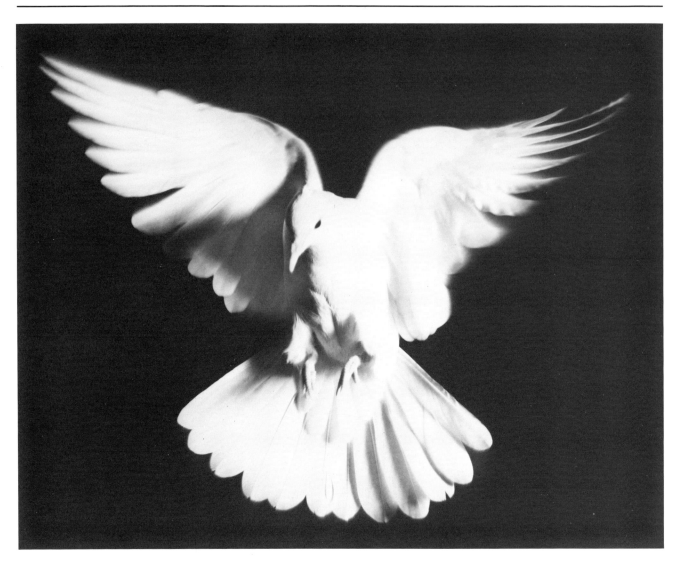

A fast shutter speed (or flash) will "freeze" a subject. Some flash set-ups can even freeze a bullet in mid-flight. In this photograph of a dove, the wings are allowed to blur just enough to suggest movement. (Student photograph by Darrel Miers.)

this wedge are the boundaries of the camera's "sight." Whatever is inside the boundaries will show up on the film. Whatever is outside won't.

The longer a lens is, the smaller its angle of view will be. (This will be explained in more detail in the next chapter, when we discuss perspective and interchangeable lenses.) If a lens has a narrow angle of view, an object won't have to move very far to create a blur.

The reason for this is that a lens with a narrow angle of view—a 200mm telephoto, for instance—selects only a small part of the total image in front of it. It effectively crops in on a small fraction of the total scene, just as you might do when editing a print. The narrow angle of view enlarges that fraction to fill the image area.

Let's say you're photographing a car driving along a road that crosses your field of view. A 200mm lens might cover only a few feet of the

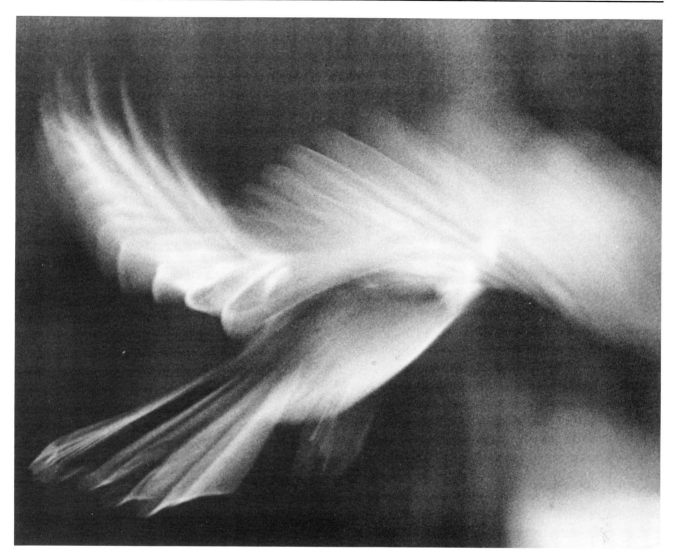

Is this bird photograph less "correct" than the previous one? It all depends on what you want to convey. Allowing a subject to blur almost to the point of becoming unrecognizable can be a very effective way of conveying movement. It generally takes several trial-and-error shots to get it just right. (Student photograph by Cheryl Plumb.)

road. In 1/60 of second, the car might move 10% of the distance from one side of the frame to the other. This would be enough to produce a very obvious blur when the photograph was enlarged.

If a lens has a large angle of view—such as a 28mm wide angle—much more of the road will fit into the image area. That same car, shot at the same shutter speed, at the same distance, moving at the same speed, would cross only a tiny fraction of the field of view, perhaps 1%. It will therefore produce virtually no blur at all.

The same principles apply to the distance between the camera and the object being photographed. If the camera is very close to the object, any movement of the object will cover a fairly large area of the image area at a moderate shutter speed. A visible blur will result. If, instead, the object is relatively far from the camera, and the same lens and shutter speed are used, the movement will cover a smaller area and be less visible.

You can also control the amount of image area affected by a moving object by increasing the shutter speed. Quite simply, the faster your shutter speed, the less time an object has to move. If the shutter is fast enough, even an object that is moving very quickly will seem to be stand-

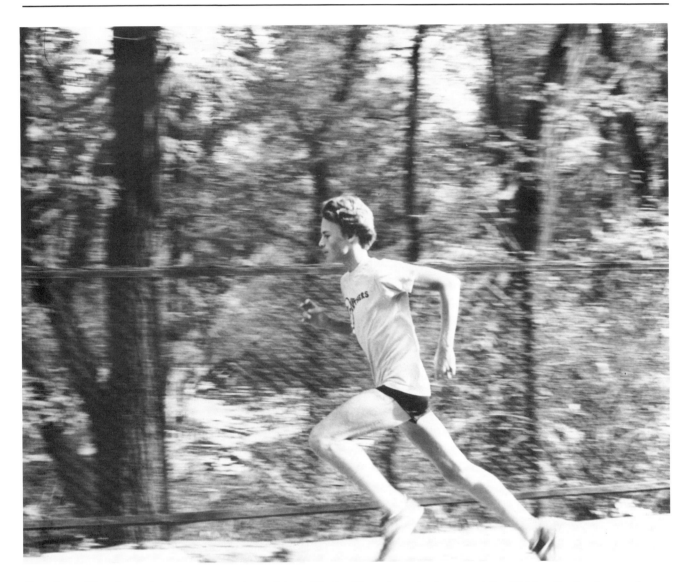

Panning will at least slow down a moving subject. Used with a slow shutter speed it will blur the background, producing an effective impression of motion while retaining the subject's clarity. (Student photograph.)

ing still. This is often referred to as "freezing."

There are other ways to avoid blurred movement. You can choose subjects that aren't moving, of course, or wait for a moving one to stop. You can also make a subject slow down by moving with it. The most common way to do this is called **panning.** To pan, you stand in one place and swing your camera to follow the movement of your subject while you click the shutter. If you're using a fairly fast shutter speed, you may be able to freeze even a quickly moving subject by panning.

If you're using a relatively slow shutter speed, however, the subject may blur less or not at all, but the background may blur considerably. This will result in a fairly crisp image of the subject, but it will seem to be moving very quickly, due to the streaks of the background.

STOP AND GO

Once again, there is no "right way" to shoot everything. Sometimes you'll want a subject to be very blurred. Sometimes a slight blur is best. Sometimes you'll want no blur at all. The important thing to recognize is that this is an aesthetic decision, and that you have several ways of putting your decision into effect.

In most cases, you don't want any blur when you're photographing im-

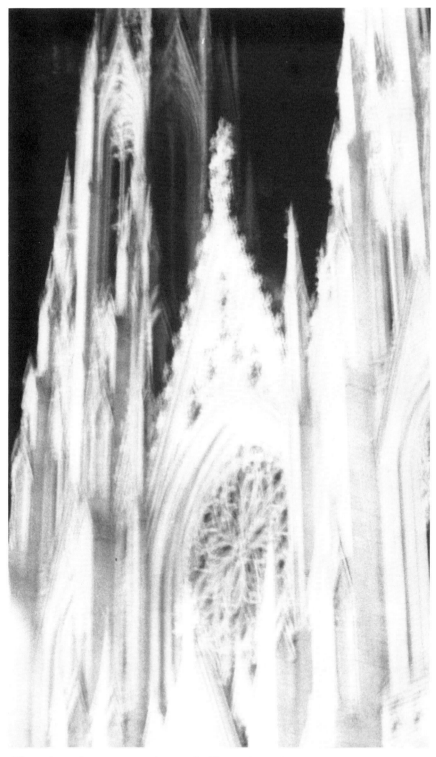

Blurred motion can even be used effectively with immobile objects, as in this impressionistic image of St. Patrick's cathedral, created by hand-holding the camera for a long exposure. (Student photograph by Mike Bracco.)

mobile objects—buildings, rocks or furniture, for example. If you try to photograph a building with a 200mm lens at 1/8 of a second, you'll produce the disturbing impression of a major earthquake.

You may or may not want some blurring when photographing objects that move occasionally or slowly: tree leaves, people walking, or flowing water. In this case, you'll want to choose the distance, lens and shutter speed that best produce the motion effect you want.

Finally, you're most likely to want blurring when photographing objects that tend to move quickly and often: racing cars, galloping horses, a basketball team in action. In this case, a long lens and/or a slow shutter speed may be in order.

As you notice moving subjects during future assignments, take a moment to consider your options. How many ways of creating blurred motion can you recall? How many can you recall to prevent blurring? The sooner all your options come to mind automatically, the sooner you'll be able to control motion effectively and creatively.

EXERCISE

Blurred Movement

Assignment: Experiment with various ways of illustrating motion by using slow shutter speeds.

Goal: Use blurred motion with a clear purpose and with a clear result. In other words, try to get a shot in which the blur really *expresses* motion.

Tips: Set your camera at f/16 and 1/15 to start. Once you get going, experiment with shutter speeds as low as 1/8. You'll find the assignment easiest on a gray, overcast day, since you don't want too much light. Alternatively, you might use a neutral density filter, which cuts down the amount of light entering the camera.

You may shoot in one of three ways:

1> Aim your camera so your subject is moving into the frame. Begin following your subject's movement and then release the shutter. Keep moving with the subject as the shutter opens and closes. This will produce a blurred background with your subject more or less "frozen."

2> Mount your camera on a tripod or find some other way to hold it very steady. Aim so your subject is moving into the frame and release the shutter. This will produce a steady background with your subject moving across the frame as a blur.

3> Attach a zoom lens to your camera, then mount it on a tripod or find some other way to hold it steady. Focus on the subject with the zoom at its maximum focal-length (i.e. 200 on a 75-200 zoom). Pull back on the zoom lens and immediately release the shutter. This produces a pattern

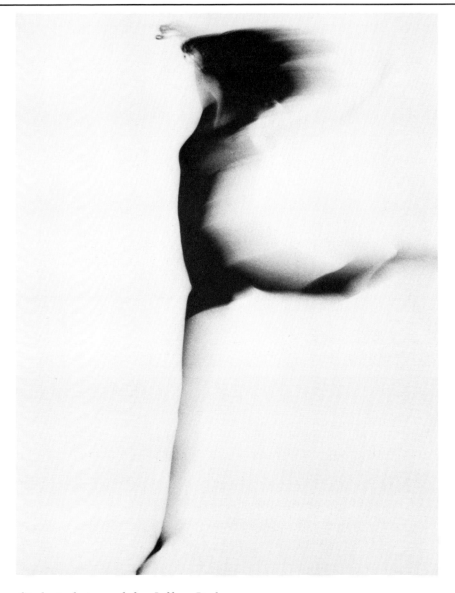

Student photograph by Jeffrey Parker.

of lines radiating out from your subject.

Note that you'll have to find something to focus on, or guess the distance, before your subject moves through the frame.

Possible subjects include runners; almost any sports activity; motorcycles, bicycles and other vehicles; a person or a group of people jumping, twirling, swinging, dancing, etc.

Your subject should contrast with the background (light on dark, dark on light). If it already blends in, the blur will make it blend even more.

(Note: If you are doing your own processing at this stage, you can increase contrast by overdeveloping your film for 2 minutes and/or using a high-contrast paper—grade 4 or 5—for printing.)

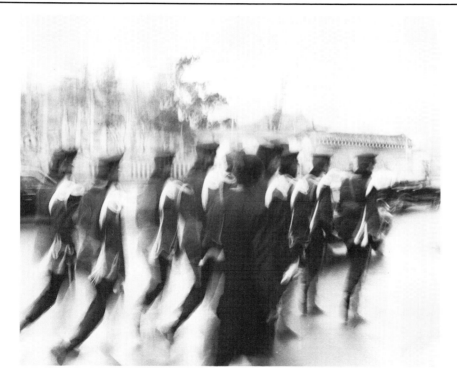

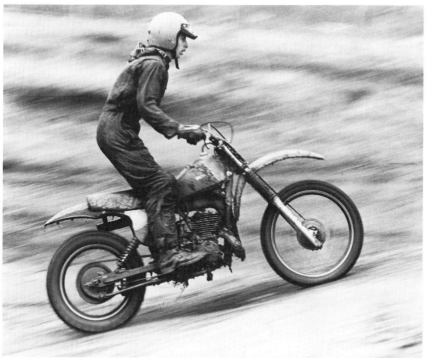

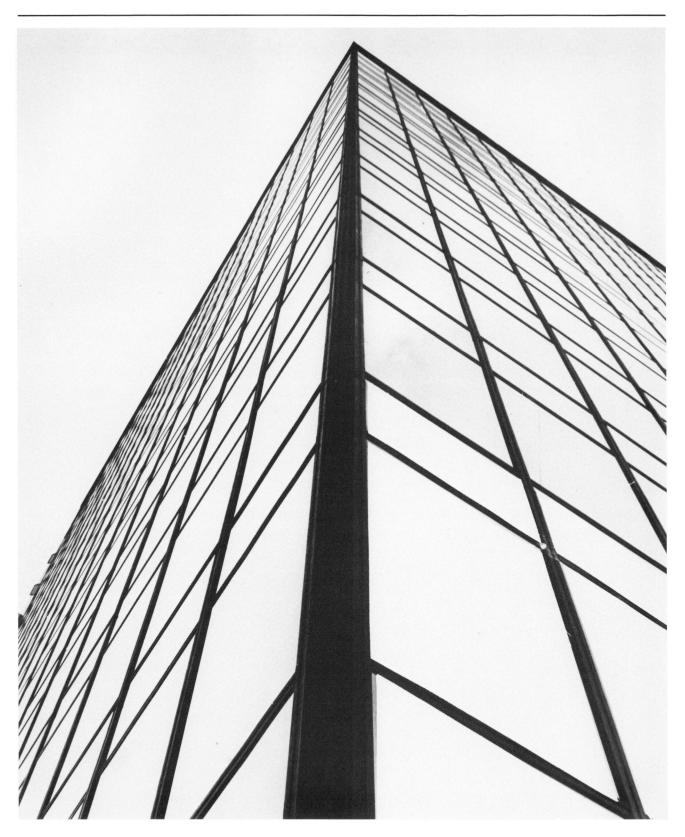

Converging lines and an appropriate point of view are the two key ingredients of perspective. (Student photograph by Kenneth Griggs.)

chapter 11 Perspective

Perspective is the one compositional element that is almost entirely in your control. The word "perspective" means "point of view," both literally and figuratively. In its literal sense, it means where you stand in relation to your subject and how that influences the appearance of your subject. In the figurative sense, it means how you feel about your subject.

The literal aspect of perspective is essentially practical. If from your point of view the sides of your subject are visible as they recede into the background, then *your* perspective will enhance the perspective of the *subject*. You can tell where it starts and how far back it goes.

If, on the other hand, the sides of the subject are invisible from your point of view (as, for example, when you photograph a low building straight-on from the front), you diminish its perspective. The building will appear flat as a pancake.

When we talk about perspective figuratively, it means how you perceive a subject, not just spatially, but aesthetically, emotionally, even morally. This kind of perspective requires that you understand your subject enough to have an opinion or idea about it . . . *and* that you have the technical skill and creativity to convey that opinion or idea to others.

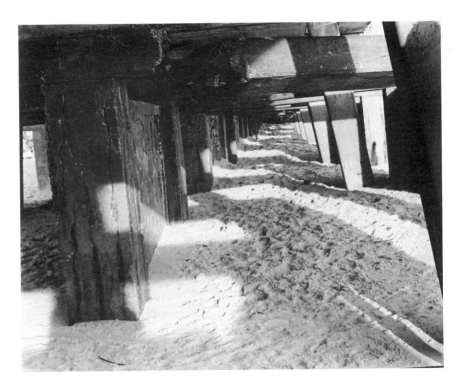

This photograph is an example of what is called "two-point" perspective. The dominant perspective lines run along the vertical axis to the right of center. A second, less evident, perspective runs out of the left side of the photograph. Try using your cropping L's to determine if the photograph is stronger with both perspective points, or with just one. In addition, notice how the shadows play off of the other structural elements of the photograph. (Student photograph by Kimberly DeMarco.)

For now, let's stick with the literal kind of perspective. No matter where you stand and where you look (straight ahead, to one side, up or down) objects are receding away from you. That's how space works.

Much of the time you aren't particularly aware of this fact. Everything just looks normal. But when you start drawing rectangles around things with the frame of a photograph, all lines become much more obvious. The lines and angles of the frame provide a point of reference with which to compare other lines within the frame. So, a building receding into the sky above you, or into the distance in front of you, may seem distorted, strange or dramatic depending on the lens you're using.

LENSES

First let's take a look at the various kinds of lenses available, all of which fit into three basic categories: wide-angle, normal and telephoto.

Wide-angle lenses have a *wide angle* of view. They allow a large amount of any scene to be included within the frame of a photograph. They have the shortest focal lengths, ranging from 15mm or less to 45mm. Extreme wide-angle lenses (18mm and below) are called "fish-eyes," because they produce a very distorted, circular image. The most common wide-angle focal lengths are 28mm and 35mm.

The next category of lenses is "normal." These are the lenses that most closely match the *normal* vision of the human eye. They range from 45mm to 55mm. The most common normal lens is 50mm.

The third category is telephoto lenses. These produce a *telescopic* ef-

FOCAL POINT: Lenses

Long & Short

The primary factor that makes one lens different from another is its **focal length.** When a photographer speaks of "a 50-millimeter lens," he or she means that the focal length of the lens measures 50 millimeters (50mm). One millimeter is a bit smaller than 1/32 of an inch. A 50mm lens, therefore, has a focal length of about 2 inches. The focal length of a 200mm lens is about 7 7/8 inches.

So, what is "focal length" and why is it so important? Technically, focal length is the distance from the **optical center** of a lens to the **film plane.** This distance is four times as long within a 200mm lens as it is within a 50mm. Until recently, this would have been fairly obvious, because the 200mm lens would have been just about four times as long. Modern techniques of "bouncing" (or, more precisely, reflecting) light back and forth within a lens, however, permit one that actually measures less than 100mm (or about 3 7/8 inches) to have a focal length of 200mm.

A 50mm lens is generally considered to be "normal" for a 35mm camera. However, any lens with a focal length between 45mm and 55mm falls within the normal range. A normal lens comes nearest to the vision of a human eye. Though you can't see as much through the lens as you can with your eyes, the size, distance and proportion of what you do see appears to be the same.

Any lens with a focal length over 55mm is in the telephoto range. Any lens with a focal length under 45mm is in the wide-angle range. Telephoto lenses, then, are casually referred to as "long" and wide-angles as "short."

Imagine that you are photographing a house from a distance of about 50 feet. The focal length of your lens determines how much of the house will be recorded on the film in the camera. With a wide-angle lens (such as a 28mm), you would probably be able to fit the whole house into one frame of film. With a normal lens (50mm) you might be able to fit in only the front door and two windows. With a telephoto (such as a 200mm) you might be limited to a single window or less.

Making the lens longer reduces the angle at which light can enter the lens. In other words, as focal length *increases,* the **angle of view** *decreases.* (The angle of view is measured diagonally across the image area, from corner to corner.)

Decreasing the angle of view also decreases the **field of view.** The field of view is what you see in the viewfinder (and what you capture on film). It is the image area.

With a 28mm lens, the angle of view is 75°. The borders of the field of view create a 75° angle (like a thick slice of pie) that starts at your camera and stretches out to infinity. Anything that can be seen within that angle will show up in your photograph. The angle of view for a 200mm lens is only 12° (like a very thin slice of pie). In simple terms: the longer your lens, the less you will see through it, and the less will appear in your photograph. Because fewer objects will fit into a single frame, looking through a long lens is a little like looking through a telescope: distant objects appear closer, small objects appear larger.

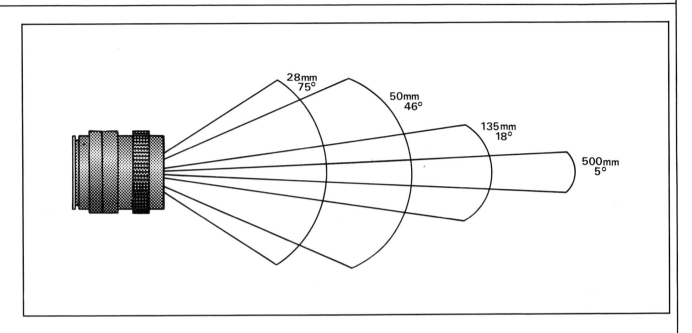

28mm 75°
50mm 46°
135mm 18°
500mm 5°

Fast & Slow

Besides being available in different lengths, lenses also differ in terms of the apertures they can accommodate. You might hear a lens referred to as, for example, a 50mm f/2.8 ("fifty millimeter, f two eight"). The first number refers to the focal length of the lens and the second number refers to its largest aperture.

As you know, larger apertures let in more light. If an image is correctly exposed in 1/60 of a second with an aperture of f/4, it will take only 1/125 of a second to be correctly exposed at f/2.8. With a larger aperture, the film is exposed more quickly.

So, a lens that can work with a very large maximum aperture (f/2 or f/1.4, for example) is called a **fast** lens. One that can work with a relatively small maximum aperture (say, f/4) is called **slow.** Fast lenses allow you to shoot at faster speeds or in lower light than slow lenses do. Unfortunately, increasing the speed

of a lens also increases its price. This is particularly true for telephoto lenses.

The aperture number is calculated by dividing the focal length of the lens by the diameter of the lens opening. The actual lens opening of a 200mm lens would therefore have to be four times as wide as that of a 50mm lens to achieve the same maximum aperture:

200mm focal length
 ÷ 71.4mm diameter = f/2.8
50mm focal length
 ÷ 17.8mm diameter = f/2.8

17.8mm × 4.01 = 71.4mm

As you might guess, increasing the amount of optical-quality glass and other materials also increases the cost of producing a lens. However, a telephoto lens — even a fast one — is rarely useful in low light. To get the best results, a telephoto needs a fairly fast shutter speed. It also needs as wide

a depth of field as possible, since it is difficult to hold telephotos steady and focus them accurately. Therefore, you can get by just fine with a fairly small maximum aperture (f/4 and f/3.5 are common and affordable). With normal and wide angle lenses, large apertures become far more useful and, fortunately, less expensive. It's a good idea (though by no means necessary) to have at least one short lens with a maximum aperture of f/2 or f/1.4.

fect, making distant objects appear larger and, therefore, closer. They range from 55mm to 500mm and beyond. Moderate telephotos (ranging from about 70mm to 150mm) are often referred to as "portrait" lenses, since they are most flattering for faces. The most common portrait lens length is probably 135mm. Other popular telephotos include 150mm, 175mm and 200mm. Longer telephotos are generally used only for such specialized work as sports photography.

(Note: Many photographers use a "doubler"—or, more properly, an "extender"—to increase the focal length of a telephoto lens when necessary. A doubler is a short tube or lens which, as its name suggests, doubles the focal length of any lens. A 150mm lens with a doubler, for example, can produce the same results as a 300mm lens, at far less expense.)

True telephotos (anything over 150mm) present some challenges that you should know about at this point. We discussed one of these challenges earlier: decreased depth of field. If you like the effect it produces, some reduction in depth of field can be perfectly all right. You *must* focus more carefully with a long lens than with a short one, however. If you don't, you may not have anything in focus at all.

Another consequence of a long lens that we've already discussed is reduced angle of view. Because a long lens has a narrow angle of view, any motion will be more conspicuous with a long lens than with a short one. Once again this can be good or bad, depending upon what you want. If you want some blurred motion, a telephoto lens can achieve it.

One of the great drawbacks of long lenses is that they magnify **camera**

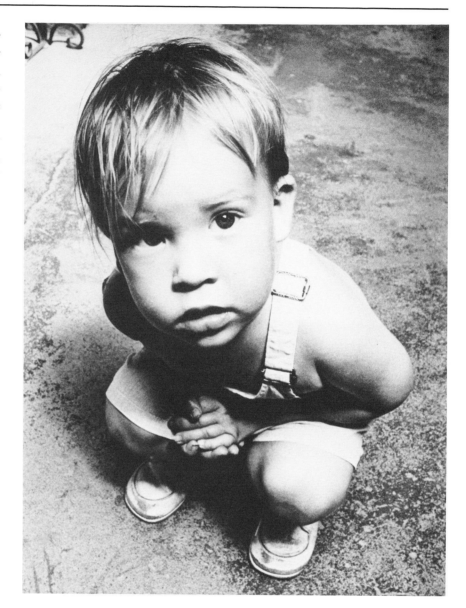

A wide-angle lens has a wide field of view, producing an apparent distortion of objects close to it. This can be very effective, if that's the effect you want. Used to photograph distant objects, however, most wide-angle lenses produce an entirely "normal-looking" image. (Student photograph by Daniel Watson.)

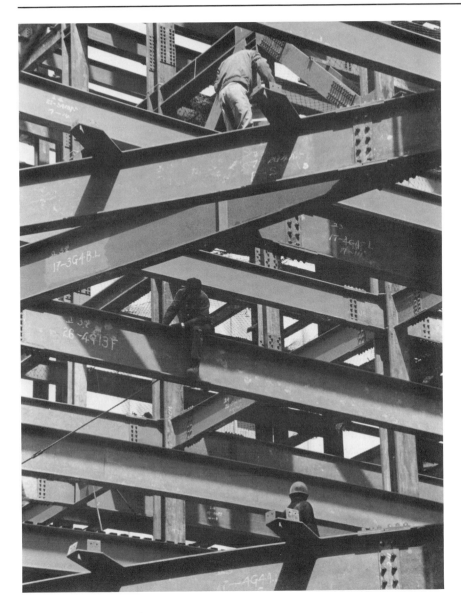

A telephoto lens allows you to "get close" to a subject without actually moving, which is particularly helpful when the subject is inaccessible. In addition, it will tend to "compress" distances, adding emphasis to the patterns created by layers of lines or shapes. (Student photograph by Michael Grassia.)

shake. Unless your camera is on a tripod, it will shake somewhat as you click the shutter. With a normal or wide-angle lens at a normal shutter speed (1/60 of a second or faster), this presents no problem. With a long lens, especially one over 200mm, the problem gets quite serious.

Because the lens is longer and heavier than normal, it is more difficult to hold steady. Because its angle of view is narrower, even slight movement is more likely to show up when you print an enlargement. You can offset some of the camera-shake problem by increasing the shutter speed. If you use a shutter speed that is roughly double the focal length of the lens you should have no camera-shake problem. In other words, you should be able to hand-hold a 135mm lens at a shutter speed of 250, or a 200mm lens at 500. With practice, however, you'll be able to do considerably better than that.

Increasing the shutter speed further reduces the depth of field, because you'll need a larger aperture to compensate for the faster speed. Furthermore, most telephotos don't open up to very large apertures. This means that in less than ideal light, you may have to choose between risking a blur or missing the shot altogether. An example would be a shot that requires you to set the aperture on f/2.8 at 125 with a 200mm lens. If your lens only opens up to f/3.5, then you'll just have to shoot at that aperture, with a shutter speed of 60, and hold your breath.

As mentioned earlier, a **zoom** lens is essentially several lenses in one, since a single zoom will provide a wide range of focal lengths. Like any other lens, however, a zoom also has limitations. If you're using a wide-to-tele zoom (say, 28mm to 80mm),

you'll have many focal lengths to choose from. But you will probably have at least one less f-stop than a plain 28mm or 80mm lens would give you. That's not a huge sacrifice under most conditions, but it is something to be aware of. (This is the reason we previously suggested that you should have at least one fixed-focal-length lens. You never know when you'll need to shoot something at f/2.8.)

Every lens involves a similar trade-off. They are all good for some kinds of shots and not good for others. A wide-angle, for example, would be a poor choice for shooting a football game. You might get some nice images of the stadium, but the action of the game would be utterly lost.

DIFFERENT WAYS OF SEEING

With a 50mm lens, as we've mentioned, things appear much as they do through a human eye. Receding objects will generally appear quite normal.

With a wide angle lens, the lines of perspective will be exaggerated, so a building will seem taller or longer as it recedes from you. The lens does *not* actually change those lines. It only seems to because of the wide angle of view.

What effect do you get if you shoot the same building, from the same position, with both a wide angle and a telephoto lens? The wide angle shot will seem to distort the image to emphasize depth, so objects will seem farther away. The telephoto will seem to distort it in the other direction, so objects seem flatter and closer than they actually are. The important word here is *seem*. If you crop out of the wide-angle photograph the portion of the entire scene that fit into

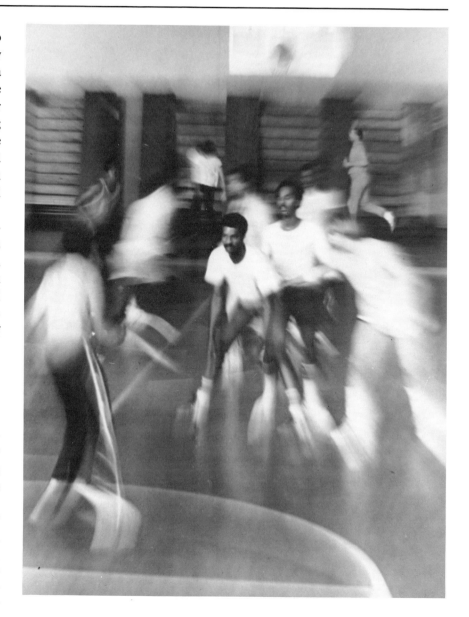

A zoom lens not only offers the benefits of several lenses in one, it will also make some interesting special effects possible. This shot was made by zooming the lens during a long exposure. (Student photograph by Charles Gibbs.)

the telephoto shot, you would have two virtually identical photographs.

But what about the way a wide-angle lens bends people's faces at the edges of the frame? This is also just an apparent distortion. The lens is accurately recording an image from a certain perspective. The best way to test this is to look at a large wide

angle print with your face as close as possible to it. The nearer you come to matching the original viewing position for the scene, the more normal the photograph will look. When you stand back from a wide-angle print, you are simply compressing a broad viewing angle into a smaller space, so things look weird.

The combination of height and distance enhance the perspective of this photograph. Notice how other lines in the photograph reinforce it. (Student photograph by Lynne Mattielli.)

Student photograph by Russell Wells.

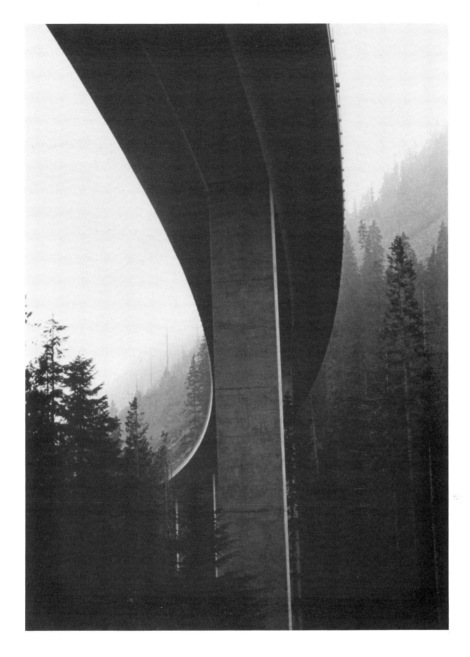

Student photograph by Laurie McMillen.

50mm lens, the relation between the person and the building will seem to be "normal." With a 200mm lens, the person may seem to be right next to the building.

So, different lenses make different points of view available to you. In a sense, the only "honest" lens is a 50mm. It's the only one that reproduces your actual point of view. Longer and shorter lenses create the impression of other points of view, by allowing you to expand or crop into an image. As a result, you appear to be closer to or farther from it than you actually are.

A POINT OF VIEW

How do you apply perspective? There are two ways, both of which involve establishing a point of view. One point of view (the literal kind) is physical — where you place yourself in relation to your subject.

The second kind of point of view is harder to describe. It too depends on where you stand in relation to your subject . . . but not just physically. It also depends on where you stand aesthetically (is the subject beautiful, plain, ugly?), emotionally (does it make you happy, amused, worried, sad?) and ethically or spiritually (do you believe the subject itself is good, indifferent or bad?).

Sooner or later, you'll want to do more with your camera than just make copies of things. You'll want to explore them, find out what makes them "tick." You'll want to reach an understanding of them and express that to others. That's when you'll begin to be an artist with a camera.

So, if you actually get the same image with each lens, why not just stick to one and move closer to or further from your subject? There are two reasons. First, you can't always do that. If your subject happens to be a pro football lineman in the middle of a game, you're much better off sticking to the sidelines. If your subject is a bird flying over a lake, you really don't have much choice. You need to take the shot from where you are.

But there's another reason too. While the subject itself may look the same, its relation to other objects in the frame will change. Imagine that you want to photograph a person standing 50 feet in front of a building. With a wide-angle lens, the person may seem to be standing 100 feet away from the building. With a

EXERCISE

Point of View

Assignment: Photograph a single subject from several different angles. At least two final prints should be produced.

Goal: See how many good compositions you can produce by looking at your subject from all sides: front, back, right side, left side, top, bottom, even up close and far away.

Tips: Use lighting as well as position to add variety and interest to this assignment. Try shooting early or late in the day to make use of dramatic light and long shadows. Alternatively, you might want to set up some kind of light source (such as a spotlight) to produce your own lighting effects. Most importantly, shoot a *lot* of film, at least one entire roll.

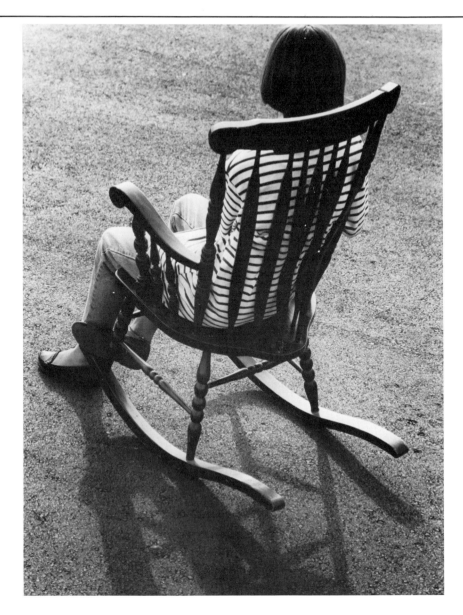

Student photographs for this exercise by Jeff Frye.

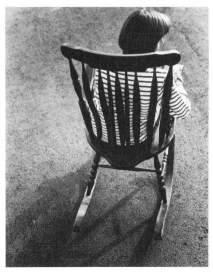
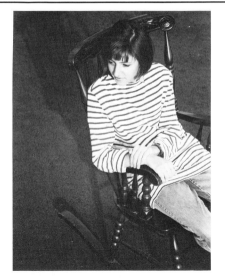
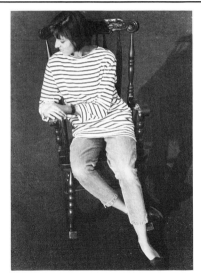
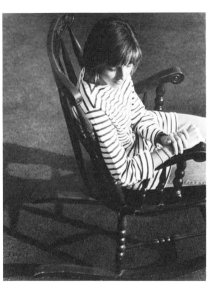
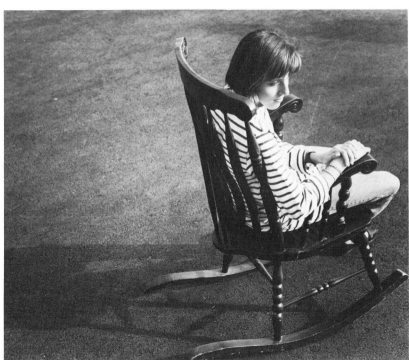

part 3 People, Places & Things: Exercises & Examples

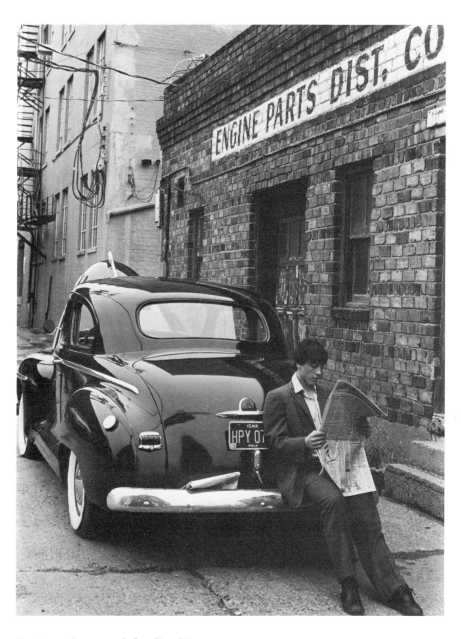

Student photograph by Jim Piazza.

Student photograph.

chapter 12 # Things

B y now, you should have a good grasp of the basic elements of photography. You may even have the beginnings of a personal style. The most important thing at this stage is practice. So, with the exception of the Appendix, the remainder of this book is devoted solely to exercises.

Each exercise assignment promotes specific skills and insights. The assignments can be as challenging (or as easy) as you choose to make them. Almost all of them can be accomplished with the knowledge you have already acquired. (If and when you feel the need for more information, the Bibliography will give some ideas of where to start looking.)

For the first category of exercises, you will be photographing "things"—isolated objects. Things are generally easier to photograph than places or people (the next two categories). However, it's not necessarily easy to do it *well*. Before you set out to capture your bicycle (or any other subject) on film, it's a good idea to set some objectives for yourself, beyond those required just to complete the assignment. In fact, this a good habit for photographing anything.

Clearly it is not enough merely to produce an accurate image of your subject. A photocopying machine accomplishes that objective quite well.

Student photograph.

But what is "enough"? While the ultimate answer to that question is up to you (and to those who critique your photos), here are a few hints.

A good first objective for any photo is to generate **visual interest.** Obviously, a photograph must provoke interest to hold a viewer's attention. Before you can make the rest of us understand your intentions, you must make us *want* to understand them.

There are many ways of achieving visual interest. First is composition. A skillful composition can generate interest all by itself. Light is another important factor. Others include depth of field, shutter speed effects and printing technique.

A second objective is **mood.** Though it is often hard to define, virtually every effective photograph has a mood of some kind. It needn't be a familiar one like "happy" or "sad." If a photograph emphasizes shape and texture, the mood may be "sensuous." If it suggests a scientific examination, the mood may be "clinical" or "detached." If it's not clear what the photographer is intending, the mood may be "confused" or "playful." A photograph that is apparently concerned only with line, or light and shadow, may have a mood that is simply "aesthetic."

A third objective is **expression.** This one is optional, though recommended. A photograph is expressive when it "says" something. You can use almost any subject to express your own feelings about the world. Or you can try to stand back and let each subject (whether it be a bicycle or a person) speak for itself. You can even do both: combining your own moods and perceptions with the inherent qualities of your subject. Decide for yourself.

FOCAL POINT: Edward Weston

By the 1920s, photography had become an accepted part of American culture. Photographers were busily producing images of people, places and events that they or their clients considered significant. Presidents, boulevards, buildings, newlywed couples, battles and factory workers were all being faithfully recorded and preserved for posterity. Edward Weston helped promote a whole new way of seeing. He photographed both soaring mountains and a handful of pebbles, the "great themes" and relative trivia. He was interested in pure aesthetics, in anything that had compelling line, texture, shape or lighting.

Other photographers, as far back as Daguerre and Talbot, had photographed small objects or details of large ones. However, Weston was among the first to consistently elevate the ordinary into fine art. He photographed weathered doorways, eggs, fruit, rocks, eyeglasses and cabbages, striving to capture the essence of each. Weston's subjects *became* important because they had been photographed. Absolutely anything was appropriate, if it could be compellingly presented.

Curiously, Weston began his career heavily influenced by the Pictorialists, one of the most conservative of the various "schools" of photography. The Pictorialists believed that photography should imitate painting, and they strove to reproduce painterly effects with their cameras. Weston's early photographs, true to Pictorialist style, tended to use soft-focus and dreamy lighting.

After encountering the work of Steiglitz, Paul Strand and other Realists, Weston changed his mind and his style. He began using large format cameras to produce "straight" photographs of exceptional precision and clarity. Along with Ansel Adams, he was a founding member of "Group f.64," an association of photographers who all believed in using small apertures to achieve extreme depth of field.

Weston was born in 1886 in Highland Park, Illinois, but spent most of his life in California and other western states. He opened his own photographic studio at the age of 18, specializing in portraits. Nearly 20 years later, in 1923, he suspended his commercial work and spent three years in Mexico. Upon his return to the U.S., Weston began concentrating on the nature studies for which he became famous. From the mid-1930s until his death in 1958, Weston was widely regarded as one of America's foremost photographers.

Edward Weston, Pepper, *1930. c Sotheby's Inc. 1987.*

EXERCISE

Bicycle

Assignment: Photograph a bicycle from various angles.

Goal: Explore the idea that there is more than one way to look at any object. Once you start *really* looking, the possibilities are endless.

Tips: Get in close and shoot parts of the bicycle: pedals, spokes, handlebars, seat, light, kickstand, gears, etc. Get even closer and shoot details of the parts: a portion of the gears, the handgrip of the handlebars, the joint of the kickstand.

Then pull back a bit and look for patterns: the various lines and circles and curves and angles of the frame, wheels and mechanism of the bicycle. Pull further back and shoot the entire bicycle in an interesting environment. Alternatively, shoot it in a very plain environment, so the shapes of the bicycle stand out clearly.

Approach the bicycle from the front, back, top and either side. Get down under it and shoot upwards. Lay it down and shoot it on the ground. Get in close again. Step back. Move around. Try to find as many ways as you can to look at this one object.

(Note: You don't have to restrict yourself to one bicycle. Look for variations in different ones. Find or place several bikes together and shoot them as a group. Do, however, get at least a half-dozen shots of one bicycle, to see how many variations you can find in a single object.)

Student photograph by Charles Bell.

Student photograph by Charles Stuart Kennedy III.

Student photograph by Bruce Wiles.

EXERCISE

Hubcaps & Taillights

Assignment: Photograph automobile hubcaps and taillights (headlights are acceptable as well).

Goal: Concentrate on cropping in on your subject. Explore various ways of composing circular and other shapes within the rectangular frame of a photograph.

Tips: Choose your subjects carefully; the more intricate the better. For example, a very plain hubcap will generally be less interesting than one with spokes or other decoration.

Shoot pieces, details. It's a good idea, for instance, not to get the whole hubcap into the frame. Crop in on an interesting part of it. Look for patterns. In this exercise, patterns are more important than the object being photographed.

Notice how light interacts with chrome and glass. Pay particular attention to precise focusing. Experiment with different angles for interesting effects. Move around.

Student photograph by Stephen Griggs.

Student photograph by Marciano Pitargue, Jr.

EXERCISE

Eggs

Assignment: Arrange several eggs on a white background and photograph them.

Goal: Explore the possibilities of a repeated simple shape, of light and shadow, of a white subject on a white background, and of a "set-up" shot—all at once. Try to produce a photograph in which the eggs are arranged in a pleasing composition which is enhanced by their shadows.

Tips: Try using a large (i.e. 32″ × 40″) piece of white mat board, so you can experiment freely with composition and viewing angle. Shoot in bright sunlight and rely on the point of departure camera setting (f/16 at 1/125 of a second). This is another case in which your light meter will only be confusing.

Don't settle for the first shot that comes to mind—explore! Try various arrangements and various angles until you get something that's exciting.

Student photograph by Jun Hwang.

Student photograph by Cliff Blaskowsky.

Student photograph by William Roche.

Things **159**

EXERCISE

Object & Its Shadow

Assignment: Photograph an object (or part of it) along with its shadow.

Goal: Explore how an object's shadow can add visual interest to a photograph.

In addition, learn to place both an object (or part of an object) and its shadow effectively into a rectangular frame.

Tips: You'll get the best results early or late in the day (from dawn to mid-morning or mid-afternoon till sunset), when shadows will be nice and long. Be sure your subject is well-placed to cast an interesting shadow. It's best if the shadow is cast on a fairly simple surface—a complicated surface tends to reduce a shadow's impact.

Pay particular attention to negative space. Try to achieve visual tension between the object and the shadow. This can be done by placing the object over to one side of the frame and letting the shadow stretch to the far side (a corner to corner stretch can be especially effective).

Student photograph by Charles Stuart Kennedy III.

Student photograph by Lynne Mattielli.

Student photograph by Evelyn Wight.

EXERCISE
Bottles & Glasses

Assignment: Photograph an arrangement of bottles and/or glasses on a white background. (32 × 40″ white mat board is recommended). Photograph the arrangement from various angles to explore the compositional possibilities in it.

Goal: Achieve the best possible white, gray and black tones, using the correct aperture and shutter speed combination (f/16 at 125 in bright sunlight).

Produce an interesting composition that makes good use of these tones.

Tips: Don't rely on your light meter. Stick to the "point of departure" setting and you *will* get the correct effect. The background should be a true white, but with texture visible. Black lines (where glass is thick or is touching something) should be clear and dark enough to contrast strongly with the white. Gray tones should be varied and delicate, not muddy.

Notice how the shapes of the bottles or glasses interact with each other, and how their shadows interact as well.

Do not let the edge of the white surface show in the frame! A telephoto or, better still, a zoom lens is helpful for an assignment like this. If you have one, use it. If you don't, just get in close.

Student photograph by Jeff Frye.

Student photograph by Bill Backus.

Student photograph by Lynn Mattielli.

Student photograph by Cliff Blaskowsky.

EXERCISE
Water

Assignment: Photograph water — any kind of water, from a puddle to an ocean.

Goal: Capture some of water's different qualities: calm and still, rippling, splashing, falling, cascading, moody, etc.

Tips: Watch for interesting reflections on calm water; for water interacting with other objects (people, animals, rocks); for how water affects and is affected by its environment; for water *as* an environment; for drops of water on leaves, glass, metal, etc. Try looking into the water for fish, pebbles, discarded bottles or whatever else you might find.

Photograph a landscape or a city street through a wet window in a home, apartment or car. Keep an eye out for floating leaves, sticks or boats, anything half in and half out of the water. Look for things growing in water: lilies, grass, algae.

You may want to photograph an object and its reflection, or just the reflection. Try shooting a calm reflection first, and then tossing in a pebble to see what effect that has.

Finally, you might catch people playing in water — at a fire hydrant, in a swimming pool, along a river or at the ocean.

Student photograph by Greg Garre.

Student photograph by Al Webb.

EXERCISE
Old Things

Assignment: Photograph a variety of old objects, things that are worn from age or use—houses, tools, toys, furniture, etc.

Goal: Show how the age of an object influences its character.

Tips: People in our society tend to think that a thing has to be new and glossy to be good. Few people appreciate things that have earned their character through age and lots of use. That's what this exercise is about.

Look for peeled paint, rust, broken glass, things that have been abandoned, used up, worn out. They have a statement of their own, a special mood. That mood may be sad ("This thing is all worn out"), or happy ("This thing has been useful for years").

Try to capture the object's character. Notice how light and texture may help to portray that character.

Possible subjects include old houses, cars, tools, bridges, train tracks, machinery, abandoned buildings, an old can, discarded toys, a chipped plate, teacup, fork.

(Note: If you find something indoors that you want to photograph outdoors, be very careful that it doesn't look set up. Adjust the arrangement until it looks natural.)

Student photograph by Mark Mealey.

Student photograph by Thomas A. Perez.

Student photograph by Richard Greenstone.

chapter 13 # Places

A s you progress from "things" to "places," the number of variables you must control will increase. Now, in addition to placing your subject carefully within the frame and worrying about the effect of light and shadow on it, you have to pay attention to all kinds of potential complications and distractions. People, animals, cars, trucks and weather can get in your way just as you're about to click the shutter. Buildings, trees and telephone poles can make it impossible for you get the composition you want.

In addition, you'll have to be very concerned with perspective: should you be close to a building or far away? How big should a tree look next to the building? How much sky should be included? Should you crop in on a small part of the scene or try to fit it all into the frame? Meanwhile, your subject is likely to be changing all the time. If you think too long, it may no longer be worth the bother. If you get impatient, you may miss out on a new and unexpected opportunity.

There are other challenges as well. For example, if your subject has any moving parts (people, animals, machines, running water, trees in the wind, etc.), long exposures will produce blurs. This means that you will

Student photograph by Debbie Taggart.

either have to stick to fast shutter speeds or learn to like the blurs. Lighting will become more complicated as you enlarge your field of view from particular objects to general scenes. While you will still need to pay particular attention to how the light affects your primary subject, its affect on the surrounding environment will be important as well.

You will also begin to face the challenge of dealing with people. If you're photographing a crowd, you may not be aware of all the individual people in it. *They,* however, may be

very aware of you. Some of them may prefer not to be in your photograph. For the assignments in this section, you should be able to avoid this problem either by leaving people out of your photographs or by asking permission in advance (e.g. for the "Construction Site" exercise). However, if you feel that some advice on photographing people is appropriate at this stage, you might want to read the introduction to the "people" category of exercises.

Overall, controlling composition is the greatest challenge you'll face as you begin photographing places. It's

you photograph. Try to crop in on them, cutting out anything that just adds confusion (unless of course confusion is what you want to express). Don't forget to move around—from side to side *and* up and down. You've probably seen other photographers crawling on the ground, climbing up trees and generally looking foolish. Here's your chance to do it too. When you're photographing a place, creative solutions may be required to resolve compositional problems.

FOCAL POINT: Ansel Adams

Widely admired both for his eloquent landscapes and his technical skill, Ansel Adams was among the most influential photographers in history. Through his exhibitions, books and classes, he inspired thousands of aspiring photographers to adopt his philosophy and techniques.

Adams specialized in photographing the natural environment of the American West. His photographs are typically vast panoramas of mountains and sky, with highly dramatic composition and lighting. Extreme clarity was a key element of his style. To achieve that goal, he used large-format cameras, very small apertures (such as f/64) and long exposures (sometimes over an hour).

His technique is based on the "Zone System," a set of procedures that provide very precise control over the range of values in a photograph. By adjusting both exposure and development times (with the appropriate burning and dodging), a photographer using the Zone System can lighten the shadow areas and/or darken the highlights to achieve finely balanced tones. The final image is often utterly unlike the original scene.

The photographer is then in suitable control of the photographic process according to the Zone System's advocates. Critics say that the resulting photos may seem to be about little more than technique itself. In any case, Adams and his use of the Zone System must be given credit for producing some extraordinary photographs.

Adams was born in San Francisco on February 20, 1902. His early interest in music led him to become a professional (self-taught) pianist by his early 20s. Photography, however, would soon demand his full attention. He obtained his first camera at 14 and promptly traveled to Yosemite to experiment with it. For the next decade, he photographed there every year. In 1927 his first collection of photographs was published—and very favorably received. By 1930, friends and admirers had convinced him to shift his career from music to photography. From then until his death in 1984, Adams remained one of the most respected and widely exhibited photographers in the world.

Ansel Adams, Moon and Halfdome, Yosemite Valley, *c 1955.*

EXERCISE

Landscape

Assignment: Photograph a large expanse of any "natural" environment. Depending on where you live, "natural" may mean virgin wilderness, agricultural land, a seashore or an inner city park. Do your best, however, to avoid buildings, roads or other indications of human influence.

Goal: Capture something of the character of the landscape you photograph. Is it lush, wild, domesticated, barren, pleasant, forbidding, calm, awesome? Take time to find out, and then express your conclusions in your photographs.

Tips: Don't just go out and point your camera at the view and call it a landscape because it has land and trees and sky in it. Make the composition work. Look for visual harmonies: recurring patterns in trees, rocks, the contours of the land, water, clouds.

Shoot in snow, rain, mist, bright sunlight, any weather. Notice how atmospheric conditions change the environment: How does rain affect an open field, a pond or river, a forest? How does bright sunlight affect them? Notice how clouds relate to the shape of the land.

Patience is important. For example, once you decide what to photograph, you may have to wait until the clouds do just the right thing.

Pay particular attention to technique. Landscapes are very demanding subjects. For example, you may want to use a filter to make clouds more distinct, to darken the sky or otherwise achieve the effect you want (see Appendix). If it's raining, or the sky is heavily overcast, you may want to use a larger aperture (or slower shutter speed) to brighten the photograph. If the whole scene seems too bright, you may want to darken it by using a smaller aperture (or faster speed). Be aware of your position in relation to the sun, and the effect that has on your results. Experiment, and take notes on what you're doing, so you'll know what worked and what didn't.

Student photograph by Clark Peterson.

EXERCISE

Architecture & Environment

Assignment: Photograph a building (or buildings), showing how it relates to its environment.

Goal: Before you start shooting, ask yourself some questions about the relation between the building (or buildings) and environment. Are they in harmony with each other? Do they clash? Does one have a negative effect on the other? Do you like one and dislike the other? Do you like or dislike them both? Use your camera to help you answer these questions. Decide what you'd like to say about what you see, and say it with your photographs.

Tips: Pay attention to the surrounding natural environment, landscaping, streets, other buildings, etc. Any kind of buildings are acceptable: suburban homes, row houses, apartments, high-rise offices, barns and silos, trailer homes, buildings shaped to fit an odd piece of land, etc.

Don't restrict yourself to an eye-level perspective. Get up high and look down. Lie flat on the ground and look up. Go off to one side or another. Step back into an alley or side street. Get in close. Move far away. If you have more than one lens, use them. Try a wide angle lens up close, a telephoto from a distance.

Student photograph by Jeffrey Richter.

Student photograph by Mark Crew.

Student photograph by Derek Leath.

EXERCISE
Neighborhoods

Assignment: Photograph a neighborhood—any place where people live.

Goal: Try to express a "sense of place": What is it about *this* neighborhood that makes it special? Don't just shoot a collection of buildings.

Tips: You may or may not want to include people in your photographs. Make that decision on the basis of what you want to express about the neighborhood. If it seems like a friendly community, a place where people are important, then you'll probably want them included. If it seems cold and empty, a bunch of buildings where people just happen to live, then you may want to express that feeling by not showing any people in your photographs.

Notice how light affects the mood of a neighborhood. Use the light to help express your feelings: dark and solemn, bright and cheerful, pale and sad, etc.

Also notice that neighborhoods, like people, tend to show their age. Is the neighborhood itself young, middle-aged, old? What about the people in it? Are many of them similar in age and character to their neighborhood?

Look for clues about how people live: tree-lined avenues, people watering lawns, trash cans in the morning, similarities and differences among the various houses or apartments. What kind of cars are in the driveways or parking lots? What kind of decorations do you see? Do people hang out their wash on clotheslines? Do they spend time outside, or stay indoors? Learn as much as you can by just looking around. Then see how much of what you've learned can be expressed in a single photograph.

Most of the rules that apply to architectural photography also apply to this assignment. You may want to get down low and look up, get up above and look down for patterns, shoot from a third story window, through trees or gates, or from down an alley.

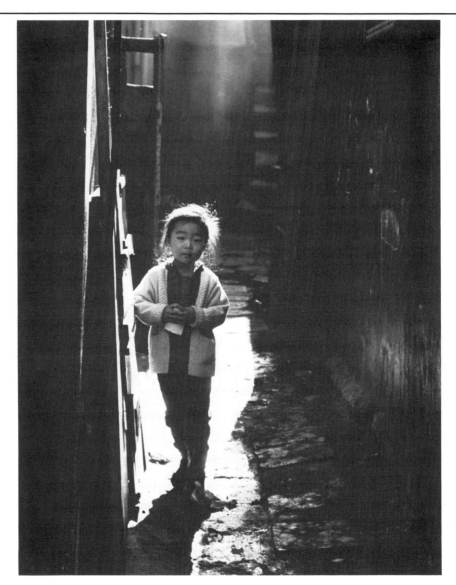

Student photograph by Bruce Wiles.

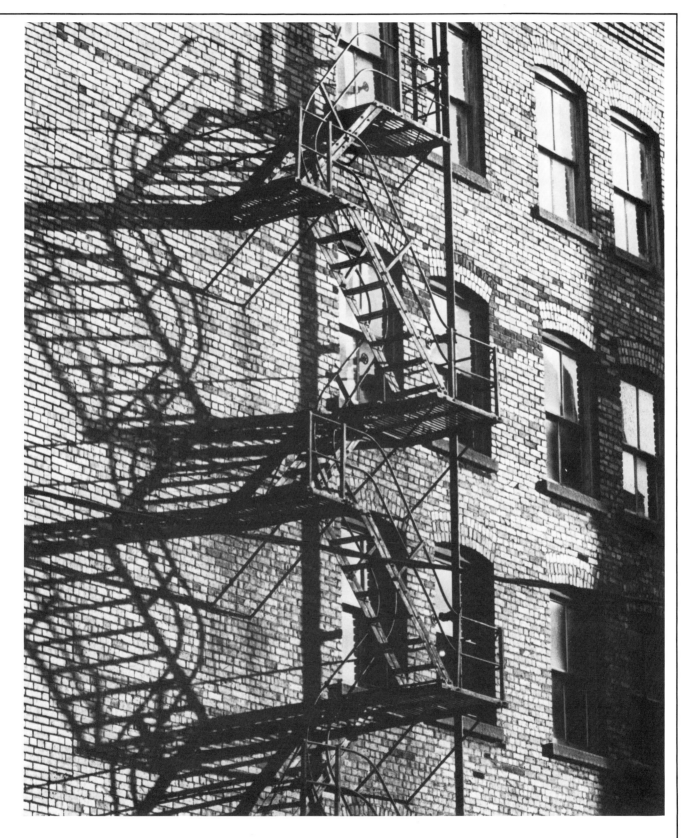

Student photograph by Gerald Allen Conway.

EXERCISE
Zoo/Farm

Assignment: Go to a zoo or a farm and photograph animals.

If you can't get to a zoo or farm, find some pets to photograph. Photograph *only* animals, not people on horseback, for instance, or an animal with a trainer.

Goal: Try to get more than just a photograph of an elephant or cow or dog. See if you can capture something special about one *particular* animal.

Tips: Animals, like people, are highly expressive and mobile. To photograph them well, you'll have to catch them in action or wait till one stops in an interesting pose.

Experiment with perspective. Get in close enough to crop out the background completely. Step back and show the animal in its environment. Show the whole animal, just a part of it—an ear, eye, tail, foot— or several animals together. Look for texture (such as an elephant's hide) and pattern (a zebra's stripes).

In addition to zoos and farms, you might find good subjects at a country fair, a cattle auction, a dog show, or in a park. Even in the middle of a city, you should be able to find dogs and cats; you might find horses; and you will certainly find pigeons.

If there is a cage between you and your subject, get as close to the bars or wire as possible (assuming you can't shoot between them). The cage will then just be a blur, especially if you use a large aperture. Try to open up to about f/2.8, but remember that you'll need to focus *very* carefully. If your subject is also fairly far away, the cage may disappear entirely. Alternatively, if you're at a zoo, an outdoor show may give you an opportunity to photograph animals outside of their cages.

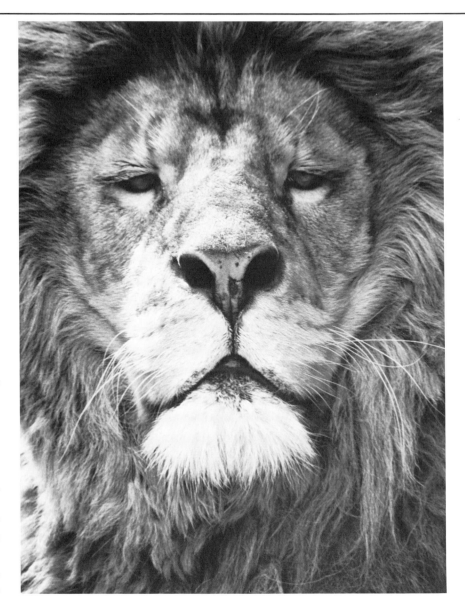

Student photograph by Sam Tipton.

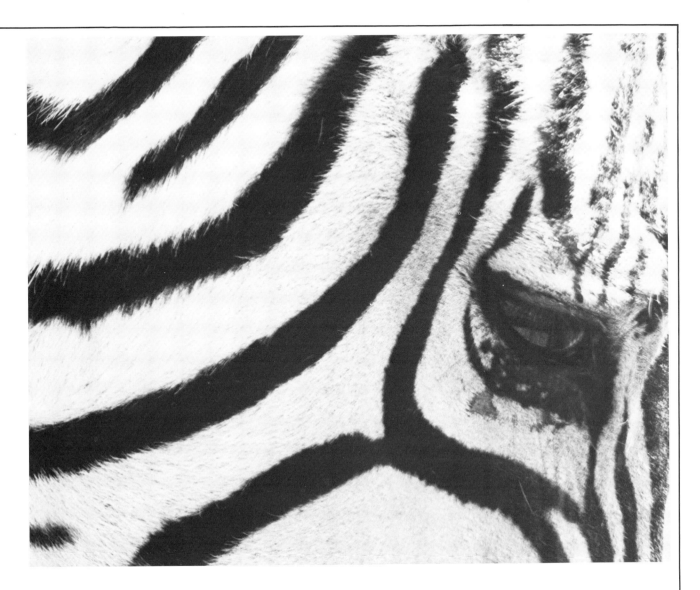

Student photograph by Han June Bae.

Student photograph by David Krumlauf.

EXERCISE

Store Windows

Assignment: As you photograph store windows, look for two things: merchandise on display and reflections in the glass.

Be careful to keep yourself out of the photograph as much as possible. It is not acceptable for you to be clearly visible.

Goal: Try to catch something unusual, especially something humorous. Don't just show a window with things in it. Make sure your photographs say something *about* those things.

Tips: Look for patterns and interesting juxtapositions (or combinations) of objects. Notice how the reflection interacts with what's inside the window. Watch for signs (inside the window or reflected in it). Keep an eye out for interesting mannequins, or displays being rearranged. Consider getting two windows together in one photograph.

Be conscious of your cropping. As a general rule, only the window should in the photograph, not the rest of the building. But if the building relates to what's in the window, then include both. Pay particular attention to converging lines caused by perspective. Make sure they work *with* the composition, not against it.

Several tricks will help keep you out of the photograph. Stand at an angle to the window so it isn't reflecting things from your direction. Or get down low, so the reflection passes over you. Position yourself so that you line up with the frame of the window. Or stand so your reflection is in a dark part of the window. This can be achieved by standing so some-

thing dark (a shadow, for example, or a building) is behind you, or by lining yourself up with some dark object inside the window. Experiment with these techniques and they'll soon become automatic. (Note: It *is* acceptable, and often unavoidable, for *part* of you to be visible. Just try not to produce a photograph that looks like a self-portrait in a window.) It is perfectly acceptable for other people to be visible, either inside the window or reflected in it.

Student photograph by John Prettyman.

EXERCISE

Construction Sites

Assignment: Find any kind of building under construction (from a glass and steel skyscraper to a wooden shed) and photograph it.

Goal: Look for more than posts and beams — people; bulldozers; machinery; tools; heaps of dirt, stone and metal, etc. Make sure, however, that you stick to the construction theme (no portraits of people who just happen to be near a building site, for example).

Tips: Don't just stand back and shoot a distant building project. If you do shoot from a distance, make the foreground and background work together. Try to find visual harmonies between them. Make sure that *something* ties them together. For example, locate lines leading to the point of interest, and emphasize them.

Try a combination of overview and detail shots: the silhouette of a building's frame against the sky, a bulldozer pushing a mound of earth, a hand holding a hammer, a nail or screw in a piece of wood or metal. How do the construction workers (or carpenters, etc.) relate to the building? How does the building relate to them and to its environment?

Student photograph by Lynn Mattielli.

Student photograph.

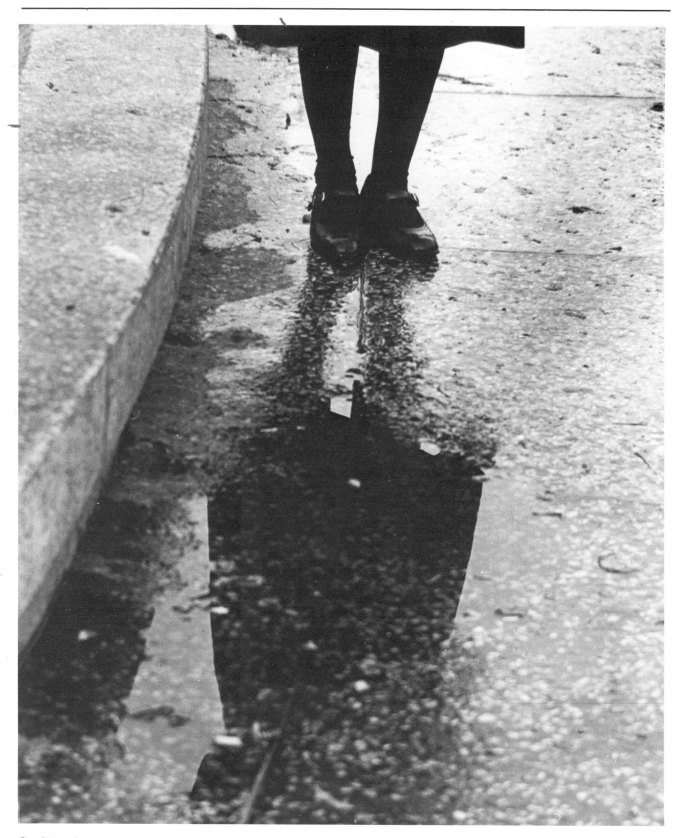

Student photograph by Lynne Mattielli.

chapter 14 People

Moving from photographing objects and places to photographing people is likely to be a bit unsettling. Not only must you think about composition and exposure, but you must also interact with your subject. A true portrait is far more than just a photograph of a person staring into a camera—it should reveal something about that person's character, experiences, feelings.

How do you achieve that? Basically, you find ways to make the camera less obvious, and ways to help the subject feel and look as natural as possible. Since you can't actually make your camera invisible, it will always have *some* effect on the subject. That effect can, however, be good. Once they are relaxed, people tend to "show off" for the camera, becoming more expressive and energetic. But people who aren't relaxed just tend to get more and more nervous. So, your first task is to make your subject as comfortable as possible.

There are two ways of doing this. The first, which is especially useful when you're photographing people you don't know, is to set the proper exposure and then keep the camera out of the way until you see the shot you want. Then you swing the camera up, focus it and "grab" the shot. You may even be able to focus beforehand as well.

Student photograph by Robert Bielk.

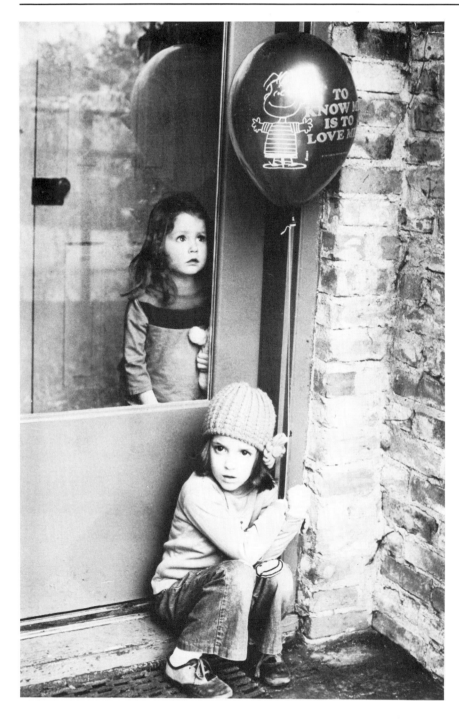

Student photograph by Susan Hodge.

You'll get the best results in bright light, when an aperture of f/8 or higher will give you enough depth of field so you won't have to focus too carefully. In this case, you can rely on **zone focusing,** focusing your lens in advance on the general area in which your subject is located. With a wide-angle lens at f/8, for example, everything between 5 and 10 feet (or between 10 feet and infinity) will be in focus.

If you use this technique with strangers, be as sure as you can that you won't regret it. The best way to do that is either to ask permission or be sure you aren't noticed. For example, it is not a good idea to grab a shot of a motorcycle gang without asking permission first. (It may not even be a good idea to ask permission!) You should always be aware of the other person's right to privacy. A beggar on the street is not likely to consider himself a good subject for a photograph. If you can't get the shot without disturbing his self-respect, then leave him alone. Photographers have earned a bad name all around the world by insulting their subjects; don't add to it.

Until you develop your own instincts for when it is and isn't appropriate to grab a shot or to request permission, photograph people with whom you are comfortable, people you know, or who at least recognize you. Then you may want to try photographing people you don't know, but who are from the same social background as you. Continue to move further from your cultural "home base" as your confidence and instincts improve. A camera is a wonderful tool for making contact with people you wouldn't ordinarily meet . . . but take it slowly.

Although the grab shot approach

is especially useful on location, it can also work very well in a portrait session. The main difference is that the subject of a portrait session (in which you take many photographs of a single person) knows that you intend to use your camera. Nonetheless, by bringing the camera between you only when necessary, you can keep the mood relaxed and casual. Chat awhile, grab a few shots, chat some more, grab a few more shots, etc.

The second approach, which is especially useful in a photograph session setting, is to place the camera on a tripod. Set the exposure and focal range and then peek out from behind it to talk with your subject. Stay close to the camera if you want your subject's eyes to be looking straight ahead. You may want to use a cable release so you won't have to try to find the shutter while you're talking.

A variation on this technique, which is probably the most commonly used of all, is to hold the camera in your hands the whole time. You compose, set aperture and focus and then look through the viewfinder and click your photos (conversing as normally as possible) until your subject begins to look nervous. Then you poke your head up, make eye contact, tell a few jokes or whatever else it takes to get your subject to relax.

The main thing to strive for in a portrait session is a comfortable pace for both you and your subject. If the camera keeps clicking at regular intervals, and conversation proceeds in a steady flow, most subjects will relax. Your instructions ("Move over there. Look into the camera. How about a smile?") will gradually fade into the background. The other person's character will begin to surface. You should expect to "waste" 10 or more exposures before this occurs.

Don't hold back, waiting for the one perfect shot, or you'll both become nervous wrecks. Just start talking and shooting, like it's the most natural thing in the world.

The most effective pace will vary depending on your subject and the mood you want to capture. If you want a solemn, soulful expression, try to speak slowly, softly and allow for some long pauses. Remember that you may be asking your subject to be very emotionally revealing . . . and it's only fair that you reveal something about yourself as well. A genuine exchange should be expected from both of you.

If, on the other hand, you want a cheerful expression, then talk fast and furiously until your subject gets so caught up in your great sense of humor (or bumbling mistakes) that he or she forgets about your camera. (By the way, don't be afraid to make mistakes and admit them. This can be a very effective way to loosen up a subject. You may even want to make a few on purpose. Just be sure you *stop* making them after the first few shots, so your subject doesn't begin to think the whole session will be a waste of time.)

One other trick: If you can't get your subject to relax and just talk, try asking him or her to recite the alphabet. This has two useful results. First, it gets the lips moving and produces a variety of expressions. Second, *everyone* asked to do this starts laughing sooner or later.

As you practice shooting portraits, you will begin to learn when your subject's expressions will change. This is necessary if you intend to catch them on film. Once you've seen the expression you want, it's too late to click the shutter. You have to do that just a fraction of a second *before*

the "right" expression occurs. Shooting several frames in quick succession can help, but that's no substitute for the true photographer's instinct for what Cartier-Bresson named the "decisive moment." Like fishermen, photographers are continually lamenting the "one that got away." With consistent practice and a bit of luck, however, they will become few and far between.

Lighting is of critical importance in portraits. For most purposes, the best light is open shade. This may be obtained outdoors on the shady side of a tree or building, or inside near a window.

For more dramatic effects, you may want your subject to be lit more directly. If so, pay particular attention to the eyes. Many otherwise good photographs are ruined because a subject's eyes were lost in harsh, black shadows. Careful positioning will usually correct the problem. If not, you may want to use a reflector (any white or metallic surface will do the trick) to throw some light back into the shadows.

FOCAL POINT: Edward Steichen, 1879~1973

Photography was initially used simply to record visual facts. A photograph of a tree was successful if the tree was immediately recognizable. A landscape was successful if all the important features were visible. A portrait was successful if it was in focus and the subject's expression was reasonably pleasant. Gradually, photographers and the public began to demand more from this new and still mysterious medium.

One of the first to demonstrate photography's full potential for expressive portraiture was Edward Steichen. The key to his achievement was light. Before Steichen, portraits were straightforward. Photographers generally employed soft, even light and a plain gray background. The main goal was produce a clear, well-lit likeness of the subject. Steichen changed all that. He posed his subjects against black walls and used dramatic lighting, often allowing part of the face to be in shadow or otherwise obscured. His portraits were not mere records of a person's appearance, they were strong statements about who that person was.

In part, Steichen's success in portraiture was due to his training in painting. Much of his earlier work suggests paintings by Rembrandt, with clearly etched faces surrounded by darkness. However, very little of Steichen's work displays the nostalgic sentiments of the Pictorialists, who also strove for a painterly quality in their photographs. He was in fact among the first to recognize that photography was a *new* art form, with rules, possibilities and limitations all its own.

Steichen's best photographs—such as his portrait of Greta Garbo—are images that would be unimaginable in any other medium. He complemented the starkness of black and white photography with equally stark poses. He encouraged his subjects to interact directly with the camera. And he watched for just the right moment to capture something of his subject's essential character. His portraits still seem very "modern." They are dramatic, confident, even confrontational. Each one is distinct and memorable.

Steichen was born in 1879 in Luxembourg, one of the smallest countries in Europe. One year later, he emigrated to the United States with his family, living first in Michigan and later in Wisconsin. In 1900, at the age of 21, he travelled to Paris to study photography and modern painting for two years. Upon his return to the U.S, he set up a photo studio in New York City, earning a reputation for his skillful portraits of the rich and famous. In 1905, he and Alfred Stieglitz established ''Gallery 291'' in an effort to promote photography as an art.

With the outbreak of World War I, Steichen directed the photographic team of the Army Air Service, coordinating an ambitious photographic record of the war. In 1923 he returned to commercial photography, doing a wide range of work for many leading magazines. He again applied his photographic and management skills to help record World War II, this time serving with the Navy. From 1947 to 1962, Steichen was the director of photography for the Museum of Modern Art in New York City. In that role, he organized "The Family of Man," a traveling exhibit designed to promote understanding and tolerance among the many cultures of the world. Steichen died in 1973, in Connecticut.

Edward Steichen, Greta Garbo, *1928. c Sotheby's Inc., 1987.*

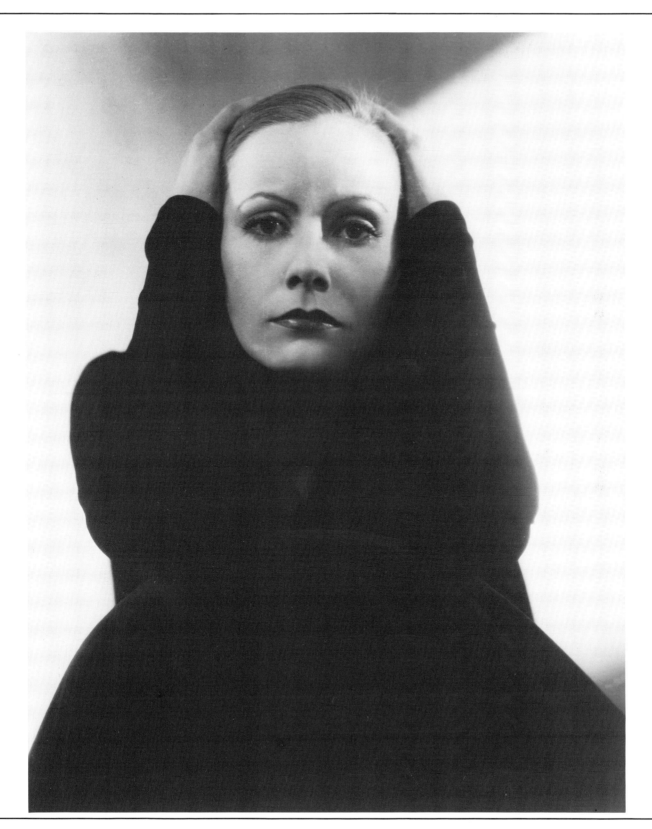

EXERCISE

Feet

Assignment: Photograph some interesting feet, with shoes on or off.

Goal: Feet can say something about a person. They have an attitude. Capture that in your photographs.

Tips: Figure out the connections between people and their feet. What kind of shoes do they wear, if any? Are their shoes new, old, shiny, dusty, worn-out, comfortable, uncomfortable, stylish, old-fashioned? How do they wear them? How are the feet positioned? What does their position tell you about what the person is feeling? What image is the person trying to convey?

Once again, look for interesting angles.

Student photograph by Vinny Rodziewicz.

Student photograph by Charles Stuart Kennedy III.

EXERCISE
Hands

Assignment: Photograph hands in expressive postures or engaged in interesting activities.

You may photograph one hand by itself, both hands of one person, or the hands of several people together. Do not include a full face with the hands, though part of a face is acceptable.

Goal: Hands, like faces and feet, have attitudes, moods, habits. Look for hands that say something about a person, or about what that person is doing, thinking or feeling.

Tips: Look for people you know who have a particular gesture that is their "signature." Alternatively, look for the various attitudes of hands (resigned, strong, casual, engaged in some task, at rest, tense) or for their position in relation to the body (behind the back, part way in a pocket, scratching the head, holding up the chin). Look also for how hands relate to their surroundings: hands reaching for something; interacting with someone else's hands; placed on somebody's shoulder; holding a baseball bat, a steering wheel, a chess piece; opening a car door.

In general, unless the context is important, the hands should be large within the frame.

Student photograph.

Student photograph by Esther Suarez.

EXERCISE
Elders

Assignment: Do a series of portraits of old people: grandmothers, uncles, aunts, neighbors, etc.

Goal: Notice that faces get very expressive as they grow older. You can often tell what kind of life a person has led just by looking at his or her face. Try to capture something of your subject's whole life in your photographs.

Tips: With the elderly, it is even more important than usual to get clear permission. Depending on how old and how healthy your subject is, the idea of being photographed may seem fine, strange or unpleasant. Help your subject feel comfortable about being photographed, before you take a single shot. If this doesn't seem possible, go find another subject. Don't just walk up to strangers and start photographing them. It is your job to make the experience pleasant and relaxing. Work at it.

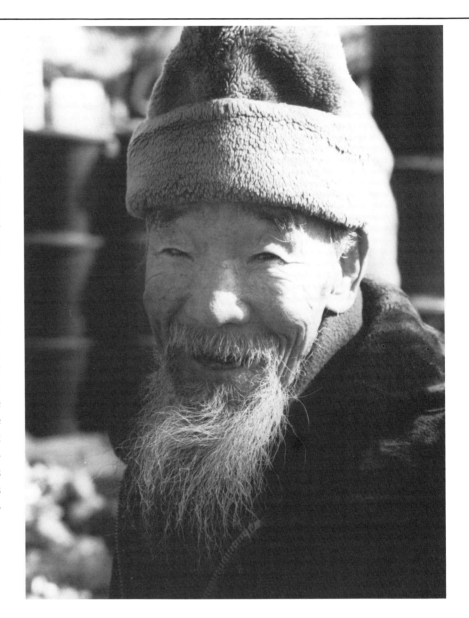

Student photograph by Joshua Noble.

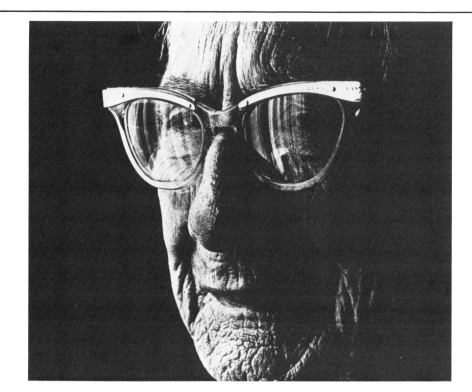

Student photograph by Kimberly S. Kosiba.

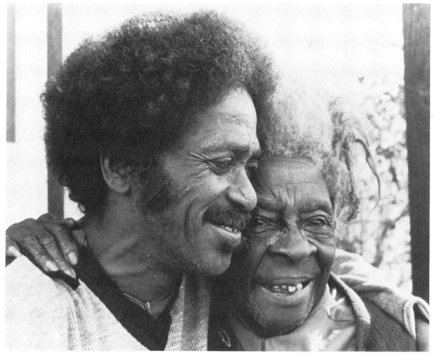

Student photograph by Neill Bevill.

EXERCISE

Children

Assignment: Photograph children doing things that come naturally to them: playing, talking, sleeping, perhaps reading or daydreaming.

Any child between infancy and about 8 years old qualifies.

Goal: Capture particularly childlike qualities, not just a person who happens to be young.

Tips: Be aware of how children respond to their surroundings. Where they are, what they're doing, who they're with may be important . . . or may not. You decide.

You'll probably get the best results with children you already know, so they can go about their business without being aware of the camera. Try your younger brothers and sisters, cousins, family friends, neighbors. If none of them is available or willing, look for children out on the street, at school, in parks, etc.

Never photograph children without getting permission from a parent. This is especially true if you don't know the child, but it's a good idea even if you do.

The main challenge is to keep the child interested and interesting. If the child is playing a game, encourage him or her to tell you about it. Try to talk to the child while you're shooting, even while you're behind camera. You may want a parent or another child to keep conversation going if it's hard to talk and shoot at same time.

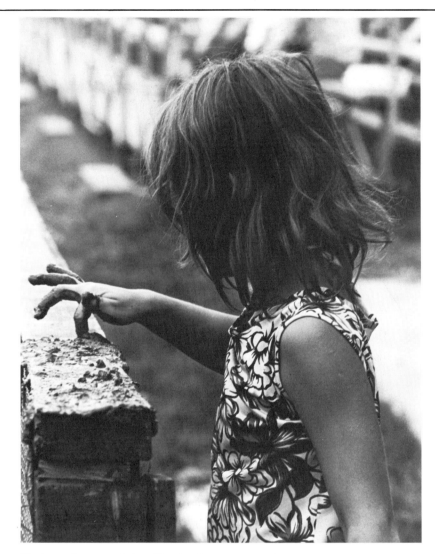

Student photograph by Charles Stuart Kennedy III.

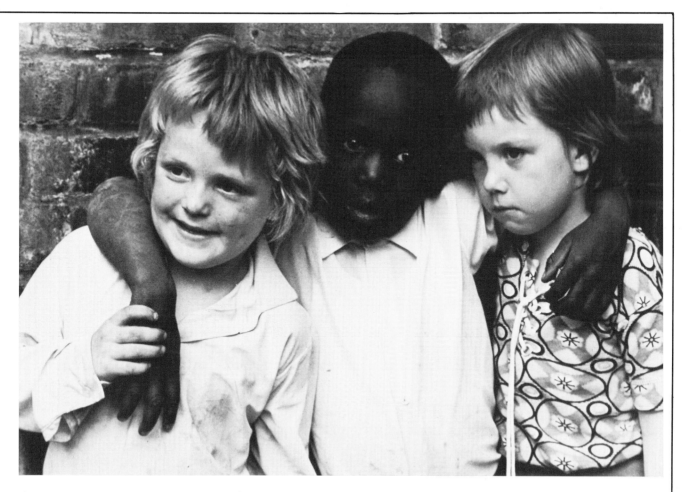

Student photograph.

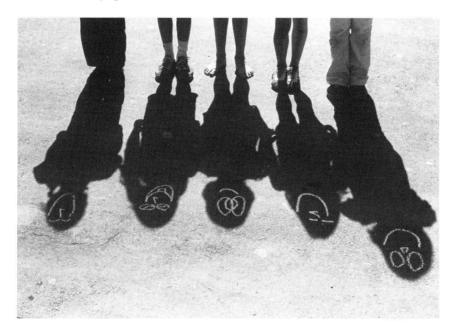

Student photograph by Chris Lombardo.

EXERCISE

Soft-Light Portrait

Assignment: Do a series of head-and-shoulders photographs in which the light source is behind the subject.

Goal: Produce an expressive portrait, with soft light and no shadows on the face.

Tips: In bright sunlight, have your subject face away from the sun. The face will thus be in open shadow, with little variation in the lighting. Keep the background out of focus by using a fairly large aperture. (Try f/5.6 at 1/125 of a second as a point of departure for this exercise.)

Be careful of "burn out": white areas that are so bright they lose all detail. Though you'll probably do best if your subject does not wear white, with proper exposure this should not be a problem.

Get in close. Frame the subject carefully. Stick to the head and shoulders for the most part, though an expressive hand is a perfectly acceptable addition.

Student photograph by Vinny Rodziewicz.

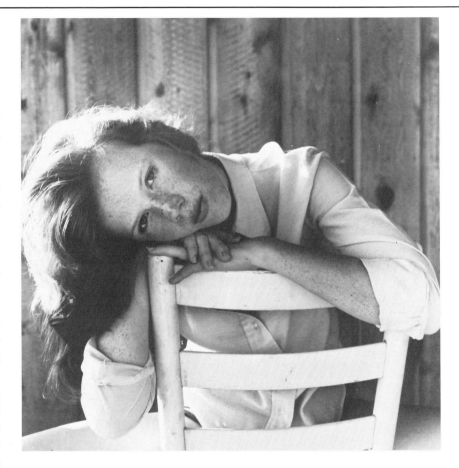

Student photograph.

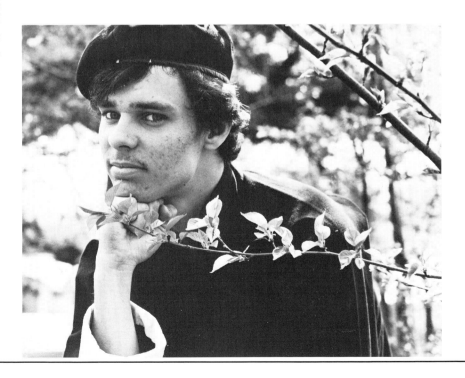

Student photograph by Norman Ryang.

Student photograph by William Roche.

EXERCISE

Side-Lit Portrait

Assignment: Do a series of portraits in which the subject is strongly lit from one side.

Goal: Side-lighting tends to be dramatic, and is often harsh, especially in very "contrasty" lighting. However, it can produce a particular mood and can be subtle when either the contrast or the overall light value is low. Control the lighting and exposure to get the effect you want.

Tips: For best results, use early morning or late afternoon light. You may want to shoot indoors near a window, so the light comes in a single shaft. You can then place your subject so the light strikes precisely where you want it to. Bracket your exposures to get the effect you want.

The degree of drama in your photographs will largely depend on the amount of detail in shadow areas. If the light is so contrasty that no details are visible in the shadows, the effect will be especially dramatic. You'll get a more natural effect if the shadow areas are gray, rather than black. Decide which effect you want and achieve it by carefully positioning your subject and by controlling exposure. As a general rule, underexposing will increase the sense of drama.

You may want the sidelit area to be the highlight of otherwise balanced lighting, or to have the sidelighting be the *only* source. In addition, experiment with placing the

subject so the lighted side faces the camera, and so the shaded side does.

Be careful of losing texture in highlighted areas. In the final print, you should be able to see pores on the brightest part of the face. Expose for the highlights.

In rare cases it can be very effective to have the whole face in shadow, *if* the background is adequately lit so features are clear.

Student photograph by Sandy Nordahl.

Student photograph by Don Ho Fuller.

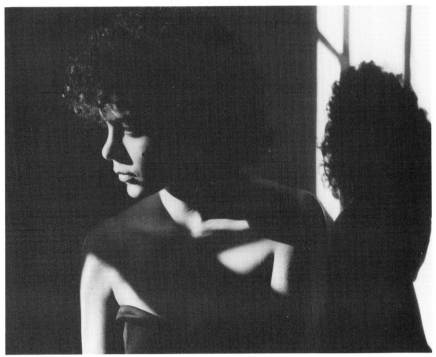

Student photograph by Kristen McCauley.

EXERCISE
Prop Portrait

Assignment: Photograph people with "props" — tools, sports equipment, musical instruments or any other object with which they can interact.

Goal: Props have two uses for the photographer. First, they can help a subject relax. Second, they can tell the viewer something about the subject. Try to select props that are useful in both of these ways.

Tips: People who are uncomfortable just standing and looking at a camera, even if you get them talking, tend to relax quite a bit if you give them something to hold or look at. Similarly, you can often produce a very revealing portrait by placing your subject in a familiar environment: in his or her own room, with personal possessions around, at a desk or workplace, in the locker room or gym, etc.

While it is often helpful if the subject can actually be using the prop in some way, be aware of how that affects the face. If it's obscured, you may have to get the subject to look up when you actually click the shutter. You may, of course, be able to position the subject (or yourself) so this isn't necessary.

Anything familiar to the subject is acceptable: a scarf, telephone, guitar, book or baseball bat. Something as simple as a chair may do the trick. Use your imagination, and don't forget to ask your subject for ideas.

(Note: Try to think of more creative props than cameras. One or two shots of someone holding a camera are fine, but no more.)

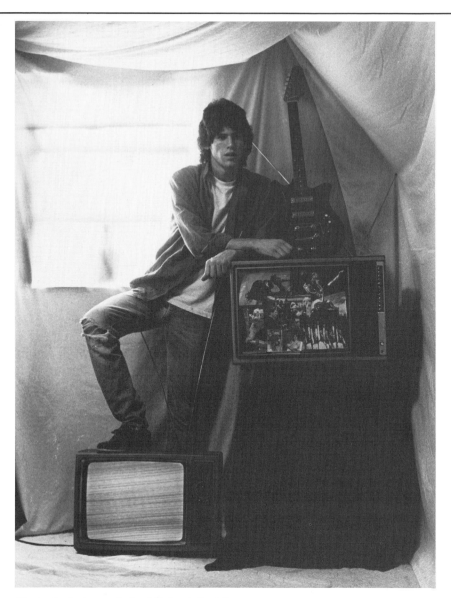

Student photograph by Michael Redding.

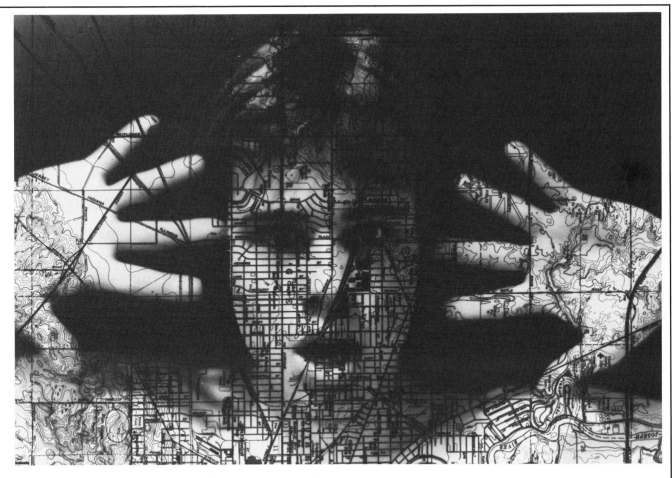

Student photograph by Scott Hughes.

Student photograph by Michael Cothran.

EXERCISE
Detail Portrait

Assignment: Do a series of "portraits" in which the subject's face is not shown. Instead, crop in on expressive details of objects that relate in some way to the subject. (Part of the face may be shown, but not all of it.)

Goal: As in the prop portrait assignments, you will be using objects to help convey a person's character. The only rule is that you must not include the full face.

You'll probably want to photograph an object the subject is either wearing or holding. This is not required, however.

Tips: Crop in on something that typifies the person you're photographing: patches on a favorite pair of jeans, a piece of jewelry, glasses, track shoes slung over a shoulder, a purse or handbag, a baseball, a book.

Keep in mind that an empty pair of shoes, for example, or a notebook by itself, or a wallet, or a coffee mug are all perfectly acceptable. The subject does not have to be in the photograph at all.

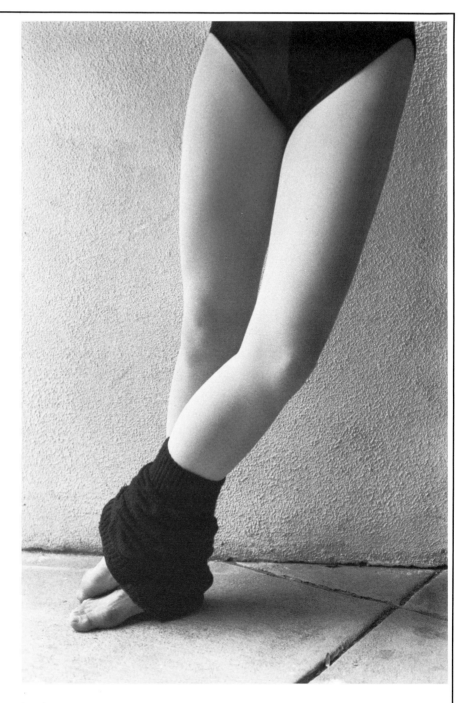

Student photograph.

EXERCISE
Mood Portrait

Assignment: Produce a series of portraits that clearly express moods.

Goal: Get more than just a picture of somebody. Capture a particular facial expression or posture to convey something of what your subject is feeling. Try to make the viewer feel the same way.

Tips: There are a lot of moods to choose from. Here are a few: happiness, sadness, curiosity, contemplation, boredom, excitement, friendliness, hostility, arrogance, delight, fear, satisfaction, anticipation, anger, patience, concentration, uncertainty, frustration.

Most of us have certain expressions or gestures that are unique, some particular way of saying who we are. If you think of someone as being jolly, how do you express that? What about solemn? Frazzled? Calm? Excited?

You might try getting several people to interact together. Or go someplace where they're likely to do that on their own, such as a football game. People in groups often don't react the same way at the same time, so you may get several moods in one shot. Alternatively, you might crop in on one person in the group and let the viewer imagine the rest of the scene.

Be selective. Surroundings may be helpful or distracting. Often, just a subject's face will be enough. However, part of the subject's body may also be expressing the mood. If that helps make a better photograph, put it in. If it doesn't, leave it out.

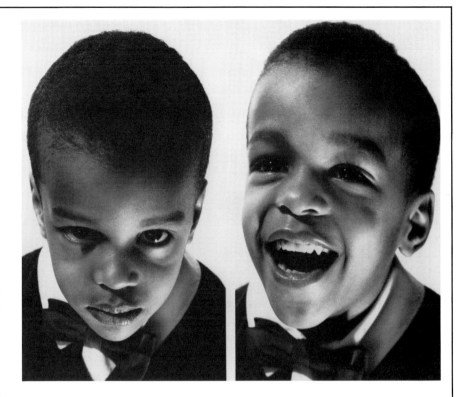

Student photograph by John Shearer.

Student photograph.

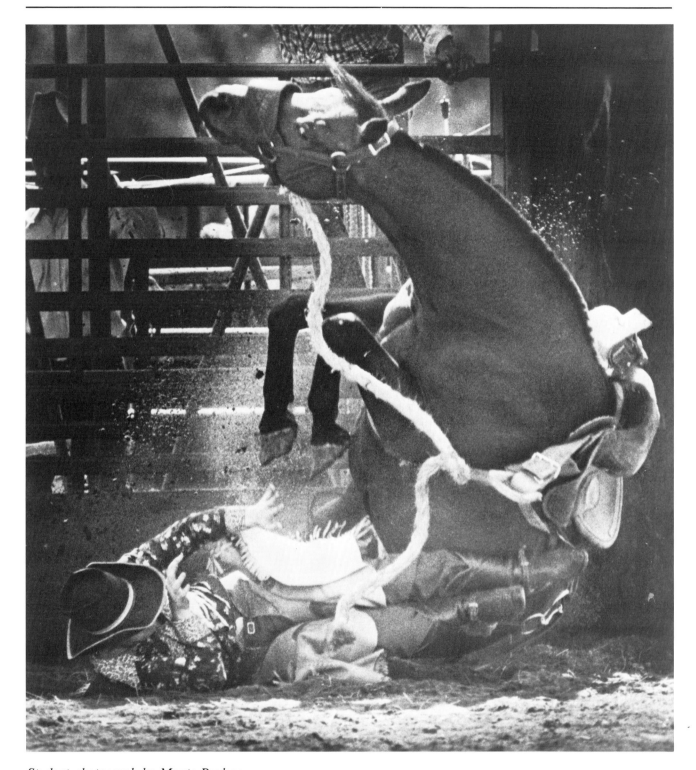

Student photograph by Monte Paulsen.

chapter 15 Putting It All Together

Photographers may be divided into two or more sides on any number of issues: manual vs. automatic cameras; 35mm vs. large format film; B&W vs. color; darkroom manipulation vs. "straight" prints. One of the most divisive issues concerns the "ultimate test" of a photographer's skill. Ansel Adams, not surprisingly, believed that landscapes deserved that title. Others have argued that the ultimate test is portraiture, photojournalism or advertising. Still others have suggested that plain old "street photography"—any photography of strangers in public spaces—tests a photographer like nothing else.

After all, landscape photographers can spend days taking a shot. Portrait photographers are helped along by their subjects. Photojournalists can count on automatic viewer interest. And advertising photographers have crowds of assistants and a small fortune in lighting equipment at their disposal.

The street photographer must make do with an instantaneous response to an unpredictable opportunity, must depend on subjects who may be violently opposed to being photographed, cannot assume any viewer interest, and must work solo, generally with inadequate equipment.

The exercises in this section are

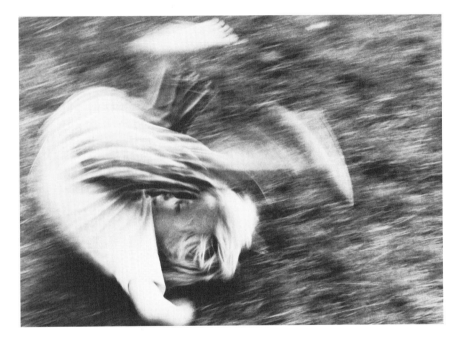

Student photograph by Sheri McHenry.

essentially variations on "street photography." They will require you to apply aspects of all three previous sets of exercises—things, places and people—all at once. As you attempt to do so, you may be dismayed at your lack of control. People moving this way and that, backgrounds that only distract from your intended subject, self-consciousness about photographing strangers may all interfere with your artistic vision. If so, relax. Part of the fun of this kind of photography is being out of control.

The trick is to remain alert and watch for the "magic." Two people interacting. Someone interacting with

the environment or an object in it. Some random grouping of people and things that is aesthetically pleasing, emotionally powerful or intellectually interesting. The second trick is to be ready to catch that magic on film. There are two essential rules for achieving that objective.

Rule #1: Adjust as many camera settings in advance as possible. First, decide on a shutter speed that will produce the effect you want: stop action or blur. Second, check out the light with your meter before you

begin photographing. If the light is fairly consistent, then set your aperture for an average reading. Adjust it for a particular shot only if you have time. (More often than not, you'll be able to produce an acceptable print, even if the negative is darker or lighter than it should be.) If your subject is likely to be difficult for any reason (such as being shy or nervous), then try to focus your lens in advance as well. Simply guess at the distance and use the distance scale on the focusing ring *or* aim at something near the subject and focus on that. Using a small aperture will help ensure accuracy. Finally be sure to advance your film before you try to grab the shot. (You'd be amazed at how often photographers forget to do this.)

Rule #2: Scan the entire frame for "interference." The most common flaw in "street" photographs is a tree growing out of someone's head . . . or some variation on that theme. A face that disappears into a matching background, legs and arms poking in from the borders of the frame and extra heads in odd places are additional examples of common interference problems. These problems can almost always be avoided with one quick glance around the frame and, if necessary, a slight shift in viewing angle before clicking the shutter. This procedure should become just as automatic as checking the light meter or focusing the lens. In fact, it is the one thing you should be doing all the time you're looking through the viewfinder. Once you have your shot all lined up, you'll almost always have time (it only takes a fraction of a second) to check out the edges of your subject and the borders of your frame just before you click the shutter.

FOCAL POINT: Henri Cartier-Bresson

Henri Cartier-Bresson (pronounced *kar-tiay brays-son*) devoted himself to the challenge of preserving "life in the act of living" — and he succeeded. In the process, he virtually invented what has since come to be *the* defining characteristic of photography: its ability to capture a fleeting instant.

From its beginnings, photography was limited by its technical requirements. Equipment was large and bulky. Film reacted slowly to light, requiring subjects to remain stationary for exposures of 15 minutes or more. Unless they confined themselves to panoramic street scenes and were content with blurs in place of people, early photographers were simply unable to pursue their craft without attracting (or requiring) attention. As a result, photographing people, from portraiture to news coverage, tended to be a rather solemn affair. Subjects would be strapped into their chairs, braced upright from behind or asked to stand very still.

The technology of photography gradually began to change. Cameras became smaller and films became faster. Despite these developments, the approach of photographers to their craft remained slow and solemn. Portraits still involved sitting up straight and staring into the unfriendly eye of the camera. Group photographs tended to convey the impression of actors posing patiently on stage. Street scenes seemed more concerned with buildings, weather and vehicles than with people. A technical requirement had evolved into a style.

Though not the first to break through this stylistic barrier, Cartier-Bresson unquestionably did so with the most flair and passion. Recognizing that a small camera permitted him to be unnoticed, he learned to "grab" events as they happened. What he lost in image quality and composition, he gained in the startling emotional impact of the image. Rather than viewing the world as a detached observer, Cartier-Bresson seemed to throw himself into the midst of things. And, through his photographs that experience could be shared by anyone.

Cartier-Bresson coined the term "decisive moment" to describe what he looked for as he explored the world with his camera. Rather than projecting his ideas or interpretations onto his subjects — as Ansel Adams, Edward Weston and others would advocate — Cartier-Bresson and others in his "school" of photography watched for that split second when all the elements of a scene fell into place on their own and "clicked." It was a radical departure, and one that is still hotly debated. Without question, however, the "decisive moment" approach has resulted in many remarkable images and profoundly affected our understanding both of photography and of the world that it records.

Cartier-Bresson was born in France in 1908. He studied in Paris and Cambridge, England. He concentrated on painting until 1931, when he began working as a freelance photographer in Europe, Africa and Mexico. He later worked with Jean Renoir, making motion pictures.

1908~

During World War II he served in the French army, was captured by the Germans, escaped and joined the Resistance. In 1946, Cartier-Bresson travelled to New York City for an exhibit of his photographs at the Museum of Modern Art. While there, he helped establish Magnum, which has long been one of the most prestigious photo agencies.

Henri Cartier-Bresson, Brussels, *1937.*

EXERCISE
Fairs

Assignment: Photograph a public gathering that fits the general idea of a "fair"—any event where people get together for festivities, entertainment, games and/or food.

Goal: People tend to go to interesting extremes at fairs: dressing up as clowns; wearing costumes from different countries or periods in history; dancing, eating, playing games and generally having a good time with exceptional enthusiasm. Try to capture this spirit in your photographs.

Tips: You may interpret "fair" to include festivals, amusement parks, carnivals, parades, cattle auctions, folk dances, craft shows, circuses, horse shows and any other similar events.

Try to take your photographs outdoors, rather than indoors. (Shooting an indoor crowd scene with even sophisticated flash equipment is no easy job.)

Think of ways to get right in the midst of the action. For example, you might get out on a ride, such as a roller coaster, and photograph people on it. Try shooting at slow shutter speeds, for blurs. Get up in a ferris wheel and shoot down.

Student photograph by Bruce Senior.

Student photograph by Amy Walsh.

EXERCISE

Open Markets

Assignment: Photograph any kind of outdoor market, from a large "flea market" to a single vendor with a cart.

Goal: Look for photo opportunities among the merchandise itself, and among the people selling it.

Try to catch people in relation to merchandise, rather than just a straight portrait of someone who happens to be selling (or buying) something. Look for money or merchandise passing between people.

Tips: Notice the sizes and shapes of various vegetables, fruits or other merchandise, the way they are arranged, the patterns they create. Watch how the vendors interact with their customers. Are they bored? Energetic? Friendly?

This is another broad category, so use your imagination. The corner grocer is okay, so is a street vendor, a yard or garage sale, a fish market, a flea market, anywhere someone is offering a service for sale (a shoeshine stall, for example), a sidewalk art show, a newspaper stand or someone selling souvenir T-shirts from a cart.

Once again, remember to ask permission.

Student photograph by Dennis Martin.

Student photographs by Chris Davis.

EXERCISE

Playgrounds

Assignment: Photograph children in action at a playground.

Goal: Try to get children actually playing—hitting a ball, upside down on a jungle-gym, using the swings or slide, etc. Avoid straight portraits of children who just happen to be at a playground.

Tips: Stay around long enough so the children get used to you. It is perfectly acceptable to ask a child (or several) to pose for you—just try to make sure the photograph doesn't *look* posed. Encourage the child to move around in the general area you've selected. Offer suggestions, but let the child come up with some ideas too.

Student photograph by Matthew Scerbak.

Student photograph by Ed Queair.

Student photograph by Vinnie Rodziewicz.

EXERCISE
Sports Events

Assignment: Photograph any sports event, outdoors if at all possible (so you won't need to use a flash).

Goal: Photographs of sports events are very common. Unfortunately, most of them are pretty bad. Your job is to get some good ones.

Tips: Be sure the center of interest is clearly isolated, either by cropping or by using shallow depth-of-field, or both. You'll generally get the best results by moving in close and/or shooting from a low or high point of view. Be very aware of what's going on in the background.

In group sports, such as football, try to get a mixture of individual and group shots. Alternate among one player, the team, one fan, the sideline crowd, etc.

Look at faces. Look at what bodies are doing: the strain of a weightlifter's arms, for example. The most important information and expression is not necessarily in the face.

Try to give particular attention to a specific quality of each sport. With football, it might be the impact of collision. With running, the solitude or tension of the final yards. With tennis, concentration or stretching for a difficult return. Try to get a feel for what is special about the sport even before you start shooting. It may help if you've had experience in the sport. If you haven't, try talking to someone who has.

Also look for the endless waiting around on the bench, the building

Student photograph by Janes Sernovitz.

tension before a player goes in, the elation or disappointment afterwards. Play with stop-action and blurs. This is a good opportunity to use a telephoto or zoom lens, if you have one. You might also get some interesting effects with a wide-angle lens. (Just be careful not to get run over!)

Notice atmospheric conditions. If the weather is interesting, you may want to do a distant shot of the game and spectators. Remember to turn around and photograph people. Catch the game in their expressions. Finally, look for objects of the sport lying around (helmets, rackets, shoes, etc.).

(Note: If you do photograph an indoor event, refer to the Appendix for information on "pushing" film and using a flash.)

Student photograph by Anne Thorstvedt.

Student photograph by Karen Demuth.

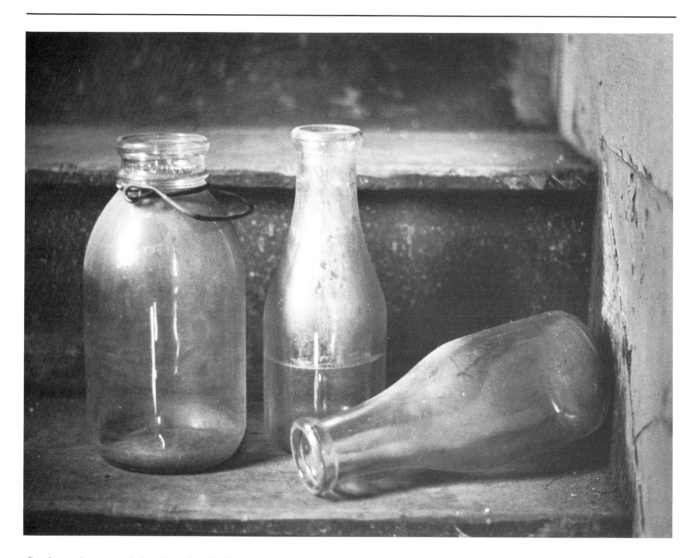

Student photograph by Dennise Dudas.

chapter 16 Breaking the Rules

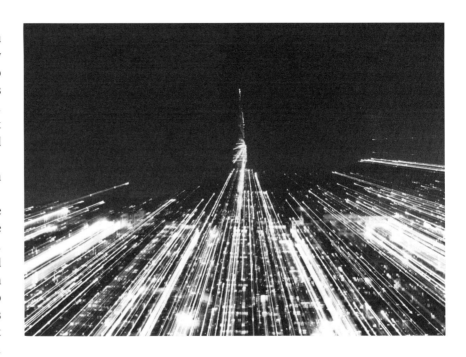

Student photograph by Helario Reyna.

T hroughout this book, you have been urged, at every possible opportunity, to bend and break the "rules." There is a very simple reason for that. Photography, like any art, must evolve to remain healthy. And all evolution requires mutations — experiments that break away from "business as usual."

For your own photographic style and insights to evolve, you must be free to record the world as you see it. If you see some aspect of the world differently than the rest of us, then our rules won't be of much use to you. If some aspect of the world has changed, then the rules of the past won't be of much use to any of us.

As each of us breaks the rules to suit our own inclinations and needs, most of those same rules are likely to remain at the center. They will continue to guide future generations of photographers, with slight shifts over long periods of time. You are now part of that process, so it's time for you to take your turn at breaking a few rules. The exercises in this section will get you started. After that, the only limit is your imagination.

Naturally there are rules for breaking rules, too. (You may feel free to break these as well, of course.)

Rule #1: Break a rule for a good reason. While it can feel liberating to break rules just to break them, the thrill isn't likely to last very long. Sooner or later, it all begins to seem like random shots in the dark. Stick to the rules until you have a good reason not to, and your results will probably be more interesting. For example, one common mistake made by both photographers and other artists is to confuse novelty for insight.

Fortunately, time tends to sort things out quite nicely. The pure novelties get tossed aside, and the true insights become lasting treasures. You can simplify the sorting process if you make a point of challenging yourself as you go along. Be especially careful to challenge any habits you develop. Are they productive? Are they causing you to miss opportunities? Do other people respond well to them? While you can't always judge your work by the response of others (many great artists were rejected at first), it can be helpful to compare notes with them from time to time. If you can't make any sense of their response, you may have a problem.

Rule #2: Break as few rules as possible. For any photograph, try to stick to as many of the established rules as you can. If you decide to break a compositional rule, try to follow the rules for correct exposure. If you want to break an exposure rule, use conventional composition. If you can't get the results you want, then—and only then—break another rule. If that doesn't work, try breaking one more. If, instead, you break all the rules at once, you're likely to end up with chaos that no one else will understand, or want to understand. Don't forget that photography is a language. If you want to be understood, you can't make up *all* your own words and grammar.

FOCAL POINT: Diane Arbus, 1923-71

Though not the most experimental of photographers, Diane Arbus was most noted, and often criticized, for breaking the rules of what is and is not an appropriate subject. For Arbus, the camera was a tool for exploring "the forbidden"—especially people who, for various reasons, were not "normal." She sought out twins, giants, midgets, outcasts and eccentrics, and photographed them just as they were. Her photographs tend to be profoundly disturbing, to raise questions and doubts, perhaps even to provoke fear.

Arbus also broke many rules of composition and technique. Her photographs tend to be very stark, with few of the comforting distractions of conventional composition. Her subjects often stand right at the center of an otherwise empty frame and simply stare at the viewer. Legs and arms are often "cut off" by the borders, so they look unnatural or awkward. If the available light was lacking, she would often use a simple camera-mounted flash, making no effort to disguise the light from it. Though her work may at first seem sloppy, her admirers argue that it is perfectly suited to the unusual subjects she chose to photograph.

Because her style and subject matter were such a radical departure from established photographic traditions, Arbus was extremely controversial. Her critics considered her a "voyeur"—a peeping-tom using her camera to pry into other people's sad lives. She, however, believed that "there are things which nobody would see unless I photographed them." To her credit, she worked long and hard to earn the trust and cooperation of her subjects *before* she aimed her camera at them.

Arbus was born in New York City in 1923. After studying painting and fashion illustration, Arbus became interested in photography. Beginning in the early 1940s, she and her husband ran a fashion photography studio, which began by doing promotional photographs for her father's fur and women's clothing store. In 1957, after years of increasing frustration with the world of commercial photography, she quit. Over the next decade, she devoted herself to photographing people on the fringes of American society. After an exhibit at the Museum of Modern Art in 1967, she became something of a celebrity and inspired many imitators. She continued to photograph people who didn't "fit" into mainstream society. However, the temperament that enabled her to communicate so well with them eventually took its toll. Arbus committed suicide in 1971, at the age of 48. Her last project was a series of portraits of the mentally retarded whom she described as "enveloped in innocence."

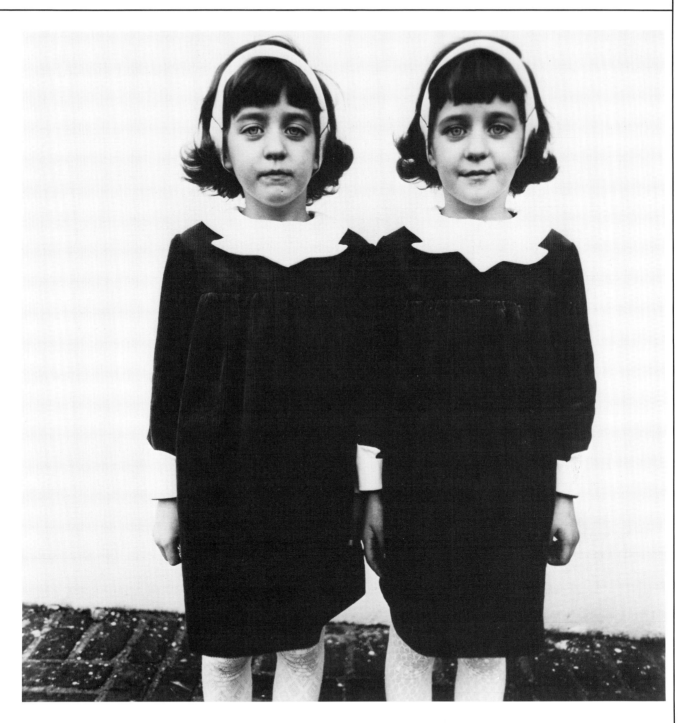

Diane Arbus, Identical Twins, *1966. c Sotheby's Inc., 1987.*

EXERCISE

Elongated Foreground

Assignment: Do a series of photographs in which the foreground fills the lower 2/3 of the frame.

Goal: See what interesting effects you can achieve by intentionally "weighting" a photograph very strongly toward the top. It's against the rules, but it can produce a great effect.

Tips: To work well, the foreground must be interesting. It may be very plain or highly patterned, but it should draw the viewer in. Bear in mind shadows and texture, reflections, contrasting values, etc.

A wide-angle lens is helpful for an assignment like this, but not necessary. If the subject is fairly close to you, try positioning yourself so you can shoot down at it. This will enable you to expand the foreground. If the subject is fairly distant, you can achieve a similar effect by getting down low as well. As always, experiment.

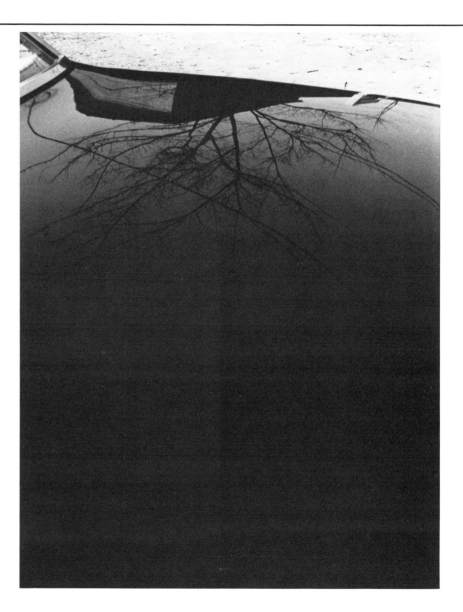

Student photograph by Marciano Pitargue, Jr.

Student photograph by Nic Tedeschi.

Student photograph by Thomas Mayeda.

EXERCISE

Rain

Assignment: Do a series of photographs of a rainy day.

Goal: Explore how objects, people and the earth interact with rain. What moods does rain provoke? How does it change the way people and things look and act?

Tips: A light drizzle is generally better than a heavy downpour. Look for how the light is striking the rain itself. Especially if it's raining and sunny at same time, the results can be stunning. (You might try using a flash to highlight the rain. Just be sure to keep it dry!)

You can shoot from under cover: standing under an awning or in a doorway, sitting in your house or in a car and shooting out a window (open or shut, wiped clean or streaked).

If you do choose to go right into the rain, be sure to protect your camera. You can use a laundry bag, for example, with holes cut for the lens and viewfinder, taped to the camera. Or, if it's not too windy, you can just keep your camera under an umbrella. It's a good idea to use a lens hood, to keep the lens dry. Moisture on the lens can be a good effect, but use it thoughtfully.

Keep shooting after it stops raining. Look for puddles, objects and people dripping droplets clinging to leaves, etc.

Student photograph by Han June Bae.

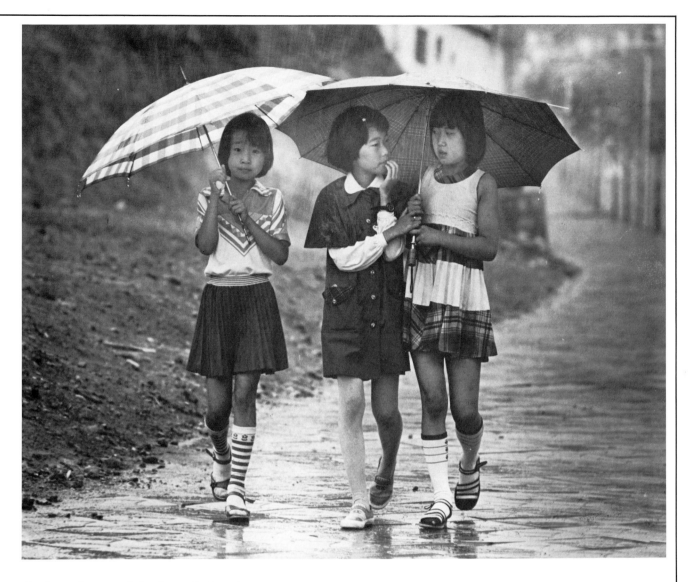

Student photograph by Steve Whiteside.

EXERCISE

Night

Assignment: Do a series of photographs outdoors at night.

Goal: By now you should have a good idea of how the camera responds to variations in daylight. How does it respond to the night? Your task is to find this out.

Tips: For best results, select a location with some artificial source of light. Streetlights, car headlights, lighted windows of a house or other building will all work well. The moon can work, but it requires good timing, luck and patience.

Take some time to find a subject that is interesting enough to deserve a lot of your time. Unless you're very lucky, you'll need to do a considerable amount of experimenting to get a single photograph that is "just right." Be patient and creative.

This is one situation in which a hand-held meter can be very helpful. If you don't own one (or can't borrow one), try shooting at f/5.6 for about 1 minute to start. (Use a stop watch to keep track of your time.) Then bracket in both directions: 2 minutes, 30 seconds, 15 seconds, etc.

Remember that doubling the time (from 1 minute to 2 minutes) will have basically the same effect as opening the lens one stop (from f/5.6 to f/4). However, at very slow shutter speeds, the ratio is not accurate, due to what is called "reciprocity failure." Basically, this means that you'll have to guess a lot. So be sure to experiment with a wide range of exposures.

You might also try using a small ("penlight") flashlight to "draw" your subject. Here's how to do it: Set your camera up on a tripod. Place your subject carefully within the frame. Open the shutter, using the "B" setting and a fairly small aperture (try f/8). Stand behind the subject and turn on the flashlight. Move the flashlight quickly along the edges of the subject, aiming it so the light is visible to the camera. After a few seconds (try 15 to start), turn off the flashlight and close the shutter. Repeat the same procedure at different shutter speeds.

Student photograph by Trevor Bredenkamp.

Student photograph by John Dean.

Student photograph by Trevor Bredenkamp.

EXERCISE
Monotone

Assignment: Do a series of photographs with a very limited range of values: black on black, white on white, or gray on gray.

This assignment is similar to the "eggs" assignment, with two important differences: 1) variations in value caused by shadows, highlights, etc. should be avoided as much as possible, and 2) any tone is acceptable (not just white). In addition, you are *not* required to photograph your subject against a background. You may prefer to crop in so the subject fills the frame. The only rule is that the overall tone of the photograph should be white, black or one shade of gray.

Goal: A contrasty print, with a full value range (from black, through various grays, to white) is generally desirable. However, limiting value to only one tone (black, gray or white) can sometimes be very effective. Find a subject that lends itself to this treatment and make it work.

Tips: Proper exposure is vital, especially if the main tone is black or white. Meter off your hand or a gray card. Remember to bracket your shots, just to be on the safe side.

Possible subjects include a black cat on a black chair, an arrangement of plain white paper, a white chair on a white porch, a black car on a black-top road, a pear on a wooden table top (both of which would show up as gray), a straw hat on a beach, etc.

For white on white, you may want to overexpose a bit, which will lighten any gray or black areas. For black on black, you may want to underexpose (to darken gray areas), but be sure

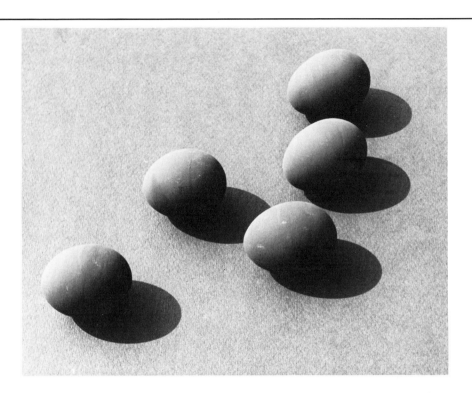

Student photograph by Helario Reyna.

Student photograph by Jack Backus.

your subject doesn't just disappear. With gray on gray, you may want a normal exposure, or one that is slightly light or dark, depending on what kind of gray is dominant and what else is in the photograph. Experiment.

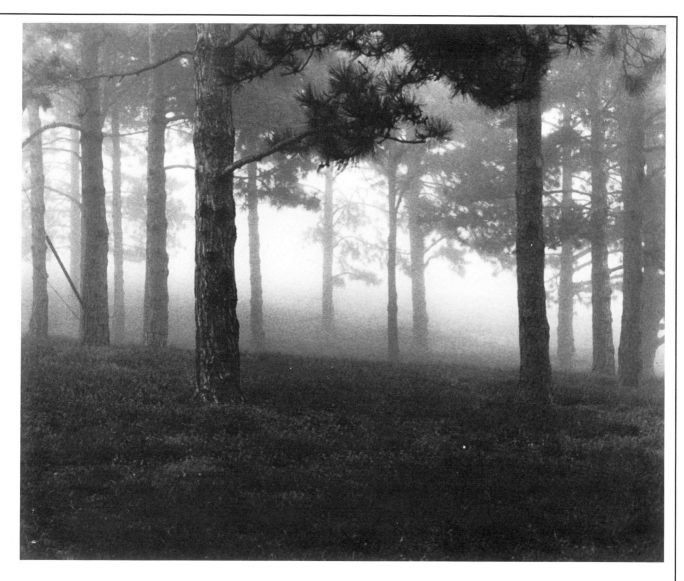

Student photograph by Dave Hornback.

EXERCISE

Silhouettes

Assignment: Photograph an object or person as a silhouette.

Goal: Make sure that the silhouetted figure makes sense as a silhouette, that it's clear and distinct. In addition, be very aware of negative space, especially if the figure is entirely within the frame of your photograph.

Tips: This assignment is difficult because you'll be shooting an object against the sky. As a result, your light meter will get *very* confused. The "point of departure" setting is no help because you don't want a normally exposed image: the figure should be black against a white sky.

So, take a meter reading off the sky and then open your lens up two stops wider than indicated by the meter. For example, if the meter indicates f/16, shoot at f/8 instead. (Remember, the meter will want the sky to be gray, which is *not* what you want.) Bracket a few stops in both directions to see what effect that has.

Try to clearly isolate your subject, unless other details work well with it. Good subjects include trees, people, playground equipment, machinery, objects with holes in them that allow some light to show through. Avoid plain rectangular shapes like a building or door, since they don't tend to produce interesting silhouettes.

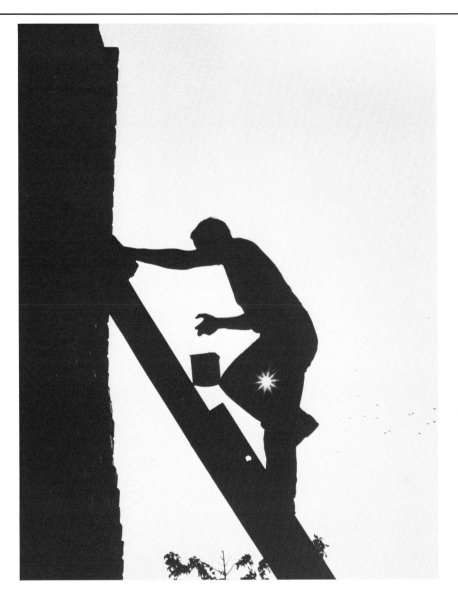

Student photograph by Darrell Converse.

Student photograph by Lynne Mattielli.

Student photograph by Jay David Blumenfeld.

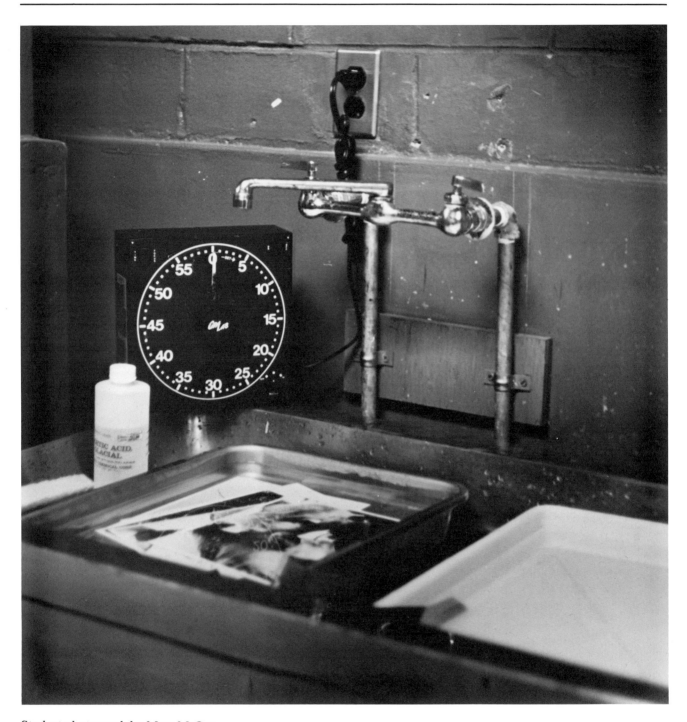

Student photograph by Marc McCoy.

appendix 1 Processing

PROCESSING FILM

Tools

• Canister Opener
The first step in processing film is to pry open the canister to remove the film. There are special tools designed for this, but a common can opener will do just fine.

• Developing Tank
The developing tank is a container that is **light-tight** (i.e., that no light can enter). It is equipped with a reel that prevents the film from sticking to itself during processing. Developing tanks come in a variety of sizes, materials, and styles. The most common version is the traditional metal tank with a metal reel. With this version, you must slide the film into the reel prior to processing it. More modern versions are made of plastic and offer innovative design features, such as a mechanism for cranking the film in, a wider mouth for pouring chemicals in and out, etc. Any tank will work well, once you learn how to use it properly.

• Chemicals
There are four stages to processing B&W film: developing, stopping, fixing and washing. First, the developer activates light-sensitive silver crystals in the **emulsion** (a gelatin coating).

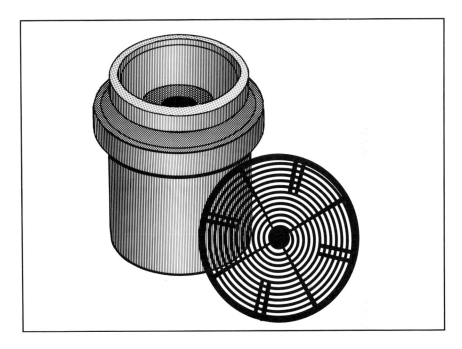

Second, the stop bath "freezes" the developing action. Then the fixer changes the chemical compounds, so they will no longer be sensitive to light. Finally, water washes away all traces of the active chemicals, so they can no longer react with each other.

Film Developer: There are many different kinds of film developers, though the basic chemistry remains the same. Developing agents (with names like metol, phenidone and hydroquinone) intensify the reaction caused by light, producing black metallic silver within exposed silver crystals. The main difference between two developers is usually the quality

of the **grain** each produces—the degree to which the silver compounds cluster together to form black lumps. Other factors, such as developing time and contrast may also be affected.

Any crystals that received light during an exposure begin turning black when immersed in the developing solution. This produces a negative image of the photographed subject. The longer the crystals are immersed, the blacker they become.

Thus, lengthening the developing time will increase a negative's contrast, since the crystals that received a lot of light will get very black. The

crystals that received no light will not be affected. Those that received a little light will become increasingly dark as the developing continues, producing a lighter print. If the developing goes on too long, the result will be a print in which the contrast will be extremely high and everything will look overexposed.

Shortening the developing time will reduce contrast, since even the crystals that received the most light will only have time to become gray.

Stop Bath: Since virtually all developers only work well in an alkaline (non-acidic) solution, the developing process will be halted if the solution becomes acidic. That's precisely what **stop bath** does.

Stop bath is simply diluted acetic acid. When the film, with developer on its surface, is immersed in the stop bath, this acid halts the development process. If you were to rinse off the stop bath and place the film back in the developer, the development process would continue.

Indicator stop bath also contains a dye that turns purple when the acid is no longer active enough to be useful. If you are using an indicator stop bath, you can safely recycle it until the dye begins to change color (to a brownish gray). Most photographers, however, simply discard it after each use when processing film. (The indicator dye is more helpful when you're processing prints.)

Fixer: "Fixing" film does two things: It dissolves all the silver crystals that have not been activated by the developer, and it hardens the emulsion. In essence, it "locks" the image.

There are two basic kinds of fixer: the regular variety (sodium thiosulphate) and "rapid fixer" (aluminum thiosulphate), which simply reacts

more quickly. The key differences between the two is speed and, of course, price.

Wash: Film must be *thoroughly* washed. Chemical traces left on the film by improper washing will interfere with the quality of your prints and may damage the negative as well. The quality of the water you use is also important. Most water that is safe to drink should be fine for washing films (as well as for diluting chemicals and washing prints).

If, however, you repeatedly discover streaks, smears, speckles or other curiosities on the film's surface, try washing a few rolls in bottled or distilled water. If the curiosities go away, then your tap water is probably the problem. It's likely to be fine for diluting chemicals and may be okay for washing prints, but keep a bottle of "good" water on hand for washing film.

Wetting Agent: A final step that is highly recommended, but not strictly essential, is coating the film with a wetting agent. The wetting agent covers the film with a slippery surface, so any impurities in the water will tend to slide off rather than stick. If you don't use a wetting agent, there's always a risk that something (mineral deposits, dust in the air, or even just bubbles in the water) will leave a permanent mark on the emulsion.

● **Interval Timer**

An **interval timer** is a device that measures the time between the beginning of a process and its end. Any timer (such as a clock, wristwatch or stopwatch) with a second-hand will do fine. There are of course a variety of very nice timers specifically designed for darkroom use . . . but you don't *need* one.

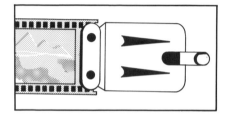

● **Negative Clips**

When you've finished processing your film, you'll need to hang it up to dry. Once again, there are special metal clips made for this purpose . . . and, once again, you don't *need* them. Plain old wooden clothespins work just as well. Whichever you use, place one clip on each end of the film, using one to hang the top up, and the other to weight the bottom down so the film doesn't curl.

Processing Tips

The golden rule of processing is BE CONSISTENT. Once you have established the chemicals, procedures and times that work for you, stick with them. Change nothing without a good reason. You will then always be able to identify and correct any problems quickly. If, on the other hand, you never do the same thing in the same way twice, you're far more likely to encounter some unpleasant surprises . . . and far less likely to know what caused them or how to correct them.

The trickiest part of film processing is getting the film loaded into the developing tank. After that, all you need to worry about is correctly timing each step.

Before you risk ruining a roll of actual photographs, practice loading the tank with a blank roll until you're *sure* you have it down pat. There's nothing quite like the panic caused by discovering that a roll of precious film is not loading correctly. With practice, you can avoid that ex-

perience. Start by loading your practice roll in normal light, so you can see how it works. Then practice in the dark.

Always be sure that your hands, opener, scissors, and developing tank are clean and *dry*—before you begin. Hands and tools that are wet or have traces of chemicals on them are a common cause of ruined film. A little planning can help you avoid a lot of regret.

Finally, darkroom chemicals deteriorate over time. Some become useless quite rapidly (once they've been mixed with water) if they are exposed to air. Therefore, they should all be stored in airtight containers, and the containers should be reasonably full. If you have only a small amount of a chemical left, pour it into into a smaller container. Flexible plastic containers are available with an accordion grid design which allows all excess air to be squeezed out. These are a useful option if you tend to store irregular amounts of chemicals for fairly long periods of time (a month is a long time for some chemicals).

Procedures
• Preparation

1. **Have all your chemicals mixed and ready to use before you begin.**
 *The developer is frequently diluted with water to produce a **working solution** appropriate to a specific film or effect. The stop bath is generally prepared by mixing a very concentrated liquid with water. The fixer may be prepared in the same way. In all these cases, be sure you have the right mixtures set aside and ready to use. It is even a good idea to have the exact amount of devel-*oper you'll need already poured into a measuring cup. You can measure the other chemicals during processing.

 Always be sure your chemicals are at the correct temperature before you begin processing. There are two ways to accomplish this.

 *If a chemical is to be diluted with water, check the temperature **before** you add the water. You can then adjust the temperature by using warmer or colder water to produce the working solution. This approach is most useful if your chemicals are still warm from mixing (some powdered chemicals require hot water to dissolve properly) or if they're cold from sitting in a storage room. In other words, this approach can be used to quickly produce a major change in temperature.*

 The second and more common way to adjust the temperature is to prepare a "temperature bath." Fill a sink or basin with warm or cool water. Place the containers of chemicals in the bath and let them soak until they are at the correct temperature. Add warmer or cooler water to the bath as needed.

 Bear in mind that the temperature will change more quickly for a small amount of a solution than for a large one. Therefore, you may want to put only the amounts you actually need into the temperature bath.

2. **In total darkness, open the film canister and slide the film out of it.**
 Pry the cap off of the flat end of the canister. Gently slide the film out, making sure the film is rolled fairly tightly, so it won't catch on the edges of the canister. Discard the canister and cap.

 *Keep the film rolled up after it has been removed. **Never** set the film down between removing it from the canister and loading it into the tank. (If you do, you may forget where it is or accidentally contaminate it by setting it down in some moist chemical residue.)*

 It's perfectly all right to touch the first 6 inches or so of the film (including the leader), since there aren't any photographs on it. Once you start loading the film, however, you will have to be more careful.

3. **Trim the leader off the film.**
 Always use scissors for this; don't tear the film. (If you try tearing the film, you're likely to bend or stretch it, which will interfere with loading.)

 *Cut straight across the film, not at an angle. Try to cut **between** sprocket holes, so the end of the film is completely straight (which will make loading easier). With practice, you should be able to do this in the dark: With your fingertips, feel for the sprocket holes on one side, and hold on to one. Begin cutting just beyond your fingertips. As you cut, feel for the corresponding sprocket hole on the other side and aim the scissors just past it.*

4. **Insert the end of the film into the developing reel.**
 The exact procedure for loading film varies according to the type of reel and tank you're using. For most plastic reels you'll need on-

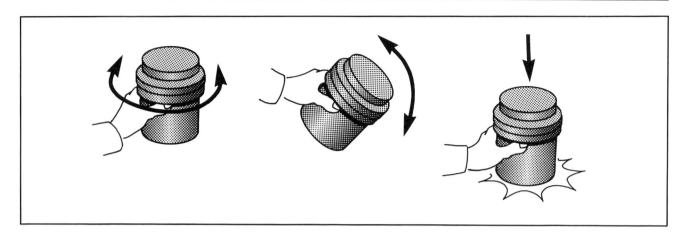

ly to feel along the outer edge of the reel for the opening and insert the film into it. For a metal spiral reel, feel on the inside for the center clip or spike. Holding the film loosely in one hand and the reel in the other, engage the film end into the clip.

5. **Load the film into the reel.**
Once the film is inserted, you will continue to slide it in, or you'll crank the reel or loader, which will slide the film in for you.

As you load the film, loosen the film on the spool so it moves smoothly. Hold the film by its edges—try not to touch the image area. The emulsion is on the inner surface of the film, so it is less risky to touch the outer surface . . . but it's still not a good idea.

As you load the film, continually check to be certain that it is not bending or catching. You may need to touch the outer surface to do this. If so, do it as lightly and briefly as possible.

With a metal reels, you'll need to squeeze the edges of the film slightly so they slide into the grooves of the reel. Try to develop a smooth and gentle movement with your hand, wrist

and arm as you slide the film into the reel, draw back to unwind it from the spool, and slide it in again.

With the crank-equipped reels, you'll have to experiment to find the technique that works best for you. You can unwind and load the film in sections, or you might prefer to let the whole roll drop and hang free from between your thumb and index finger as you crank it up into the reel.

6. **Place the reel into the tank and securely attach the top.**
Once the film is in the tank and securely covered, the hard part is over. You may now turn on the lights. Processing should begin immediately (to reduce the chances of the film being harmed by left-over chemicals).

● **Processing**
1. **Pour the developer (already diluted to the proper strength, if necessary) into the mouth of the developing tank and cap it.**

2. **Immediately after pouring, shake the tank to ensure that the film is evenly covered. Then bang the tank down a few times—hard!—to dislodge any**

air bubbles clinging to the film.

3. **Agitate the tank for specified periods of time, at specified intervals.**
Read the instructions packaged with the developer and/or film and follow them **exactly**. Both too much and too little agitation can ruin your photographs. Use a stopwatch or a clock with a second-hand to ensure precise timing.

Generally, you will be instructed to agitate the tank for 5 seconds at 30-second intervals. If so, then do exactly that. Do not, for example, agitate it for 10 seconds at 20-second intervals, or for 3 seconds whenever you feel like it. The most common cause of ruined film is incorrect or careless processing. **Follow the instructions.**

Once you have established a method of agitation that seems to work, stick with it. Unless specifically instructed to do otherwise (i.e. for a special kind of film or processing) use the exact same method every time you process film. If you alter your method significantly, you may cause problems in the processing that will **seem** to be caused by other

influences, such as incorrect exposure or exhausted chemicals.

Try this method, counting slowly from 1 to 5: On 1, twist the tank clockwise. On 2, twist it counter-clockwise. On 3, turn it upside down. On 4, turn it right side up. On 5, bang it down on a hard surface.

4. Begin pouring the developer out of the tank 15 seconds before the end of the processing time.
Unless instructed to do otherwise, pour the developer down the drain. You generally will not want to use it again.

5. Immediately after pouring all the developer out, fill the tank with the pre-mixed stop bath, cap the tank and agitate it once.

6. Leave the film in the stop bath for about 30 seconds, with some agitation. Then pour it down the drain.

7. Fill the tank with fixer and follow the timing and agitation instructions.
The same rules apply to fixing as to developing: Follow the instructions exactly. Though precise timing is less important with the fixer, you should not allow yourself to get careless. Poorly fixed film will be just as ruined as poorly developed film.

Generally, you will fix the film for about 5 minutes, agitating for 10 seconds at 1-minute intervals.

You may open the film canister in dim light during fixing. However, try to resist the urge to "peek." If you've messed up the processing, there's nothing you can do about it now.

8. Pour out the fixer.
You *may* want to re-use your fixer. Do not, however, mix used and fresh fixer unless specifically instructed to do so. (It's all right to do this if all the fixer will be used and disposed of within a relatively short period of time. It's not all right if it will be stored for a while.)

9. Wash the film for the specified time.
The simplest way to do this is to remove the top and place the tank under running water, draining it at regular intervals to ensure a complete wash.

10. Soak the film in the wetting agent.
Do not remove the film from the reel yet. Just pour the wetting agent into the developing tank after pouring out the water. Plunge the reel up and down a few times to ensure that the film is evenly coated. Lift the reel out of the tank and shake it gently. Pour the wetting agent back into its container if you plan to use it again soon; otherwise discard it.

11. Remove the film from the reel and hang it up to dry in a dust-free space.
Hang the film so the last frame is at the top (which will make it easier to file once it's dry). Let the film dry overnight, and do not touch it again until it **is** dry.

The "dust wars" begin as soon as you hang your film up to dry. If the drying area is kept absolutely clean, you'll have a good head start. If, on the other hand, it's even slightly dusty, you'll probably never win. If your film

has dust on it after drying, try to think of ways to correct the problem, or locate a better drying space.

12. Cut the film into strips and insert them into a negative file.
You have not finished processing your film until this vital step is complete. Never leave processed film hanging or rolled up or lying around any longer than absolutely necessary. (The dust wars require constant vigilance.)

Using the Negative File

Negative files generally hold either 5 or 6 frames per row and have 7 rows per sheet. The 5-frame-per-row variety with holes to fit a standard 3-ring binder is very handy. Unfortunately, it holds only 35 exposures, so you'll probably want to limit yourself to 35 shots per roll of film, so you don't have one too many frames for the file. The easiest way to do this is to advance the film until the frame-counter reads "2" before you take your first shot. You can then trim off the excess leader after processing, and you won't have to remember to stop at your 35th shot.

To use the file, fill in the label area with the date, assignment and file number, using a ball-point pen.

While the film is still hanging, cut off the leader (which should be at the bottom). Then count the number of frames that your file holds per row (5 or 6) and cut them off. Take care to cut precisely along the narrow band between frames, so you don't trim off part of the image area.

With the label of the file facing you, slip the film into the first row with the "hump" up (i.e., with the emulsion side down). Repeat until the whole roll has been placed in the file.

To avoid confusion, do not add pieces of other rolls to the file even if you have plenty of extra space in it. Don't mark the file to indicate which frames to print or how to crop them. That's what the contact sheet is for.

PRINTING

Tools

• Photographic Paper

Photographic paper is functionally the same as film, except it has opaque paper instead of clear film for its backing. Like film, it is coated with silver crystals which turn black when they are exposed to light and processed. However, the coating on photo paper reacts far more slowly than that on film.

Photo paper is graded according to its contrast. Contrast grades are generally numbered from 0 to 5—the higher the number, the higher the contrast. In some cases, descriptive words, such as soft (low contrast) and hard (high contrast) may be used to indicate contrast grades. Or you can use a variable contrast paper with filters to yield a range of contrasts.

In addition, the surface texture, image tone, base tints and weight may be indicated either with a code or a few descriptive words. **Surface texture** descriptions include **glossy** (smooth and shiny), **matte** (textured and dull) and **lustre** (in between glossy and matte). **Image tone** depends on the chemistry of the emulsion, and ranges from "cold" blue-black to "warm" brown. **Base tints,** produced by dyes that affect the color of the paper, are described as white, warm-white, cream, etc. Finally, the **weight** of a paper indicates its thickness. For photo paper, this is generally expressed as

ENLARGER

"single-weight" (S) or "double-weight" (D). (Resin coated paper, described later, comes only in "medium weight.")

Most of this information may be compressed into a single code, such as F3 (in the Kodak code). In this case, the "F" stands for glossy and the "3" stands for moderate contrast.

Whatever brand of paper you use, familiarize yourself with its code. As time and money permit, experiment with a variety of contrast grades and surfaces. To begin with, however, a glossy and moderate-to-high contrast (#3 or #4) paper should suit your purposes well. (#2 is considered "normal" contrast.)

• Enlarger

The enlarger is essentially a camera in reverse. It projects light back through the negative and focuses it onto a sheet of light-sensitive paper which, when processed, produces a positive image.

The enlarger can be raised or lowered to alter the size of the printed image. It may have one or two focusing controls. If there are two, one will be for coarse focus (getting in the right general range) and the other will be for fine-tuning. The lens is calibrated like the lens on a camera, in f-stops. Under the lens there should be a red filter which, when it covers the lens, blocks any light that might expose the paper (most photo paper is not sensitive to red light). In addition, a set of filters may be attached to the enlarger for controlling contrast, when using variable contrast paper. (Variable contrast paper used with no filter will print as #2 grade.)

• Safelight

Because photo paper is coated with a light-sensitive emulsion, just like film, it will turn black if fully exposed to light and processed. Unlike film, however, photo paper has limited sensitivity. It will generally react only to the blue end of the spectrum. Therefore, most photo papers can safely be exposed to a quite bright red or orange light. This is the reason that a safelight is safe. Nevertheless, it's a good idea not to leave uncovered photo paper near a safelight for extended periods of time, as some safelights will eventually cause the paper to **fog** (turn gray) when processed.

(Most films can also be exposed to very dim light in certain ranges of the spectrum — Plus-X, for example can tolerate some green light — but it is generally not worth the bother and risk.)

• Film Cleaners, Etc.

The simplest dust-fighting tool is a **blower-brush.** The blower is simply a rubber bulb that you squeeze to force air down the tube of the brush. The brush itself should have very soft bristles, so it can be used to "sweep" dust off film without scratching.

A more sophisticated variety of brush is the **anti-static brush** (such as the Staticmaster™). It contains a tiny amount of radioactive material that neutralizes the electrical charge of static, which helps to actually get rid of dust, rather than just move it around. An anti-static brush is a very effective and useful tool. It is slightly radioactive, however, so use it cautiously.

A somewhat tamer tool for fighting static is an anti-static cloth, such as Ilford's Antistaticum™. Provided that the cloth is sufficiently soft, smooth and lint-free, you can use it to *very gently* wipe dust off of film.

You can also use canned **compressed air** (such as Dust-Off™) to clean film. However, some of the gases used in the compression process can do more harm than good. Holding the can perfectly upright will minimize the escape of these gases. Test the product (and your technique) on film you don't care about first. If you see smudges or other signs of damage, use something else instead.

Another option is Edwal's Anti-Static Film, Glass and Chrome Cleaner™. Though not especially recommended for everyday use, this is a useful tool for cleaning up film that has gotten out of control. Use it very carefully to avoid scratching the film.

Finally, if you do scratch some film (and, sooner or later, you will), Edwal also makes a product called No-Scratch™. It covers the film with a coating that fills in scratches, making them less evident (and even invisible) in the print. While No-Scratch is a great help when you really need it, use it *only* as a last resort. It is very messy to work with and hard to clean off the film.

• Timer

You will need a fairly sophisticated timer to obtain the best possible results with an enlarger. Because you'll be measuring time in seconds (and maybe even fractions of a second), rather than minutes, it is not practical to turn the enlarger on and off by hand.

With a proper timer, you simply set the amount of time you want the light to be on and click a switch. The timer turns the light on, keeps it on for precisely the amount of time you selected, then turns it off.

• Developing Trays

Since photo paper can be safely exposed to some light, it is processed in trays instead of tanks. The trays, made of plastic, come in a variety of sizes, designs and colors. White is recommended, since it clearly shows chemical discoloration (which could be a sign of trouble). However, you may prefer to use different colors for each chemical, so you can easily tell them apart. Be sure your trays are large enough to easily accommodate your paper. A tray that is too large is better than one that is too small. On the other hand, a tray that is *much* too large will only waste chemicals.

• Tongs

Tongs, made of plastic or bamboo with rubber tips, are used to move the paper from one tray to the next. They also come in a variety of colors. Use one color for each chemical (blue for developer, red for stop bath, etc.). This will help you avoid accidentally

contaminating your chemicals. **Always use your tongs do *not* use your fingers.**

- **Chemicals**

The chemicals used for processing prints are essentially the same as those used for processing film. Some of them, in fact, can be used for either purpose. In both cases, you develop the image, "stop" it, fix it and, finally, wash and dry it.

Contact Prints

- **Additional Tools**

Glass: To make a contact print, the negative must be pressed flat against—or in *contact* with—the photo paper. The simplest way to achieve this is to place a piece of glass on top of the negative. (Though special **contact printing frames** are sold for this purpose, they are not necessary.) The glass should be heavy enough to hold the negatives flat and slightly larger than the photo paper (generally 8x10″).

It is essential that the glass be clean and unscratched, since any flaws in the glass will show up on your contacts. You should have a dry and protected place in which to store the glass, and *always* put it away immediately after using it. Wipe the glass clean with a dry, lint-free cloth (using a glass-cleaning spray if necessary) prior to each use.

Lupe: The primary function of a contact sheet is to enable you to inspect your photographs before you enlarge them. To avoid disappointing results, you need to know more than just what's in each photograph. Is it in focus? Is the lighting exactly right? Are the subject's eyes open? Is the facial expression good? These are some of the questions you can only answer with a lupe or magnifying lens.

To use a lupe, place it directly on the contact sheet over the frame you want to inspect. Bring your eye down to the lupe (don't lift the lupe) and look through it. It's important that your head does not block the light. Do not place the contact on a light box or hold it up to the window, as this will only make all the photographs look over-exposed and out of focus.

Grease Pencil: As you inspect each contact sheet, you'll want to make notes regarding which photographs to enlarge and *how* to enlarge them. The best tool for this is a white grease pencil. A grease pencil writes easily on photo paper, and can also be erased with a fingertip or tissue. A *white* grease pencil will show up fairly well even under a safelight . . . so your notes will be legible in the darkroom, where you need them most.

What sort of notes should you put on your contacts? First, mark each frame that you want to enlarge. The usual way of doing this is simply to draw a box around it. You may also want to cross out any frames that are out of focus. If you see a good way to crop a photograph, mark that as well. Finally, you may want to jot down suggestions on how to print a photograph, so you'll remember your intentions when the time comes.

- **Procedures**

1. *Turn the enlarger on and open the lens to its largest aperture.*
2. *Adjust the enlarger's height as needed until the light is covering an area slightly larger than the negative file.*

 It's a good idea to focus the enlarger when you do this, so you'll always be setting it at roughly the same height. The reason for this is that the amount of light reaching the paper decreases as the distance to the light source (the enlarger bulb) increases. You can focus the enlarger without putting a negative in it: simply adjust the focusing knob until the edges of the lighted area are crisp and clear.

3. *Set the enlarger lens two stops down.*

4. *Cover the lens with the safelight filter.*

 At this point, check to be sure that all lights except safelights are turned off, and that there are no light leaks around doors, window, etc. Leave the enlarger light on.

5. *Center a sheet of photo paper in the lighted area.*

 Remove one sheet of photo paper from its container. Always close the container immediately. Do not leave photo paper uncovered, no matter how light-tight you think your darkroom is. There's always the chance that you or someone else will turn the lights on before you've put the paper away. Learn good habits from the outset and stick with them.

6. **Place the negative file over the photo paper.**

 Be sure that all the negatives and the label area are within the paper's borders.

7. **Place the glass over the negative file.**

 Hold the glass by the edges to avoid finger-printing the image area. Gently press the glass down against the paper to ensure full contact. You may want to use a cloth for this, to keep your fingers off the glass.

8. **Turn off the enlarger.**

9. **Swing the safelight filter out of the way of the enlarger lens.**

10. **Expose the contact sheet.**

 For your first contact, follow the procedures for making test strips (see below). Later, once you know the exposure that works for you, you probably won't need a test strip except for film shot in tricky lighting situations.

Test Strip

1. **With the enlarger light on and covered by the safelight filter, place a piece of photo paper in the image area.**

 When you make your very first test strip (of a contact), you may want to use an entire sheet of photo paper. Later, you'll be able to save paper (and money) by using a smaller piece (such as 1/3 of a sheet). Always be sure that the test strip area covers a representative sampling of the photograph's contrast. In addition, be sure that the most important elements of the photograph are represented (for example, the face in a portrait). Generally, this can be accomplished by placing the test strip diagonally across the center of the image area.

2. **Cover all but one narrow band of the test strip with an opaque card.**

3. **Make a 2-second exposure.**

4. **Move the card to uncover another narrow band of the test strip.**

5. **Make another 2-second exposure.**

6. **Repeat until you have made a total of at least 8 exposures and the entire test strip has been exposed.**

Enlargements
• Additional Tools

Easel: The **easel** is simply an adjustable tool for holding photo paper in place and keeping it flat. Most easels have two **blades** which slide along a slot marked in inches. To move the blades, you press a lever which unlocks them. When you have set the blades at the correct measurements, you release the lever, locking the blades in place. Other easel designs provide standardized openings ($4 \times 5''$, $5 \times 7''$, $8 \times 10''$) or have 4 adjustable (often magnetic) blades. Here again, which tools you use is of far less importance than how you use them.

Grain Focuser: An enlargement is correctly focused only when the **grain** (the pattern of silver dots that compose the image) is in focus. With most films, you need a **grain focuser** to see the grain well enough to achieve this degree of precision. It enlarges a very small portion of the image area and reflects it up through a lens so you can see the grain clearly enough to focus it.

Before using a grain focuser, adjust the enlarger until the photograph is fairly well focused. Then place the focuser on your easel within the image area. Look through the lens, making sure your head isn't blocking the light from the enlarger. Move the focuser around within the image area until you can see clusters of black dots. That's grain. You'll be able to see more grain, and therefore to

focus more accurately, in the darker areas of the image. Looking through the focuser, adjust the focusing controls of your enlarger until the grain is nice and crisp.

(Note: If your grain focuser is equipped with a "target" like the sight of a gun, the grain will appear to move up and down, rather than in

and out of focus. To use this type of focuser, keep your eye on the target and then adjust the enlarger until the grain lines up with it.)

• Procedures
1. Insert the negative into the negative holder, emulsion-side down.

The easiest way to identify the emulsion side of a negative is to set it on a flat surface, with its edges touching the surface. The film should look like a tunnel. The underside (or ceiling) of the tunnel is the emulsion.

The reason this works is that the emulsion tends to contract (or shrink) as it dries. This is because it absorbs (and later evaporates) more liquid than the plastic backing.

You can also tell the emulsion side of film by looking at it in fairly bright light. The emulsion side is the dull side (the plastic backing is shiny). In addition, if you carefully examine it, you should be able to see layers in the emulsion side (the backing is smooth).

2. Be sure the negative is free of dust.
This is the hard part, but it is essential. For best results, use an anti-static brush before and after placing the negative in the holder. Hold the negative up against a light and check for any remaining dust spots. Use the brush or compressed air until the negative is perfectly dust-free. Bear in mind that the darkroom safelight is not bright enough to reveal dust. Turn the enlarger or room light on for this purpose.

3. Place the negative holder into the enlarger and turn the enlarger light on.
Generally, you will turn a lever to lift the lighting unit out of the way, slide the holder into place and lower the lighting unit back into place.

Be careful not to dislodge more dust when you do this. In other words, be gentle. If you suspect that dust is hiding in your enlarger, then clean it.

4. Place the easel under the lens.

5. Adjust the height of the enlarger and the position of the easel until the image is cropped the way you want it to be.

6. Turn off all room lights at this point, leaving only one or two safelights on.

7. Open the enlarger lens to its largest aperture and focus it.
Always focus at the largest aperture. This will ensure that you have enough light to focus accurately. Remember to open the lens and re-focus every time you raise or lower the enlarger head. For best results, use a grain focuser.

8. Close the lens down two stops.
This is a point-of-departure setting. Once you have acquired some darkroom experience, you'll learn to use other f-stops to achieve the effects you want.

9. Cover the lens with the safelight filter.

10. Place a piece of photo paper on the easel.

11. Expose the paper for the correct amount of time.
Follow the instructions for making a test strip if you don't know what the "correct" time is.

12. Slide the paper into the developer, face-up.

13. Immediately turn the paper face-down and let it sit for 30 seconds.

14. *While continuously agitating the tray, turn the paper over at 30-second intervals until it has been in the developer for the specified amount of time.*

Two minutes of developing, for example, would be face-down for 30 seconds, face-up for 30 seconds, face-down for 30 seconds and face-up for 30 seconds. This procedure will ensure that the print is evenly developed and may help to reduce curling.

Follow the timing instructions packaged with the developer or paper. ***Do not attempt to correct a poor exposure by changing the developing time!***

15. *Lift the paper out of the developer with tongs and gently shake excess liquid from it.*

16. *Place the paper in the stop bath for 15 to 30 seconds with occasional agitation.*

17. *Lift the paper from the stop bath with tongs and gently shake excess liquid from it.*

18. *Place the paper in the fixer for the specified time, with occasional agitation.*

Once again, read the instructions packaged with your fixer or film to determine the fixing time.

19. *Place the paper in the washing tank and wash for the specified time.*

20. *Dry the paper.*

RC (or resin coated) papers have a layer of plastic between the emulsion and the paper, and a second coat on the back of the paper, to prevent the paper from absorbing water during processing. As a result, they dry very quickly. Special drying racks are available to ensure that they dry flat, but you can achieve the same result by laying your prints face-up on towels until they dry and then pressing them under some heavy books.

*More traditional **fiber-base** papers absorb much more water. They should be dried in a **glazer** (a specially designed heater that effectively "irons" photographs). Fiber-base papers may also be dried with blotters (rolls or sheets) or electric dryers.*

Dodging and Burning

Occasionally, you will discover that there is no "correct" exposure for the entire image area of a single photograph. If you expose for the dark areas, the light areas will look washed out. If you expose for the light areas, the dark areas will look dense and "lumpy." Fortunately, you can alter the exposure of selected areas by dodging and burning.

Dodging (or **dodging out**) a photograph involves covering up part of the image so it will receive *less* light during an exposure. **Burning** (or **burning in**) involves using an opaque card with a hole in it to expose part of the image to *more* light.

• **Dodging**

Dodgers: These are simply small pieces of opaque material on sticks. You can make your own quite easily (with cardboard, wire and tape) or purchase a set at any camera store. The edges of a dodger are generally irregular to help the dodged area blend with the rest of the print.

Raise or lower the dodger to make its shadow the right size for the area you want to dodge (generally a bit smaller).

It is very important to wiggle the dodger during the exposure so the edges of the area being dodged will fade into their surroundings.

If one part of the image is too dark when the rest is correctly exposed, then you'll want to dodge it. There are two approaches to this. The first is to dodge out the dark area (or areas) while making a normal exposure for the print. The second approach, which will produce more accurate results, is to make a series of short exposures rather than one long one.

For example, let's say the normal exposure is 20 seconds and the dark area should receive only about half as much light as the rest of the photograph. Set the timer for 10 seconds and expose the entire image once for

that amount of time. Then cover the lens with the safelight filter and turn on the enlarger so you can get your dodger in position. With your free hand, turn the enlarger off and swing the filter away. Begin wiggling the dodger and activate the timer. Continue wiggling throughout the second 10-second exposure.

If, instead, you needed to dodge two areas for 5 seconds each, then you might make three separate exposures: 10 seconds for the entire print, 5 seconds to dodge one area, and 5 seconds to dodge the other area. Most of the print would still receive a total of 20 seconds of exposure.

A face in deep shadow can often be "rescued" with careful dodging. Student photograph by Mike Wiley.

• Burning

Burner: The burner is simply a piece of cardboard or other material that is thick and dark enough to prevent light from going through it. A hole (ideally with irregular or rough edges) cut in the center allows a narrow beam of light to reach the print, so only that area is exposed while the burner is in use.

If one area (or several) of a photograph is too light when the rest is correctly exposed, then burning is the answer. As with dodging, you may either slide the burner into place and wiggle it over the area while making a single exposure, or you may make a series of exposures for greater control.

Though you may want to keep a few commercially available burners on hand, you'll probably discover that it's often useful to make your own, with the hole just the right size and in just the right place for your specific needs. The black cardboard of photo paper boxes works perfectly, and its a good idea to save them for this purpose.

As with dodging, raise or lower the burner to get the size right, and be sure to wiggle it so the edges blend.

FOCAL POINT: Common Disasters

Your camera, as we've noted, is a machine. Like any machine, it won't always produce the results you expect.

Blank Film

One of the most upsetting unexpected results is an entire roll of film that comes out blank. Unless something went very wrong during processing (such as using the wrong chemicals), this means that the film did not advance correctly. (The old problem of leaving the lens cap on while shooting has been eliminated with through-the-lens cameras.) Film does not advance for one of two reasons: either it was incorrectly threaded into the take-up reel, or the sprocket holes were torn.

Both problems are fairly easy to discover and avoid. Each time you advance the film, the rewind knob should turn slightly. If it doesn't, crank it counter-clockwise until the film in the canister is tightly wound. Release the shutter and advance the film again. If the rewind knob still doesn't turn, you have a problem. Take the camera into a darkroom or use a light-tight **changing bag** to remove the film in total darkness. (If you don't, you'll probably lose any photographs you've taken so far.)

If the film is partially advanced (and therefore has been exposed), cut the exposed part away from the canister. Store it in a light-tight container, such as the black plastic containers that come with Kodak film. Develop it as usual when you can.

If no more than the first "lip" of the film (called the "leader) is extended, check the sprocket holes. If they are not damaged, reload the film carefully. If the sprocket holes are torn, cut off the damaged part of the film. Trim the new end of the film to create a new leader, and reload.

So much for finding and correcting the problem. How do you avoid it? The key is being careful to load film properly. Always advance the film at least one frame with the camera back open, so you can check to be sure it is "catching" correctly on the take-up reel. Then close the back and advance it two more frames, checking to be sure the rewind knob is turning as well.

To avoid tearing the sprocket holes, be certain as you load the film that they fit the sprocket reel properly. In addition, avoid advancing the film with abrupt, jerky movements. Instead, move the film advance lever in one gentle, steady sweep.

Double Exposures

If some frames of a roll of film are double exposed (and you don't know why), torn sprocket holes may again be the problem—especially if the two exposures don't line up exactly. Often the problem will correct itself after ruining a few frames, but only if you stop jerking the film forward and extending the tear. If the problem happens again and again even though you are being careful, take the camera to a camera shop for possible repairs.

Blurs

If your photos display blurs or poor focus, always in the same area of the frame, your lens may be flawed. The most common "flaw" that produces this result is a dirty lens. You may not notice fingerprints, water (especially if it has chlorine or salt in it), dust, and other environmental hazards until you try to make enlargements. If you make a habit of inspecting your lens before you shoot, you'll avoid a lot of frustration. Always carry lens tissue or a soft, lint-free cloth (or wear a thoroughly "broken-in" cotton shirt) to wipe the lens as necessary.

It is a good idea to use a UV or skylight filter at all times. The main reason for this is that it is far less painful to replace a scratched filter than a scratched lens. In addition, a filter can be removed for more thorough inspection than is possible with a lens. You'll be surprised by the amount of dirt that can hide on a filter and be invisible until you hold it up to the light.

If your photographs are consistently blurred, especially around the edges, the lens itself may be causing the problem. Some inexpensive zoom lenses, for example, produce distortion at large apertures or at certain focal lengths. The only solutions are to avoid using the lens under conditions that cause the undesirable results . . . or to replace it with a better (and probably more expensive) model. Before you do that, however, take the lens back to where you bought it. It's possible that the lens was improperly assembled by the manufacturer and can be repaired. (For this reason, you should always test any new camera equipment *exhaustively* while it is still under warranty.)

Scratches

If your film shows long horizontal scratches, you either have dust in the

camera or are being careless during processing. It's a good idea to blow and brush the camera's interior from time to time. Be especially careful not to load or unload film in a strong dusty wind.

IN PROCESSING

If you're at all prone to anxiety, then processing film is likely to be a nightmare for you. All those precious images sit soaking inside a little metal or plastic tank. You can't see what's going on and any mistake may result in utter disaster. Rest assured that, sooner or later, you will ruin a roll. Try to accept it as a learning experience, as your photographic dues. It happens to all of us.

Streaks
The most common cause of streaking in a negative is incorrect agitation. If you agitate the film too little during processing, you're likely to get vertical streaks (running across each frame) that line up with the sprocket holes. If you agitate too much, you're likely to get horizontal streaks (running along the edge of the film lengthwise). Both are caused by inconsistencies in the rate at which bromide in the developer is refreshed. The solution is simple: once you establish an agitation pattern that works for you, stick to it.

If you are quite certain that you are agitating the film correctly, you have been using old or contaminated chemicals. Replace them.

Polka Dots
If your film comes out of processing looking like it has a bad case of

chicken pox, you probably are having trouble with air bubbles. When an air bubble attaches itself to the film, it blocks out the developer. As a result, the film under the bubble doesn't develop. To avoid this, remember to bang the developing tank good and hard after each agitation.

Fogging
If large patches of your negative, including the narrow band between frames, are cloudy (i.e. dark gray even in the lightest areas), you almost certainly have a light leak. Check out your darkroom by closing the door and turning off all the lights. After three minutes, stretch your hand out. You should not be able to see it. If you can see it, try to find out where the light is coming from. Look along the edges of any doors and windows. Check to see if any darkroom equipment is glowing too brightly (indicator lights on your enlarger timer? a glowing radio dial?). Also examine your processing tank to be sure it hasn't developed any light leaks. Have any portions of the light trap inside the tank broken off? Is the cover not sealing properly?

White Blotches
If your negative comes out looking like irrefutable proof of UFOs, you probably failed to load the film properly onto the developing reel. If the film is stuck together during loading, it can produce an airtight seal which, like air bubbles, prevents development. Little crescent moons are caused by bending the film. The only solution is to be as careful as possible when loading, and to practice

with blank rolls until you can load correctly every time.

Scratches
You have many opportunities to scratch your film. The first is when you remove it from the canister. Be sure the film is wound tightly enough to slide out all together. The outside of the roll (the leader) is not being developed, so be sure it is protecting the rest of the roll. Your second scratch opportunity is when you transfer the roll onto the developing spool. Good ways to scratch the film at this stage include bumping or sliding it against a table or other surface, letting one part of the film edge scrape along another portion of the emulsion, or running your fingers along the emulsion (inner) surface. Once the film is in the developing tank, it is relatively impossible to scratch. Your next big chance comes when you hang it up to dry. Squeegees are the best tool for scratching. Just squeeze good and hard and you're certain to destroy the entire roll. Finally, any time the film is out of its negative file it stands an excellent chance of being scratched. Particularly effective techniques include dropping it on the floor (stepping on it just about guarantees complete destruction), sliding it through a closed negative holder, leaving it unprotected while you go out for a snack, and trying to rub dust off with a cloth that could pass for sandpaper.

Ernst Haas, City Lights. *Courtesy Magnum Photos, Inc., New York.*

appendix 2 Color

I t's a good idea to spend at least a year concentrating on black-and-white photography, before adding any other complications. As you become fluent in black and white, however, you will probably want to explore color photography as well. It is an equal, though not necessarily greater, source of discovery and expression. It is no more difficult and no easier; no more or less important, "artistic," or expressive than black-and-white. It's simply different.

Certainly every photographer should learn to work in both black-and-white and color. You may choose to use one more than the other, but you should get to know both.

This chapter is intended solely as an introduction. Full coverage of all the various aspects of color photography would require a book in itself. Color imposes a new layer of possibilities and decisions. The skills and insights you've already developed in black-and-white, however, will give you a head start.

FROM B&W TO COLOR

What changes when you move into color? What stays the same? Let's deal with the second question—and shorter answer—first.

David Hockney, Studio, L.A., Sept. 1982. *Photographic collage,* © *David Hockney. If Hockney's intention here is to simulate human sight, in what ways would you say he has succeeded?*

One key to effective color photography is including an appropriate number of colors in any single photograph. Though lots of splashy colors may be perfect for some subjects, others — such as this winter detail — achieve greater impact with a limited pallette. Notice how the green leaves stand out clearly from the more neutral brown and white background. Student photograph by Mark Harrington.

The basic photographic process stays the same. Light enters the camera and exposes silver crystals on film. The main difference is that the film has four layers, each of which captures one color of light. When these layers are dyed the right colors, they produce overlapping dots which produce a wide range of tints and shades. The result is a color image.

The equipment also stays the same, for the most part. You use the same camera and same lenses. If you do your own processing, temperature control becomes more important due to more sensitive chemicals. The enlarger must be equipped with filters for color printing. Outside of that, and a number of additional steps, the procedures remain similar.

What changes? The most obvious change is that colors will be recorded as colors, instead of black, white or gray. As a result, you'll need to be aware of whether those colors complement each other or clash. You'll have to pay attention to the ability of some colors to "steal" attention away from what you've chosen as the subject. You'll also have to learn to control the range of colors in a photograph: how many colors are in it, and how bright or dark they are.

Finally, you'll have to choose between negative (print) or reversal (slide) film. Each has its benefits and drawbacks and is suited to a specific kind of work. You'll also have to spend more money.

The following sections will provide a brief discussion of each of these issues.

Complicated Imagery

The first thing you're likely to notice when you first start working in color is that there's suddenly a lot more to think about. Color tends to make individual objects more noticeable. What was pattern in a black and white may be a chaotic mess of separate things in color, each one trying to be the dominant subject. If the background colors are too strong, they'll overpower your subject. If they're too weak, they'll decrease its impact.

The best way to begin with color, therefore, is probably to stick to a strict "diet." At first, try to have one **color theme** throughout each photograph.

Look for images in which a single color, or a group of similar colors, appears in various places. A blue car in front of a blue house, for example, or someone in a purple coat with a pink umbrella, standing next to a stop sign. This is equivalent to a painter's selection of a **palette,** a set of related colors to use throughout a picture. You might also look for lighting situations that give a **color cast** to an entire scene, such as the orange light of late afternoon, or the pale blues of a morning mist.

Once you get a feel for color themes like these, try introducing one "discordant note," a color that contrasts or even conflicts with the prevailing color theme. For example, you might photograph someone in a bright red shirt sitting in the blue car in front of the blue house.

A second way to keep color under control is to use the relative sizes of objects to structure a photo. For example, if that blue car is the subject of your photo, but the house behind it is brown and the person sitting in it is wearing a light green shirt, you

All of the basic compositional elements of black and white photography also apply to color. Notice how the repeating shapes of the bowls and peppers produce interesting visual harmonies in this photograph. The bright colors add impact, but do not alter the essential composition. Would this photograph work equally well in black and white? Why or why not? Student photograph by Josh Noble.

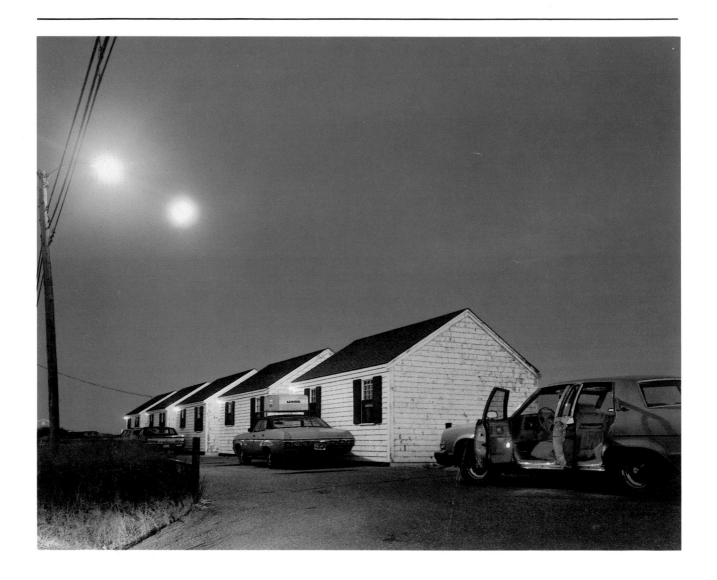

Joel Meyerowitz, Red Interior, Provincetown, *1977. Crisp focus and intensity of color give this scene a surreal air. Does there seem to be an unfinished story here?*

can't get a color theme. You can, however, move in close on that car, possibly shooting it from the front rather than the side, so it fills the frame as much as possible. The car should almost certainly cover the four key points of the composition grid. By doing this, you will ensure that the blue car is clearly dominant, and that the less important features (the person and the house) are less conspicuous.

What can you do to emphasize the person in the car? How would you compose the photo to emphasize the house?

Similarly, if you want to single out one subject from among a clutter of shapes and patterns, move in close to it. Make it as large as your composition will allow, and position it over one or more of the key points of the grid.

Another good way to single out a subject is to "spotlight" it. If the light is brighter on your subject than on its surroundings, then the subject will naturally "pop." It will stand out clearly. If the natural light doesn't provide an opportunity for this effect, you can "fake" it by using a reflector (such as a mirror or a piece

of white mat board) or flash fill (see Appendix) to throw some additional light onto your subject.

How do you achieve this? One way is to be patient and hope that either your subject moves or the light does. Another way is to make sure that the sun is behind you, so it is likely to be shining on your subject. If you do that and get up close, your subject will generally appear brighter than the background.

Sometimes you'll want to do just the opposite of "spotlighting." A shadowed or silhouetted subject can occasionally stand out beautifully from a brightly colored background.

The main thing you need to keep in mind is that a color photograph is almost always "about" color before it is about anything else. The color makes its impact first, and other elements emerge more gradually. If you don't control the color by deciding how much of it gets into the photo, then it will probably compete with your subject, rather than enhancing it.

Pow! or Subtle?

As you begin playing with color themes and different palettes, you'll also want to begin making decisions about value. Value, as you may recall, is the darkness or lightness of color tones. In black-and-white photography, value concerns the range of grays. In color photography, it essentially concerns the **density** of color. If you underexpose a color photo, you will intensify and darken the values in it. You will increase their density. If you overexpose it, you will lighten and possibly weaken them, reducing their density.

Most color photographers settle on a value level that expresses the way they see things, and then tend to stick

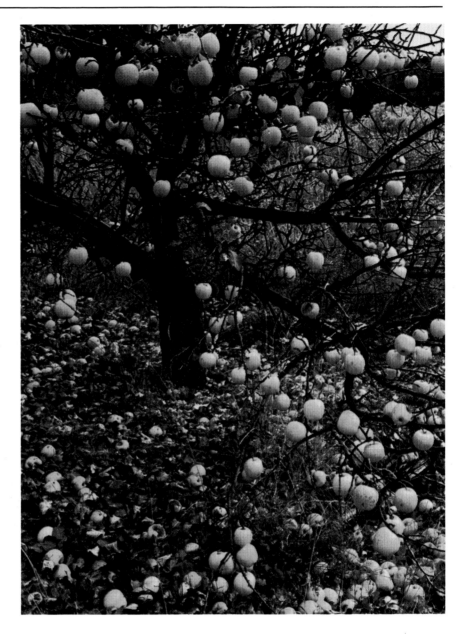

Eliot Porter. Frostbitten Apples, Tesuque, New Mexico, November 21, 1966. *Dye-transfer photograph. The Metropolitan Museum of Art, New York (Gift of Eliot Porter in honor of David H. McAlpin, 1979).*

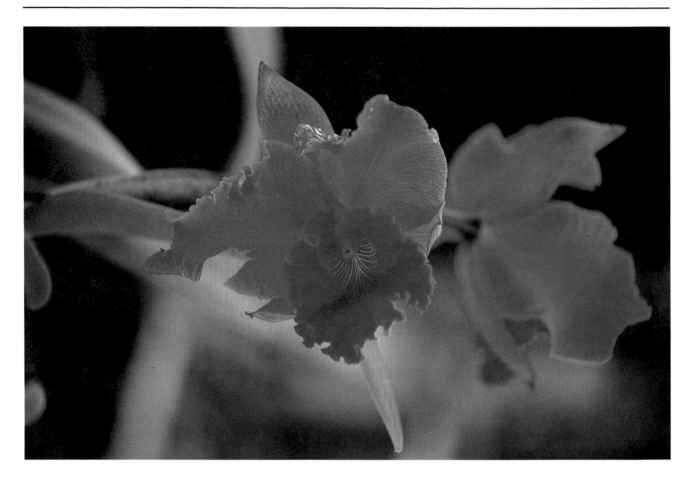

In color photography, as in black and white, selective focus can be used to clearly indicate the center of interest. In color, it is all the more important because colors tend to "fight" for the viewer's attention. Student photograph by Jeff Frye.

close to this level in most of their work. Before you decide on a consistent value level, however, be sure to experiment. The best way to do that is to bracket your shots. Make it a habit to shoot one normal exposure first, and then to try several darker and lighter variations.

After a while, you'll probably find that you generally want to set your camera a half or full stop above or below what your light meter indicates. If so, you might want to adjust the ISO accordingly. For example, let's say you want to underexpose Kodachrome 64 by about half a stop. To do that, set the ISO at 80. If you want to go even darker most of the time, set it at 100. Bear in mind, however, that you will be darkening *everything*. This means that you'll have to be especially careful to avoid

shadows on people's faces and other potential lighting problems.

If you want to get a lighter effect, you can try lowering the ISO to 50. Most color films are rated fairly low already, so it's unlikely that you'll want to set them lower, but don't be afraid to try it. Sometimes even a very pale, washed-out look is just right.

The main point here is that you should be aware of the effect that exposure has on color. Some photographers prefer a dark, or **color saturated,** style. Others prefer a very light, delicate one. Most probably prefer to stay right in the middle, with "normal" exposures most of the time. Take some time to sort out your own preferences.

TECHNICAL CONSIDERATIONS

In addition to all the various aesthetic decisions that color photography requires, there are some technical ones as well. As is usually the case, these technical decisions have aesthetic implications.

Prints or Slides?

The first decision you'll need to make is whether to use film that produces color prints or transparencies (slides). Both kinds can produce prints of roughly equal quality, but you cannot easily produce good transparencies from negative film.

Transparency film (technically called **color reversal**, since the negative is chemically "reversed" to produce a transparent positive image)

offers one distinct advantage: After it is developed, you can look at what you've got before making prints. With color negatives, you pretty well have to have prints made of an entire roll before you can choose the ones you like. Transparencies are also virtually required if you hope to have your color photographs published.

On the other hand, if you know that you will always want just prints, then print film is what you should use. This is especially true if you plan to do your own developing and printing. To get a print from a transparency, you'll probably need to make an **interneg** (by copying it onto another film) to use in the enlarger. If you have no use for the original transparency, then this merely adds an unnecessary step.

Finally, transparencies impose one

Don't forget to look for photographs in unlikely places. This reflection of a neon sign is almost certainly more interesting than a straight shot of the sign would have been. Also notice how the deep "saturated" colors add impact. With color slide film, this effect is achieved by slightly underexposing. With print film, color saturation can be controlled during exposure or printing. Student photograph by Jeff Frye.

High-speed films (some rated as high as ISO 3200), can be used in very low light. Though they are grainer than slower films, most produce quite good results. Many photographers even find the grain of high-speed films to be an asset, since it conveys a soft, moody quality. Photograph by Michael F. O'Brien.

more important consideration: cropping. Unless you plan to make your own prints from your transparencies, or are willing to pay for custom printing at a lab, you must do all your cropping when you take a photograph. Is your eye good enough so you *never* need to make corrections after a shot is taken? Shooting transparencies is a good way to find out. It's also a good way to work toward that goal.

Films

Deciding between negative and reversal film narrows your choices down . . . but not by much. Both kinds of film offer a wide range of choices in speed and other factors. The following examples of transparency films will give you an idea of your choices.

Kodachrome has been the reigning professional standard for several decades. It has a good **grain structure,** which means that the dots that produce the colored image are small and densely packed. It also has good **contrast,** so objects look razor sharp. These two factors are especially important if you hope to have your photographs published.

Kodachrome reacts particularly strongly to red, so anything red is likely to seem dominant. It's important to be aware of this, especially if your primary subject is not red. All color films have a similar bias or cast. Kodachrome is *not* especially good at rendering bright greens, so if you're photographing springtime in the park, for example, you might do better with some other film.

The grain structure of Ektachrome is not as good as Kodachrome's, giving it a "soft" quality. It also has relatively low contrast and a green bias. All these factors make it a good choice for nature photography. It is less good for some skin tones.

Fujichrome is a very bright film with a yellow bias. The brightness is the result of an unusually thin emulsion. Its grain structure is comparable to Kodachrome's, though it has somewhat less contrast. Fujichrome tends to make things look rather cheerful because of its brightness and yellow bias.

You also need to choose a film speed that is appropriate to specific subjects and lighting conditions. In most cases, you want the slowest film that will work in the light you have at the shutter speed you need. For example, on a bright, sunny day on which you plan to photograph people walking in a park, you might choose a fairly slow film, such as ISO 50 or 64. For darker lighting or faster subjects, you'll probably want a faster film, such as ISO 200 or higher.

You can get higher ISO ratings by **pushing** the film, achieving faster speed by altering the development time. The film that works best for this is Ektachrome 400. Many labs will push it to ISO 1600 or 3200. Be sure to point out that you want it pushed, and how high, when you drop off the film.

Money

One last technical issue is money. Color film costs more than blackand white. It also costs more to develop and print. While shooting many photographs of a single subject is just as good an idea in color as in black and white, it is expensive. So, experiment to your heart's content at the start. Later, once your experience grows (and your wallet shrinks), you'll probably want to be more conservative. Try to make every shot count. Don't stop bracketing, but be careful not to waste color film on subjects that are only moderately interesting. Hold out for the really good stuff.

Student photograph by John Strange, Jr.

Manipulation & Presentation

PRESENTATION

Mounting Prints

Any photograph that is to be displayed, even just for a class crit, should be mounted. This will prevent the photograph from curling and help to protect it from accidental damage.

There are several ways to mount a photograph. The most common is to use **dry mount tissue** in a heated **mounting press.** This procedure is explained below. Another, more sophisticated technique is to use a **vacuum press,** in which a special spray is used instead of the dry mount tissue. The simplest technique is to use **spray mount,** a rubber cement spray that produces an even gluing surface. This is an acceptable (and inexpensive) alternative if you don't have access to a press.

When you are ready to hang a show (and probably not before then), you will want to put your prints in some kind of frame. This is called **matting.** We'll get to that after we discuss mounting.

• Dry-Mounting: Tools

Mounting Board: You can mount a photograph on virtually any stiff fiber-board. One of the best materials is Bainbridge Board™, a thin mat board with a smooth surface. Any other non-corrugated, stiff

cardboard, however, will work almost as well.

Dry Mount Tissue: This is a kind of tissue paper that contains a special glue. The glue is activated by heat and tends to be very permanent. You will place a sheet of dry mount tissue between a print and a mounting board, like a sandwich, then heat it and press it to stick the whole thing together.

Paper Cutter: The first step in mounting a print is to trim off the white borders around the edges. You will probably also need to trim your mounting board, so a fairly heavy-duty paper cutter is recommended.

Always **be mindful that a paper cutter is a very dangerous tool. Use it carelessly and you could lose a finger. Never leave the blade up after use. Always look before you cut, to be sure no part of you, your clothing or anything else you don't want to cut is in the path of the blade.**

Tacking Iron: Before going into the press, a photograph must be anchored in place with a tacking iron. This is exactly like the sort of iron used to press your clothes, except it's smaller and has a long handle.

Mounting Press: A mounting press provides two things: heat and weight. The heat activates the dry mount tissue's glue. The weight presses everything flat. The press is

equipped with a thermostat and a light to indicate when it is at the correct temperature for mounting.

• Dry Mounting: Procedures

1. *Place the photograph face-down on a clean surface.*

2. *Place a sheet of dry mount tissue on top of the photograph.*
 Be sure the tissue is large enough to cover the entire image area.

3. *With the tacking iron, attach the tissue to the photograph, at the center.*
 Lightly "iron" the tissue so it sticks to the center of the photo-graph. Confine the tacking iron to the smallest area possible, just enough to hold the tissue in place.

4. *Trim all borders off the photo-graph (and, of course, off the tissue as well).*

5. *Place the photograph face-up on a piece of mounting board.*

6. *Lift one corner of the photograph (keeping the tissue flat against the mounting board) and tack the tissue to the board.*

7. *Cover the print with a clean cover sheet (ordinary tracing paper will do fine) and slide it, with the attached mounting board, into the press.*

8. *Close the press and let it "cook" for 5-10 seconds.*

9. *Check to be sure the print is firmly mounted.*
 The best way to do this is to gently curve the mounting board. A well mounted print will curve with it. A poorly mounted one will begin to peel away. If this happens, press it again.

10. **Trim the edges of the mounting board flush with edges of the photograph.**
 The easiest way to do this is to trim a fraction of an inch (say 1/8″) off all 4 sides of the print. Use a mat knife if you have one and know how to use it safely, or just chop the sides off with the paper cutter.

- **Spray Mounting: Tools**
 Spray Mount
 Mounting Board
 Paper Cutter and/or Mat Knife
 Newspaper

- **Spray Mounting: Procedures**

1. *Select a work area that has **plenty** of ventilation.*

2. *Spread an ample supply of newspapers on the floor (or other working surface) to protect it from the spray mount glue.*

3. *Trim all borders off the photograph.*

4. *Place piece of scrap paper slightly larger than the photograph in the center of the newspaper.*

5. *Place the photograph face-down on top of the scrap paper.*

6. *Hold the spray mount can about 12″ away from the print and spray an even coat of glue.*

7. *Let the glue "set" for at least 1 minute.*

8. *Dispose of the scrap paper.*
 The purpose of the scrap paper is to protect one print while you spray it. Don't re-use it. Don't leave it lying around. You'll soon discover that spray mount tends to get all over everything if you aren't careful. If you do get spray mount on your print, hands or clothing, wipe it off with cotton or soft cloth dipped in rubber cement solvent or thinner.

9. *Carefully set the photograph in place on the mounting board.*

10. *Cover the photograph with tracing paper (or any clean paper or cloth).*

11. *Gently but firmly rub (or burnish) the photograph to ensure that it is firmly stuck to the mounting board.*

12. *Trim the mounting board and photograph with a mat knife or paper cutter.*

Matting
- **Procedures**

1. *Select or prepare a mat with an opening slightly smaller than the print. There should be at least 2 inches of border on all sides.*

 Again, cutting mats is risky work. Do it carefully and, if necessary, with assistance.

2. *Mount the print in the exact center of a mounting board that has been cut to the same size as (or slightly smaller than) the mat. Do not trim the mounting board. Follow the steps listed above to mount the print. If you're using spray mount, center the print on the mounting board **before** spraying it, and mark the correct position for each corner. This will enable you to position it correctly without smearing spray mount all over the mounting board.*

3. *Place the mounted print face-up on a clean surface.*

4. *Set the mat face-down along the top of the mounting board. The edges should be touching.*

5. *Use an 8″ strip of masking tape to attach the mat to the mounting board.*

 This step is not strictly necessary. If you are placing your prints in frames, there's really no need to tape the mat to the mounting board. It's up to you.

6. *Fold the mat over the top of the mounting board.*

 Don't worry if the tape shows a bit, it will be covered by the frame.

7. *Sign your name on the mat just under the lower right-hand corner of the print.*

8. *Write the title of the photograph (if it has one) on the mat to the left of your signature (slightly to the right of the print's center).*

9. *If you are producing a numbered series (such as limited edition), write the print number on the mat under the lower left corner of the print.*

10. *Insert the matted print in a frame (generally under glass) and show it off.*

Hanging a Show

There are basically three approaches to selecting and arranging prints for a show. The first is to group the prints by theme (subject matter, style, tone, mood, etc.). The second is to group them by photographer (assuming there's more than one). The third approach is not to group the prints at all; just put them up in the order they come. Each approach can be quite effective. Base your decision on what feels right for all or most of the participants.

However you choose to arrange them, it is a good idea to mix verticals and horizontals as evenly as possible. You will probably want to separate black-and-white and color prints, but not necessarily.

Before you make your selection, decide where the show will be hung and calculate how many prints will fit well in the space available. They should be at least a foot apart, preferably further. Generally, it's a good idea to hang the photographs in a single row at average eye level. If you do hang all the prints at one level, be sure it is exactly the *same* level. This may require considerable adjustment, so leave yourself plenty of time for it.

Be sure you have a good method of hanging the prints . . . and one that won't destroy the walls. One method that is often successful is to suspend the prints from wires attached to the moulding along the edges of the ceiling.

Each photograph should be accompanied by a small placard with the name of the photographer, the title of the photograph, the date it was taken (month and year are sufficient) and where it was taken.

In addition, there should be some kind of sign at the entrance, to attract attention and suggest the show's theme. The theme may be nothing more than "recent work by the photography class." It may be as vague and suggestive as "light and shadow." Or it may be as specific as "views of main street." Be certain, however, that the theme is representative of the show as a whole.

In general, a show is an excellent opportunity to work as a team. By cooperating and working creatively together, you can produce something that is "greater than the sum of its

parts."

Slide Presentations

Once you've begun to experiment with color photography, you may want to produce a slide presentation. This can be done as a solo project or as a group venture.

To be effective, a slide show virtually has to have an identifiable sequence. That sequence may be chronological (the "how I spent my summer vacation" sort of thing); it may be thematic (shifting moods, lighting, a linked series of subjects, etc.); or it may follow some narrative structure.

You might want to make your own equivalent of a rock video by illustrating a favorite song. This is especially effective if the song is about some issue you care about (love songs can be tricky). You might illustrate a piece of jazz, folk, classical or contemporary instrumental music. You might combine music and narration, perhaps using poetry to suggest the themes of your photographs. You might even team up with a musician

friend and compose something entirely original.

With any of these approaches, don't feel tied to a literal expression. Instead, try to combine sounds and images that *evoke* the same mood. You might select a piece of music that suggests a certain environment to you (a forest, mountains, a river, city streets, etc.) and shoot a series of photographs of that environment.

However you structure your slide show, a few basic rules will apply. First, remember that your primary purpose must be to entertain . . . or at least to hold your viewers' interest. Even if you're sure everyone would love to watch your show till doomsday, don't let it run for more than 20 minutes. Five minutes is a perfectly good length. Three minutes is not necessarily too short.

Avoid abrupt shifts of light value from one image to the next. Don't go from a very dark slide to a bright white one if you can possibly avoid it. Certainly don't do this often. The strain on viewers' eyes will seriously reduce your show's impact.

Look for color harmonies in your slides and try to arrange them so the harmonies are evident. For example, you might have one slide of someone holding a red flower. The next slide could have someone in a red shirt standing in the same general area of the frame as the flower. If that person is also wearing black pants, your next slide might show a blacktop road in the same general area as the pants. Establishing these kinds of patterns can help provide a sense of flow.

Finally, be a critical editor. There are few things as dull as a slide show full of photographs that "got away"—overexposed, underexposed, poorly focused, poorly composed shots. If a slide isn't technically good,
it is not worth showing. Test your show on some trusted friends before you inflict it on an unsuspecting public. Do whatever you must to make it interesting, even if that means cutting out all your prized slides of your parakeet.

MANIPULATION

Sometimes you can increase a photograph's impact and effectiveness by producing a non-standard print of it. There are many ways of altering a print's appearance, some of which are explained in this section. One word of warning: It is very easy to get carried away with these special effects processes. If you're not careful, you may fool yourself into believing that you're producing great art when you're only playing visual games. Try to discipline yourself to not indulge in a special effect without a good reason.

Kaleidoscope Composite Print

By combining 4 2×3″ prints of a single photograph into one composite print you can produce startling and intriguing images with a kaleidoscope effect. It's important to be as precise and neat as possible in assembling the composite print, so it will appear to be a single image, rather than 4 pieces glued together.

You'll generally get better results with a photograph that has diagonal lines, rather then just vertical and horizontal lines. Curves, especially if they run out of the frame, also work well. The subject mater is virtually irrelevant. Any subject can produce an interesting effect . . . if the composition makes an interesting pattern.

● Procedures

1. *Place the photograph you have selected in the enlarger and turn the enlarger light on.*

2. *Set your easel up for a 2×3″ print and position it so the photograph is cropped the way you want it.*

3. *Place a sheet of tracing paper in the easel.*

4. *Draw an outline of objects in the photograph, carefully marking the exact location of key elements. Outline the frame of the photograph as well by running your pencil around the edges of the easel's blades.*

5. *After you have determined the proper exposure, expose 2 2×3″ sheets of photo paper in the usual way.*

6. *Reverse the negative.*
 This is where the outline drawing comes in handy. Place it back in the easel (upside down) and line up the projected image with it. Bear in mind that you may need to re-adjust your focus. If so, do this before you line up the image with the drawing.

 For best results, simply turn the negative holder upside down, without removing the negative. With some enlargers, however, this is not possible. In this case, you'll have to remove the negative, turn it upside down, and re-position it in the negative holder. Some adjustment may be required to get everything lined up just right.

7. *Expose 2 more 2×3" sheets.*

8. *Develop all 4 prints at one time, to ensure that they all come out exactly the same.*
 *It's a good idea to hold on to the black plastic bags in which photo paper is usually packaged. Keep them on hand for temporary storage of exposed photo paper anytime you want to do this sort of **batch processing**.*
 As you expose each sheet of photo paper, simply slide it into the bag. When your whole batch is ready for processing, you can then load it into the developer as a group. You will, of course, place each sheet of paper into the developing tray separately, but you should be able to immerse the whole batch within a few seconds.

9. *When your prints are processed and dried, experiment to see which arrangement of them is most effective.*
 Notice that you have 4 possible arrangements. Try them all and decide which produces the most interesting composition.
 If you happen to notice that your prints don't match in exposure or cropping, then do them over until you get them exactly right.

10. *Mount the prints together onto a mat board.*
 This is the tricky part. There are two ways of doing it. The first is to arrange all 4 prints on one large sheet of dry mount tissue and anchor them in place with the tacking iron. Then tack the composite print onto a piece of mounting board and press it.

Student photograph by William Roche.

The second approach, which will probably be easier and neater, is to cut the dry mount tissue to fit each print. Then tack each print to its own piece of dry mount, tack them onto the mounting board, and press them.

Whichever approach you follow, neatness counts. Be sure that all lines at the edges of the prints that are supposed to connect, do connect.

Strip Composition

Another technique for producing surprising images is to combine 2 prints of a single photograph into a single **strip print** by cutting the prints into narrow strips and re-assembling them as a single image.

Select a photograph that will gain impact or expressiveness from the "choppy" look of a strip print. Any action photograph is likely to be a good choice. Faces tend to produce humorous results. Experiment.

It is important to use a photograph with relatively high contrast. At the very least, be sure that the subject stands out clearly from the background, or the final strip print will just look like mush.

- **Procedure**
1. *Make 2 prints using exactly the same exposure and development time.*

2. *Attach dry mount tissue to the back of each photograph with the tacking iron.*

3. *Trim 1/16" off of one end of one of the prints.*
 *Whether your photograph is vertical or horizontal, you'll generally get the best results by cutting it the **long** way (i.e. cut a vertical print vertically, and a horizontal print horizontally). So, for vertical prints, trim 1/16" off the bottom or top of **one** of them. This is to ensure that the 2 prints are not quite identical,*

which improves the effect.

Leave the rest of the trim edge intact for now. Do not cut it off. You'll need some space to number the strips, and it's handy to have some blank area to work with when you assemble the composite.

4. Cut each print into narrow strips.

All the strips (for both prints) should be the same width, about 3/8". Narrower strips work well too (down to about 1/4"). Wider strips are generally less effective.

It is very important to keep track of the sequence of the strips as you cut them. You can either number them in the borders as you go, or measure where your cuts will be and number the strips before you cut them.

It is also important to keep the strips from each print separate. You may want to use different colored pens; or use "A" for one print and "B" for the other (i.e. A1, A2, A3, etc. and B1, B2, B3, etc.); or use numbers for one and letters for the other; or number one along the top and the other along the bottom . . . whatever works for you.

5. Re-assemble the strips on a mat board, alternating one strip from one print with one from the other.

The easiest way to do this is to use the tacking iron on the borders of the strips to stick them to the mounting board. Get a bunch of strips (about 1/4 of the total) tacked in place, press them, tack another bunch, press them, and so on until the whole composite print is assembled and pressed.

(Note: Do not place uncovered dry mounting tissue in the press.)

High Contrast

A high contrast print (often referred to as a **line** print) is simply a photograph that is all black or white, with no gray tones at all. A photograph of this kind has a very dramatic, graphic quality. Special "lith" film and developer are used that are not at all responsive to gray.

For best results, select a negative that will still make sense when all the grays turn either white or black. (Light grays will turn white, dark ones will turn black.) It should be fairly contrasty to begin with, so the lith film won't get "confused." Generally, a simple image (one subject against a plain background) works better than a complicated one. Elaborate patterns can, however, make very effective high contrast prints.

(Note: You can save a few steps if you have a suitable color slide to work from. In this case, your first lith film will be a negative. If the contrast looks right, you can then go directly to your final print.)

• **Tools**

Lith Film: Normally used to prepare photographs for printing, lith film has a very narrow contrast range (essentially black-and-white, with no gray tones) and fine grain structure.

Lith Developer: Though a high contrast print can be produced without using any special chemicals, lith developer is specially formulated to accentuate the high-contrast tendencies of lith film. It will convert a normal negative to a high contrast positive in one step or "generation." With ordinary film developer, you will have to make several "generations" (positive and negative copies) of a photograph to achieve the same effect.

Most lith developers come in two parts (A and B). Once they are mixed together, the resulting solution tends to deteriorate quickly. So, be sure that you have set aside enough time (and negatives) to make good use of the entire batch before you mix it up.

Opaquing Compound: Once you make copies of the original negative on lith film, you can paint out undesirable effects. The "paint" you'll use is opaquing compound (generally

Student photograph.

just called **opaque**), a sticky red goo that effectively blocks all light and dries quite rapidly.

Brushes: You'll of course need some brushes to paint on the opaque. Any ordinary watercolor brushes will work, but a relatively fine tip is desirable.

- **Procedures**
1. *Place the negative in the enlarger and prepare to make an enlargement measuring 2¼″ × 1¾″ (the size of a 120 roll-film negative).*

Be sure that your enlarger can accommodate a negative of this size. If not, then use whatever size you can. If 35mm is your only option, then simply contact print the negative onto the lith film. You may then contact print one lith film onto another . . . producing a final negative that is still 35mm.

If, on the other hand, your enlarger can accommodate a negative larger than the 120 size, then use the largest size you can. Using

the entire 4×5″ of standard lith film is ideal, since that will give you more room to work in and produce a more detailed print.

2. *Stop the enlarger lens down to f/16.*

3. *Instead of photo paper, place a piece of lith film on the easel.*
 To save on film, which is quite expensive, cut each sheet into about three pieces. Use these for your test strips.

4. Make a test strip of at least 10, 1-second exposures.

5. Develop the test strip in lith developer and ordinary stop bath and fixer.

6. Select the shortest exposure that produces a deep black in the darkest shadow areas.

7. Expose and process a full sheet of lith film.

8. Use the opaquing compound to block out areas that you want to appear as solid blacks on the final print.

9. Remove the negative from the enlarger.

10. Raise the enlarger and make a contact test strip of at least 8, 2-second exposures onto a third piece of lith film (with the aperture still set at f/16).

11. Make a full contact print at the shortest exposure that produces a deep black.

12. Use the opaquing compound to block out any areas that you want to appear as clear white in the final print.

13. Cut the the final negative out of the lith film, place it in the enlarger, and focus it as usual.

14. Make a test strip on a piece of ordinary photo paper (#4 or #5 for best results).

15. Make your final print at the shortest exposure that produces a deep black.

Solarization

A **solarized** print is produced by making a normal print on film or paper and **fogging** it (exposing it to light) during development. The effect this produces is a result of the chemistry of the photographic process.

As you know, the developer causes a chemical reaction converting silver crystals to silver metal. The waste material (bromide) of this reaction collects around the edges of the image, forming a wall. In addition, once the normally exposed image has been developing for awhile, the chemical reactions in its area will be slowing down. Therefore, fogging the image causes a greater reaction in the unexposed areas. This part turns black very quickly. Only the wall of bromide remains white. That is what causes solarization, or (as it is officially known) the **Sabbatier effect.**

• Solarizing a Print: Procedures

This is a very simple process. In fact, if you happen to dig through your darkroom trash, you'll probably find that some prints have solarized themselves without any help from you. Any print that is exposed to light before being fixed will solarize . . . including any that you throw away without fixing. You can achieve more aesthetically pleasing results, however, by playing a more active role.

Solarization is a very fluid process: one that produces highly varied results with slight variations in timing. So, once again, experiment by changing the timing of each step — but change them one at a time, so you'll know what caused the resulting effect.

1. Start as you normally would to make a normal 8×10" print: Place the negative in the enlarger, crop, focus, determine timing and expose.

2. Place the print in the developer and agitate normally for 1 minute.

3. Let the print sit with no agitation for 1 minute.

4. Expose the print to light until it begins to produce an interesting result.
 The print will begin turning gray and black at a rapid rate. Let it go for a few seconds, then turn off the light. Watch how the print develops and move it into the stop bath as soon as you like what you've got.

5. Fix, wash and dry the print normally.

• Solarizing a Negative: Procedure

This process is a bit more complicated. However, it produces superior — and more controllable — results. Since it employs lith film, you'll need the same tools as for high contrast printing.

1. Set up the enlarger to make a 2¾" × 1¼" negative.

2. Make a test strip on a piece of lith film.

3. Select the shortest exposure that produces a deep black and expose the image onto a full sheet of lith film.

Student photograph by Ray Shaw.

4. **Process the resulting positive image normally.**
 Ideally, you should let the film dry overnight. If you're in a hurry, however, you can use a blow dryer to speed things up.

5. **Raise the enlarger as you would to make an 8×10″ print and remove the negative from it.**

6. **Make a contact test strip on a piece of lith film, again selecting the shortest exposure that produces deep black.**

7. **Contact print the image onto a full sheet of lith film.**

8. **Place the lith film in lith developer and agitate normally for 40 seconds.**

9. **Place the developer tray (with the film in it) under the enlarger.**

10. **Stop agitating immediately.**

11. **Let the film settle for about 15 seconds (for a total of 1 minute of development).**

12. **Turn the enlarger on and expose the film for the same amount of time as you used for your initial print (at the same f-stop).**
 The film will turn black. Don't panic. This is what it's supposed to do.

13. **Agitate the film normally to the end of the development time.**

14. **Stop and fix the film normally.**
 After a minute of fixing, you may turn on the room light and examine the film. It should be

predominantly black, with a white outline of the image. If the negative has a lot of gray in it, double the second exposure.

15. **Cut out the image area and place it in the enlarger.**

16. **Set the lens to its largest aperture and make a test strip with at least 10 30-second exposures.**
 Depending on how fully solarized your negative is, you may need a very long exposure to make your final print.

17. **Make your final print at the exposure that produces crisp and solid black lines (not gray from under-exposure or blurred from over-exposure).**

Note: You can make a negative image (white lines on a black ground) by making a third lith film copy. This version will be far easier to print, since most of the negative will be clear. If you have trouble getting a good positive print, you're almost certain to succeed with a negative one.

Toning and Tinting

B&W photographs don't necessarily have to remain black and white. You may want to give the whole image a color tone, such as the warm, brown, "old-fashioned" look of sepia. Alternatively, you may want to add real or imagined colors to a print by painting it with photographic tints.

● **Toning: Tools and Procedures**
 Chemicals: Toning is a two-step process. First you **bleach** the print. Then you re-develop it in a **toning solution.** The easiest method of obtaining the right kind of bleach and

toner is to buy a kit that contains them both. If you can't find the right kind of kit, buy the toner and read its label to find out what kind of bleach to use. Toners are available in sepia, blue, red and other colors.

1. **Expose and process a print as normal.**
 The print should be fully fixed and washed, but need not be dried. If, however, you want to tone an already dry print, that's fine too.
 Once your original print is ready, you may work entirely in normal room light.

2. **Soak the print in the bleach solution for the specified period of time or until the blacks are reduced to pale browns (usually 2 to 3 minutes).**

3. **Place the print in the toner solution.**
 The image should become clear again within a few seconds.

4. **Soak the print in the toner, with some agitation, for the specified period of time or until the image returns to full strength (about 5 minutes).**

5. **Wash and dry the print normally.**

● **Tinting: Tools and Procedure**
 Photographic Dyes: Several manufacturers produce dyes specially formulated for tinting photographs. Ask at your local camera store.
 Cotton Balls: These will be used to dampen and paint large areas of the print.
 Brushes: Any good watercolor brushes will do fine. Try to have a

variety of sizes on hand, including at least one small brush for details.

1. **For best results, begin with a sepia-toned and mounted print.**
 A normally exposed black-and-white print is likely to be too dark in the shadow areas to be suitable for tinting. If you aren't able to use a sepia-toned print, make a lighter-than-normal black-and-white print and use that.
 Do mount the print before you begin, as the dyes may be sensitive to heat.

2. **Wipe the print with a damp cotton ball or lint-free cloth or sponge.**
 This will enable the surface of the print to absorb the tints more evenly.

3. **Dip a cotton ball into water and then add some dye to it. Use this to fill in any large areas, such as the sky, a building, foliage, etc.**

4. **Dip a brush into water and add dye to it. Paint in the smaller areas.**

5. **Use several layers of thin dye, rather than a single heavy layer, to achieve dark colors.**

6. **When the print is colored to your satisfaction, simply set it aside to dry for awhile.**

Retouching

Even if you are extraordinarily careful, sooner or later you're likely to need to hide a few blemishes on a print. That bit of dust that just wouldn't go away, a development flaw or scratch on the negative, a highlight that won't quite burn in . . . these are example of situations that require retouching.

• Tools and Procedures

The simplest, least expensive and (in most cases) least effective retouching tool is a set of paints (usually black, white and sepia) sold at most photo stores. While these can be very useful for fixing minor, *small* flaws, their utility is very limited. To use the paints (generally known as **spotting colors**), simply rub the tip of a moistened brush in the color you need, adding water until you have the appropriate shade or tint. Then paint the color on the print as needed.

A more sophisticated alternative is **spotting dyes.** These actually change the pigment of the photographic image, rather then merely covering it up. Use a very finely tipped paintbrush to apply the dye in dots. Never paint in lines or strokes, just tap out a series of small dots until you have achieved the result you want.

Always practice on a print you don't care about, to warm up and select just the right tone of dye. Some prints will need a warm gray; some will need a cold gray. Once you feel ready, start working on the actual print, beginning with the lightest grays and proceeding to any darker tones you need. Dilute the dye with

water so it is a bit lighter than the area on which you plan to use it. Then blot it almost dry on a lint-free cloth before starting to work on the print. Let it build up slowly to the shade you need.

Some dyes (such as Spotone™) actually get darker as they soak into the print surface. Be especially sure to start out light with these, as you can't remove the dye once it has settled in.

With all dyes, you may need to dampen the surface of the print so it will absorb the color well. This is especially true for RC prints.

Major corrective surgery for a badly damaged negative or print can be done with airbrushing. If you need this kind of retouching, get help from someone who already knows how to do it.

Photograph by Ron Schloerb. Courtesy The Cape Cod Times.

appendix 4 Advanced Techniques

TOOLS

Tripod

Any time you need to hold your camera very still, either during or between exposures, you need a tripod. For example, you can probably hand-hold your camera (with a 50mm lens) at 1/30 of a second without blurring the shot. With a tripod, the shutter can stay open for as long as needed without blurring. You can also use a tripod to support a long telephoto lens (if the lens needs support, it should come with a tripod mount on the barrel), to pan for action shots, to make accurate multiple-exposures or to make a series of exposures of exactly the same area.

There's no such thing as a good cheap tripod. There's also no such thing as a good small tripod. If a tripod is cheap enough to be bought without a second thought, it's almost certainly too flimsy to be useful. If it's small enough to be *carried* without a second thought, then it's certainly too flimsy.

Plan to spend close to $100 for a good tripod. Also plan to complain a lot about how heavy your tripod is. Don't carry it around unless you expect to need it.

A good tripod is, above all, sturdy. When extended to its full height, it should not wobble, wiggle or shake

in the wind. Its full height, for most purposes, should bring the camera at least up to your eye level, preferably higher. The tripod's **head** (the platform on which the camera is mounted) should move through all conceivable angles (up, down, around, and side to side). It should lock tight and loosen quickly and easily.

As for options, one hotly debated choice concerns the **leg releases,** which either clip or screw open and shut to unlock and lock the leg extensions. Clip releases tend to be faster to operate and are less likely to "freeze up."

One option that is unquestionably desirable is a removable or releasable camera mount. On the simplest tripods, the camera screws directly onto the tripod head. Unfortunately it can often be exceedingly difficult to *unscrew* it. The solution is to have a mount that can be removed or released by flipping a lever.

Additional options that come in handy but are not necessary include metal prongs that screw out of the rubber tips on the ends of the legs (to anchor the tripod in soil); a level (to help in aligning the tripod on uneven ground); and a circular scale (for measuring off camera positions for a panoramic series of shots).

When you use a tripod, first adjust the legs so the head is just below the height you need. Be sure the legs are spread out fully. Plant the feet firmly in the ground if you're outside. Check to be sure that the tripod is sturdy. If it isn't, adjust it. Attach the camera body (or lens) and crank the head up to the desired position. Aim the camera at your subject. Adjust the head (or the legs if necessary) until the camera is level—line it up with the horizon if possible. Shoot away.

For very long exposures (i.e., over 1/8 of a second), use a **cable release** to avoid camera shake. Unfortunately, some shutters will still produce a considerable amount of camera shake, especially if the camera is fairly light and the tripod is unsteady. If your tripod does wobble despite your best efforts to make it stand still, you may do better by pressing down *hard* on top of the camera and pressing the camera's own shutter release. Just be sure you don't wiggle during the exposure. (This only works for exposures down to about 2 seconds.)

A short, inexpensive tripod *can* be very useful in emergencies. It will cover your needs for steadiness under most conditions . . . so long as you can set the tripod on a table or can get the shot you want from a very low angle. Do *not* extend the legs if they are at all wobbly.

For sports photography requiring long telephoto lenses and other situations in which a moderate degree of steadiness will suffice, you might try using a **monopod,** which has one leg instead of three. Since you have to provide the other two legs to hold the thing up, it won't be much help for very long exposures.

Filters

There are essentially three kinds of filters: atmospheric, colored and special effects. Each kind has very specific uses.

The basic atmospheric filters are UV, skylight and polarizing. The first two have very mild effects on the quality of the sunlight. Their greatest utility is in protecting the lenses from accidental damage.

The polarizing filter is more interesting. Under certain lighting conditions, it can reduce or eliminate glare on glass, water or other partially reflective surfaces. It can darken colors dramatically. And it can make clouds far more vivid in contrast to the sky. Though most useful for color photography, a polarizer can help for black-and-white as well. To use one, focus on the subject and then turn the outer rim of the filter. This shifts the polarization, often substantially altering the image quality.

Color filters have very different effects in black-and-white and in color. When used with black-and-white film, they can compensate for the film's limited responsiveness to certain ranges of the spectrum. A color filter lightens the black-and-white rendition of its own color and darkens its complementary color. Red, for example, *lightens* red and *darkens* blue.

When used with color film, colored filters can produce subtle or dramatic shifts in a subject's appearance. A subtle shift might be produced by using a light orange filter to enhance a sunset, for example, or by using a light magenta filter to "warm up" the bluish tones of twilight. A dramatic shift might be to use a green filter to make your friends look like Martians. Used carefully and for specific purposes, color filters can be very useful expressive tools.

Finally, special effects filters do all sorts of things. Some play tricks with light, some play tricks with color, some play tricks with your vision. A **defraction** filter may make every point of light into a starburst or a mini-rainbow or a repeating pattern. A **multi-color** or **split-field** filter combines two or more colors, such as purple and yellow, to produce a surreal lighting effect. A **multiple image** or **prism** filter scatters a series of "ghosts" of a subject all around the

image area. Special effects filters (like print manipulation) should be used very sparingly and only for good reasons. Used too frequently, they quickly become boring cliches.

Motor Drive

If you need to make several exposures fairly quickly—as in sports photography—then a motor drive or auto winder may be a good investment.

An auto winder, the less expensive choice, automatically advances the film after each exposure. This is all the winding assistance that most photographers actually need.

A motor drive does the same thing, but does more as well. Generally, a motor drive will trigger 5 exposures, for example, every time you release the shutter . . . or 2, or 10, or whatever number you select. It may also have a delay and/or interval timer, which will release the shutter after a specified time or at specified intervals. Unless you have a clear need for these features, a motor drive is primarily an excellent way to waste film. Stick with the auto winder unless you have a good reason not to.

Flash

A modern electronic flash emits a very short (often 1/500 of a second or less) burst of light that is essentially the same color as midday sunlight. To work properly, the shutter must be in sync with the flash, which means that it must be wide open at the exact instant that the flash fires. If it isn't, only part of the frame will be correctly exposed. The traditional standard setting for electronic flash sync is 1/60 of a second. Recently, however, there's been a trend toward faster flash sync speeds (from 1/125 of a second all the way to 1/1000), which can more effectively freeze

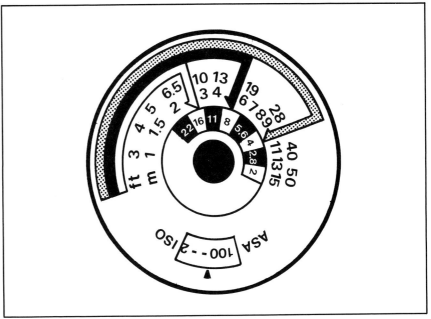

motion.

The flash sync speed should be indicated on your shutter speed dial. It may appear in a different color than the other shutter-speed numbers, or it may be marked with a lightning bolt. Any shutter speed lower than the sync speed will work fine with the flash. You may get a **flash-and-blur** effect at a slower speed, with the flash producing a crisp, bright image and the rest of exposure producing a darker blur. This can be very effective or disastrous, depending on your intentions.

Most camera-mounted flashes (i.e. non-studio models) offer one or a few f-stop options. If you have a choice, you select the f-stop that will work best for the range you need to cover (the approximate distance between the *flash* and the subject). The flash then sends out an appropriate amount of light.

More recently designed flashes allow you to shoot at any aperture (with some distance limitations) and will pass your instructions along to the camera for you (automatically setting the aperture and even the shutter speed). Though these models cost over $100, they are very useful if you need a flash often.

A camera-mounted flash is triggered through a hot shoe, the little clamp above the viewfinder. This sends an electrical impulse to the flash when the shutter opens, so the flash knows when to fire. Some flashes can also be connected to the camera by a cord attached to the X-sync outlet on the camera body. This permits you to place the flash somewhere other than on top of the camera, which often produces a more natural lighting effect.

Flash fill can be used to add light to undesirable shadows.

• **Using a Flash**

The basic rule for using a flash is this: A flash has been used well when it doesn't appear to have been used at all. There should be no black ghosts around your subject, no bleached out faces, no red dots in the eyes. Unfortunately, this is a lot easier said than done.

There are two basic applications for a flash. One is **flash fill,** in which the flash simply adds to the existing light. The other application is **controlled lighting,** in which the flash is the dominant, or only, light source.

Flash Fill: Often, even when you're shooting outside in bright sunlight, you won't have the right amount of light in some critical area of your composition. A subject's face may be in shadow, for example, or the background may be too bright. Situations like these call for flash fill.

In the first case (a subject's face in shadow) you can use the flash to balance the lighting. Let's say the overall light of your image area calls for an exposure of f/8 at 60 (remember to use the flash sync speed!). If

you set your flash for f/5.6 (assuming you can) and expose the film at f/8, the subject's face will still be slightly darker than the surrounding area, but all the features should be clearly visible. With luck and practice, no one will know that you used a flash.

If you set the flash for f/8, the subject's face would be just as well lit as anything else in the photograph. This tends to produce "flat" effect and is generally not desirable.

What happens if you continue to raise the flash's power? It begins to "take over" and control the lighting. Let's say you set both the flash and the camera lens at f/16. The background will still be receiving only an f/8 amount of light (assuming the flash doesn't reach far enough to light everything up). So, the subject will now be brighter than the surrounding area. The effect will be a bit odd, but may be very dramatic and interesting as well.

Depending on the flexibility of your flash, and how well you learn to use it, you can gain a tremendous

amount of control over everyday lighting situations.

Controlled Lighting: But what about the non-everyday situations? Perhaps you need to shoot indoors or at night. You will then have to rely on your flash as the primary or sole light source. This is a good deal more difficult than flash fill.

While you can get good fill results with virtually any flash, controlled lighting pretty well requires a flash with an adjustable head. At the very least, it should swivel sideways. Ideally it will swivel up and down as well. In addition, a flash equipped with its own light meter (which tells it when to stop firing) will produce far more consistent results with far less hassle than one that you must control manually. But, here again, make do with what you have.

The first rule for controlled lighting with a flash is never point the flash directly at your subject. There are, of course, exceptions to this rule . . . but not many. Direct flash tends to produce stark and unpleasantly artificial lighting. Instead, try to **bounce** the flash's light off something, which will soften it and spread it around more naturally.

Indoors, the ceiling often works perfectly for this purpose, if it is fairly low and light in color. Angle your flash head (assuming it is adjustable) so its light will shoot up to the ceiling and bounce down right on the primary subject of your photograph. If your angle is too low, the light will end up behind the subject. If it's too high, it will light a little pool at your subject's feet.

If you don't have access to a nice white ceiling (or even if you do), you can steal a trick from photojournalists: the white card. Any card will do; a standard 3 × 5 note card is

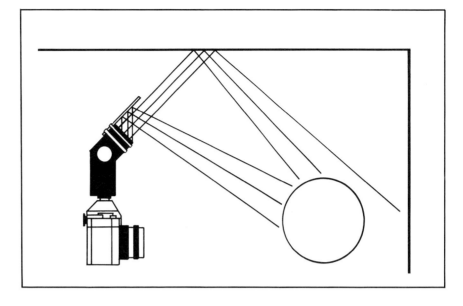

Attaching a white card enhances the effectiveness of "bouncing" the flash off a ceiling indoors.

very commonly used.

Wrap a rubber band around the flash head and slip the card in under it, with most of the card sticking out beyond the head. Angle the flash so it is aimed above the subject (bouncing off the ceiling if possible). As most of the light from the flash shoots upwards, part of it will be reflected from the white card directly into the subject. The light that hits the ceiling will help to illuminate the surrounding space. With luck and skill, you can produce very adequate and natural lighting with this technique, indoors or out. (Look closely at the next press conference you see on TV and you're certain to spot a few photographers using this trick.)

You can often find or concoct other reflecting surfaces as well: a white wall, a window (which can reflect light from the inside as well as let it in from the outside), a large sheet of white paper or mat board, etc. Keep your eyes open and you'll generally find what you need.

Shooting for Publication

If you hope to have some of your photographs published (don't we all?), you'll have a head start if you're familiar with some basic guidelines.

First of all, it is a very good idea to obtain **releases** from everyone you photograph. It is *required* for virtually all journalistic photography. A release is a signed contract giving you permission to use a person's photograph in certain ways. If you have a photograph published without a release, there's always a chance you'll be sued for invasion of privacy, misusing a person's image or causing them some kind of damage (financial, emotional, etc.). Here's a sample release:

RELEASE

I _____ do hereby give _____ ,
his/her assignees, licensees and legal representatives the irrevocable right to use my name (or any fictional name) picture or portrait in all forms and media and in all manners, including composite or distorted representations, for advertising, trade, or any other lawful purposes. I waive any right to inspect or approve the finished product, including written copy, that may be created in connection therewith.

I have read this release and am fully familiar with its contents.

Signed: _____

Date: _____

Consent
(if applicable)

I, _____ , am the parent and/or guardian of the minor named above and have the legal authority to execute the above release. I approve the foregoing and waive any rights in the premises.

Signed: _____

Date: _____

Use only the release portion (the first part) for anyone over 18 years of age. Have a parent or adult sign the consent form for anyone younger.

Don't panic every time you photograph someone without getting a release. First of all, as an artist you have considerable protection. It is only when you begin pursuing photography as a business that releases really become necessary. The laws vary from state to state, so it would be a good idea to check things out with a knowledgeable editor or lawyer if you plan to sell your photographs for publication.

On a more technical note, it's important to know how publication will affect the quality of your photographs. An offset printing press can't generally print gray. Instead, it reduces the gray tones in a photograph to varying densities of black dots. The dots are close together in the dark areas and far apart in the light areas. This creates the impression of a **continuous tone** photograph (which is what your original is called).

A photograph prepared for publication is called a **halftone.** It has been **screened** — copied onto high-contrast (lith) film through a screen, which produces the dots. This process has two effects.

First, it *increases* the photograph's mid-range contrast. All the subtle grays get separated out into a few basic values. The lightest grays become white (or almost white) and the darkest ones become black (or almost black). Second, the screening process *decreases* the photograph's overall **latitude** — the total range of tones from black, through gray, to white. This is because a halftone normally cannot produce either pure black or pure white. There are always some white spaces in the black areas

and some black dots in the white areas.

Both these effects are most extreme when the photograph is printed on newsprint, which requires very large dots. Good quality magazine paper is more responsive, but still a far cry from photo paper. Some art books come quite close to matching the quality of the original print . . . but you're probably a few years from that yet.

In essence, this means that in most cases your photograph won't look nearly as good in a magazine as it does on your wall. A contrasty print—with clear blacks and whites—will look fairly similar, though the contrast will increase. A low-contrast print may turn into a smudge, especially when printed on newsprint.

You can minimize the damage by shooting with publishing's constraints in mind. Always try to have your central subject fill the frame (so it gets as many dots as possible). Try to photograph your subject against a contrasting background. A white wall will set off someone's face and hair better than a gray or black one.

The standard format for black-and-white is an $8 \times 10''$ glossy print ($5 \times 7''$ for newspapers). The print should have a label taped or glued to the back with your name, copyright (i.e. © *1988*), when and where the photograph was taken, the name(s) of any identifiable person(s) in it and a note indicating that you have a release if you do (i.e., *Release on File*).

With color, the rules change a bit. The photograph is still reduced to dots, but this time the dots are in the 4 primary colors (yellow, magenta, blue and black) and they overlap in a sort of daisy-shaped pattern. Color photographs actually tend to repro-

Photographs that are reproduced by standard publishing techniques, such as all of the photographs in this book, are first "screened." This reduces all tones—white, gray and black—to dots of varying sizes. This is an enlargement of a photograph used elsewhere in this book.

duce much more accurately in a publication than black-and-white. In general, bright and **saturated** (strong) colors will work best. Good contrast will help make the focus seem nice and crisp. The problem area generally is shadows, which tend to become murky and blotchy. For this reason, it is especially important that faces and other key features be well lit.

For color work, most publishers prefer to receive 35mm transparencies. The films that produce the best results are Kodachrome (ISO 25 or 64) and Fujichrome (especially ISO 50), both of which have very fine grain and good contrast. Ektachrome is weak on both counts (grain and contrast) and is not recommended for general publication work.

On the slide mount you should write your name, copyright, when and where the photograph was taken, the name(s) of any identifiable person(s) and a note about a release if you have one.

Finally, before you abandon your most prized transparency into the hands of a stranger (or a friend, for that matter) it's a very good idea to get a signed contract stating what rights you have if the original is damaged. Generally, you should expect to receive some extra payment if the transparency cannot be printed again. Anything from $50 to $200 is a reasonable starting point. A publisher who values your photograph enough to use it should be prepared to guarantee its safekeeping.

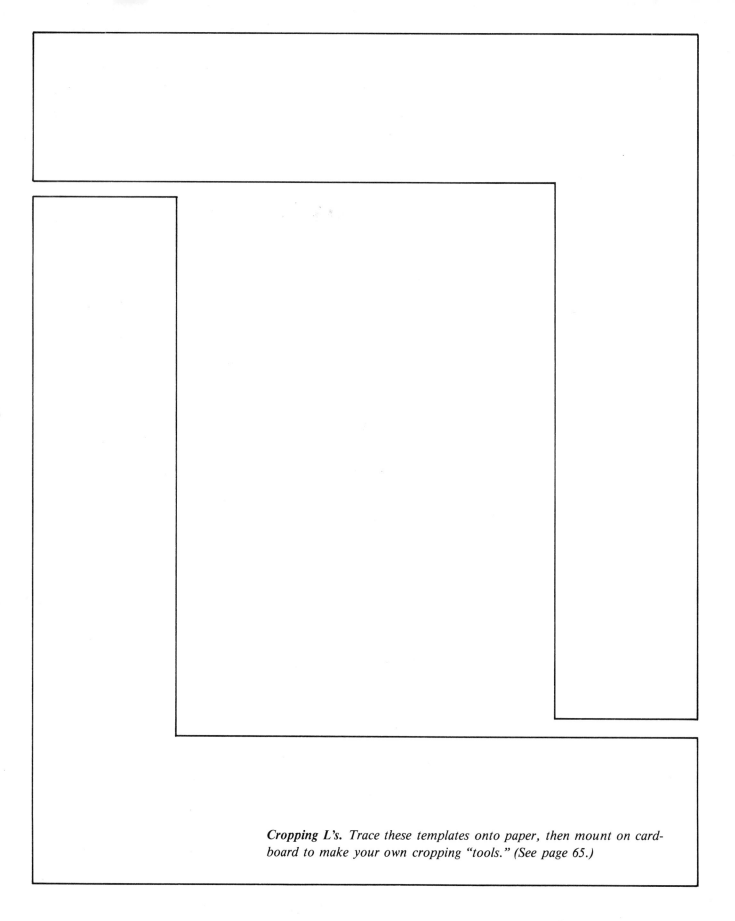

Cropping L's. *Trace these templates onto paper, then mount on card-board to make your own cropping "tools." (See page 65.)*

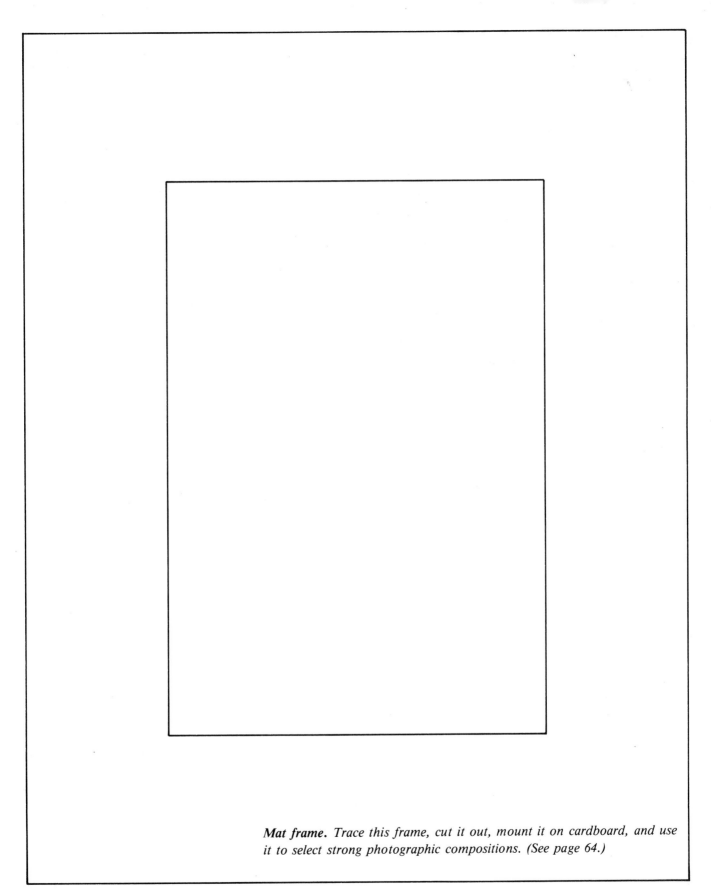

Mat frame. *Trace this frame, cut it out, mount it on cardboard, and use it to select strong photographic compositions. (See page 64.)*

Bibliography

Books

Books on photography move in and out of bookstores at a rapid rate. Many of this year's books will be replaced by new ones next year, if not sooner. Any list of specific titles, therefore, is likely to be only briefly valid and unlikely to be very helpful. Fortunately, several excellent writers and important topics find their way into print year after year. As points of reference, they're likely to be more useful than specific titles.

The following list, then, is intended as a general guide. Though some titles are mentioned, the authors and topics are more important. Check your local bookstore or library for new or old books by these authors or about these topics:

Davis, Phil Author of several excellent instruction manuals. His college-level textbook, *Photography* (published by Wm. C. Brown Publishers), is a detailed introduction to photographic theory and practice. It is highly recommended for anyone with an interest in the technical side of photography.

Eastman Kodak The "editorial team" of this renowned film and camera manufacturer produces books on a wide range of photographic topics. Some (notably *The Joy of Photography,* published by Addison-Wesley, and *The Complete Kodak Book of Photography,* published by Crown) are essentially "idea" books, containing a mix of information and photographs. They won't answer all your questions, but they will make you want to get out and try new things. Others (such as the *DATAGUIDE* series and a variety of how-to manuals) provide more detailed information than you're ever likely to need. Kodak books are sold in many camera stores, as well as in bookstores.

Equipment Manuals These are published by the manufacturers of cameras and accessories, as well as by independent publishers. They include specialized guides to the use of brand-name cameras (such as *Canon SLR Cameras* and *Nikon SLR Cameras,* both published by HP Books) and more general summaries of important accessories (such as *Flash Photography,* also by HP Books). For publications of this kind, check in camera stores as well as bookstores and libraries.

Hedgecoe, John One of the most prolific and competent authors of all-purpose "how-to" guides. At least one of Hedgecoe's books (including *The Photographer's Handbook, The Book of Photography, The Art of Color Photography* and *John Hedgecoe's Pocket Guide to Practical Photography*) should be included in every photographic library. All of them provide brief and precise answers to a host of "How do I . . . ?" questions.

ICP The International Center of Photography, based in New York, produces one of the most impressive photographic reference books, the *Encyclopedia of Photography* (published by Pound Press). Everything from biographies of major photographers to explanations of photographic theory and practice is covered in this enormous (and expensive) book. In addition, ICP is responsible for numerous collections of photographs published in conjunction with museum exhibits.

Inspiration The list of books that contain collections of photographs is virtually endless. Every photographer should regularly spend time admiring, critiquing and learning from books like these. Fortunately, almost any bookstore or library will provide ample opportunity to do so. Some noteworthy publishers of photographic collections include The New York Graphic Society, Aperture, and

The Museum of Modern Art (of New York).

Processing If you spend much time working in the darkroom, especially if you want to explore advanced techniques, you'll probably want more guidance than we've offered in the Appendix. There are essentially three kinds of books for this purpose: general manuals, special technique manuals and standard reference books.

A good general manual will help you select and use equipment, explain both basic and advanced procedures and offer helpful tips. Examples include *The Basic Darkroom Book* by Tom Grimm (Plum Books), *Basic Guide to B&W Darkroom Techniques* (part of the "Learn Photography Series" published by HP Books) and *Beginner's Guide to Color Darkroom Techniques* by Ralph Hattersley (Doubleday/Dolphin). A special technique manual may cover anything from high-contrast processing to the production of museum-quality prints. Examples include *Darkroom Magic* by Otto Litzel (Amphoto) and, for advanced Zone System work, Ansel Adams' *The Negative* and *The Print* (New York Graphic Society). Darkroom reference books provide very detailed information on films, papers, chemicals and procedures. Examples include *The Photographic Lab Handbook* by John Carrol (published by Amphoto) and such Kodak publications as *How to Process Ektachrome Slides Using Process E-6* and *Kodak Black-and-White Photographic Papers.*

Special Techniques If you're interested in some particular aspect of photography, odds are that someone has written a book about it. Few of the more specific titles, however, will ever show up in your local bookstore, or even in the library. If you want more information than you can find in the usual general interest books, try looking in *Books in Print,* a standard reference available for use in both bookstores and libraries. Most bookstores will be happy to place an order for you, and may even be able to convince a library to do so as well. Examples of the kinds of books you might find include *John Shaw's Closeups in Nature* (Amphoto) and *Frame It: A Complete Do-It-Yourself Guide to Picture Framing* by Lista Duren (Houghton Mifflin).

Time-Life Another editorial team. *The Time-Life Library of Photography* is an extensive (and expensive) series of books whose titles include *Color, Photojournalism* and *The Great Themes.* They are all good reference books, though you'll probably want to check them out of your local library, rather than buy them.

Vestal, David The author of numerous instruction books stressing black-and-white photography and processing. His books (especially *The Craft of Photography*) are excellent resources for anyone wishing to achieve a high level of technical skill.

Zone System The exposure control technique of Ansel Adams and his disciples. If you're interested in producing exquisite prints of subjects that will sit still for a long time (like buildings and rocks), then the Zone System is an essential tool. It has been explained in numerous books by numerous authors, including Adams himself. Probably the best known book on this subject is *The New Zone System Manual,* by Minor White, Richard Zakia and Peter Lorenz (published by Morgan and Morgan).

Magazines

There are many magazines and other periodicals devoted to photography, from glossy, mass-market monthlies to simple camera club newsletters. The following list covers those that are most commonly available. The best way to make your selection is to find a bookstore or drugstore with an extensive magazine rack and browse.

American Photographer If you consider advertising photography to be as important as traditional landscapes (as many contemporary photographers do) then you'll probably like *American Photographer.* If you enjoy a slick and occasionally flippant style, then you'll probably love it. At the very least, *American Photographer* is more enthusiastic than most photography magazines. In terms of content, it is primarily devoted to discussing photographers and showing their work, rather than to explaining how their results were achieved or what tools they used.

Aperture This is the classic photography magazine: a *very* serious publication, almost solely devoted to presenting the work of art photographers. It is elegantly designed and beautifully printed. Every photographer should own at least one issue.

Darkroom Photography For anyone wishing to master the darkroom, *Darkroom Photography* is an important resource. It contains a good mix of detailed "how-to" guides, equipment reviews and collections of inspirational photographs.

Modern Photography Both *Modern Photography* and its near-twin, *Popular Photography,* are utterly practical. Both are primarily about photographic tools. Most articles either evaluate a new product (camera, film, lens, etc.) or compare several that are similar. Collections of photographs illustrating a specific technique are another common feature. At least half of the reason to read either magazine is the ads, both the manufacturers' own and the mail-order listings in the back.

Peterson's Photographic This one is something of an oddball. Despite a style of writing and photography that are notably outdated, *Peterson's Photographic* is one of the most useful photography magazines available. It is filled with very practical step-by-step instructions on everything from studio lighting to building a homemade synchronizing flash trigger. The photographs are rarely better than mediocre, but the information is great.

Popular Photography See *Modern Photography.*

Zoom Rather aggressively off-beat, *Zoom* is the main forum for what might be described as new-wave photography. Stylistically, it favors bold, gritty imagery with a strong urban flavor. It is primarily devoted to collections of work by contemporary photographers. (Parental discretion is advised.)

Manufacturers' Magazines Several leading camera manufacturers publish magazines to show off the photographs produced with their cameras. These magazines are equally useful for inspiration and critiquing, even if you happen to own a competitors' camera. Minolta's is particularly good.

Glossary

Aperture Ring The ring on the lens of a manual camera which controls the size of the aperture.

Aperture The size of the lens opening. Apertures are measured by dividing the focal length of the lens by the diameter of the opening. For example a lens with a focal length of 50mm opened to a diameter of 6mm would produce an aperture (or f-stop) of f/8, or 1/8 the focal length.

ASA/ISO Standard numbers indicating film speed.

Cable Release A flexible cable which takes the place of a camera's shutter release button, allowing a photographer to "click" the shutter without shaking the camera. Used primarily for photography in low light, when long exposures are required.

Composition The arrangement of objects within the frame of a photograph.

Contact Print A photograph produced by placing the negative in *contact* with the photo paper under a light. For 35mm film, a contact print is almost exclusively used to test the negative's quality and provide a record of the photographs on it.

Contrast The range of values in a photograph or subject. Low contrast compresses all colors into a narrow range of grays. High contrast separates the colors so the darkest tones are very black and the lightest tones are very white, often with little or no gray in between. Normal contrast provides black blacks, white whites and a wide range of grays as well.

Critique The process, usually conducted in groups, of evaluating the strengths and weaknesses of one or more photographs.

Cropping Trimming the borders of a photograph, generally to improve composition. Though the term usually refers to trimming done on a finished print, cropping may be done by moving the camera before taking a photo, or by raising the enlarger so that less than the full photograph appears in the print. It is generally preferable to crop before the print is completed.

Dynamic Balance A composition in which the visual elements are arranged to produce a sense of harmony and to suggest motion of some kind.

F-Stop Number indicating a specific aperture (or lens opening), such as f/16. Higher numbers indicate *smaller* apertures (f/16 is smaller then f/11). See **Aperture.**

Film Speed The rate at which film reacts to light. A fast film reacts more quickly than a slow one. Film speed is measured as ISO and/or ASA numbers. ISO 400 is twice as fast as ISO 200.

Fixed Focal-Length Lens Any lens for which the angle-of-view is not adjustable (since extending the length of the lens narrows the angle at which light can enter it). For example, a 50mm fixed focal-length lens will always have a 55-degree angle-of-view. Any lens that does not have a fixed focal-length is a zoom. (See **focal length** and **zoom.**)

Fixed Lens A lens that is permanently attached to a camera body.

Focal Length In a general sense, focal length refers to the distance that light travels between entering the lens and arriving at the film. Longer focal lengths produce a telescope effect, shorter focal lengths produce a wide-angle effect.

Focal Point The point at which all the rays of light from a single object converge, causing the object to be in focus. By extension, the focal point of a photograph is the object on which the lens is focused. Other objects may of course be in focus as well.

Focusing Ring The ring on a lens which moves the lens forward and back, causing objects to go in and out of focus at the film plane.

Ground-Glass Focusing Screen A piece of glass with a matte finish onto which the camera projects the same image as it is projecting at the film plane, permitting the photographer to compose and focus.

Highlights Bright areas of a photograph or subject.

Interchangeable Lens Any lens that may be removed from the camera body and, therefore, exchanged for another.

Mass The *apparent* weight of an object in a photograph, as indicated by its size, tone (dark objects generally appear more massive), position and shadow.

Negative Space The space between one object and the frame of a photograph, or between two or more objects within the frame.

Objective (adjective) Factual; not influenced by a person's feelings or opinions.

Point of Interest The object in a photograph that attracts the most attention. Ideally the point of interest is also the primary subject (what the photograph is "about"), but this is not always the case.

Positioning Placing an object within the frame of a photograph. Generally this is done by moving the camera rather than by moving the object.

Positive Space The space filled by an object.

Proportion The relative sizes of two or more objects within the frame of a photograph. (Proportion may also refer to the contours of a single subject which, if distorted, may appear to be "out of proportion.")

Relation Anything that links two or more objects together, such as a similarity, contrast or contact between them.

Shutter A mechanical device which uncovers a single frame of film for a specified period of time so light traveling through a lens can produce an image.

Shutter Release A mechanical or electrical button which causes the shutter to open.

Shutter Speed The time that a shutter remains open, expressed in fractions of a second (i.e. 1/125 of a second, commonly referred to simply as 125).

Split-Image *Focusing Screen* A piece of glass (generally a small circle in the viewfinder) onto which two fragments of an image are projected by the camera's lens (or lenses). When the two fragments are aligned, the image is in focus.

Static Balance A composition in which the visual elements are arranged to produce a sense of harmony with no suggestion of motion.

Subjective (adjective) Dependent on a person's values, tastes or opinions.

Telephoto Lens Any lens that reproduces a smaller than normal portion of a given scene, so objects seem closer and larger than they actually are.

Value The range of dark and light tones in a photograph.

Viewfinder The camera's "window," which shows the photographer the image that will appear on the film. Many viewfinders also indicate the amount of light entering the lens, the shutter speed and other technical data.

Visual Elements All the basic components of an image. An element is a fundamental unit, such as line, which cannot be broken down into smaller parts.

Visual Harmony Any repeating visual element, such as a line or circle or a larger pattern of shapes and values. Visual harmonies are used to add interest and structure to photographs.

Weighting Positioning key subjects toward one side or the top or bottom of a photograph.

Zoom Lens Any lens of variable focal length, i.e. with an adjustable angle-of-view. A 35-150mm zoom lens, for example, provides the same focal-lengths as a 35mm, a 50mm and a 150mm lens, plus all the focal lengths in between.

Index

Acknowledgments

The authors wish to thank Scholastic, Inc., especially Eudora Groh and Mimi Sanchez, for generous assistance in providing student photographs. We also wish to thank the individual teachers and students who responded to our request for samples of their work, especially Jeff Frye, Trevor Bredenkamp and other students at Seoul American High School who undertook special assignments for us. We are grateful, too, to Tommy Clark (Lamar High School, Houston, Texas), William Jerdon (Cleveland Heights High School, Cleveland Heights, Ohio) and Shirley Rosicke (John Hay High School, Hopewell Junction, New York) for carefully reviewing the manuscript before publication.

Scholastic Inc. provided photographs that appear on the following pages: 4, 9, 36–38, 50, 53, 57, 60, 63, 68, 71–73, 75, 76, 80, 84, 85, 88, 91, 99, 109, 112–114, 118, 119, 122–124, 129–131, 133, 134, 140, 145, 164–167, 170–173, 177, 181, 182, 187, 189, 190, 195–198, 202, 209, 210, 219, 221–223.

Sotheby's Inc. provided photographs that appear on pages 14, 16–19, 21, 22, 25, 27, 29, 153, 169, 185, 201, 213.

The following high schools also provided student photographs (page numbers in parentheses): Dowling H.S., West Des Moines, Iowa (56, 149, 175, 193, 203); James W. Riley H.S., South Bend, Indiana (195); Wagner American H.S., Phillipines (70); Largo H.S., Florida (137); Colo Community H.S., Iowa (164, 171, 209); Central Visual and Performing Arts H.S., St. Louis, Missouri (165); East H.S., Waterloo, Iowa (192).